THE JAPANESE PRINT

Hugo Munsterberg

The
JAPANESE PRINT
A Historical Guide

New York • WEATHERHILL • *Tokyo*

First edition, 1982

Published by John Weatherhill, Inc., of New York and Tokyo, with editorial offices at 7–6–13 Roppongi, Minato-ku, Tokyo 106, Japan. Protected by copyright under terms of the International Copyright Union; all rights reserved. Printed in the Republic of Korea and first published in Japan.

Library of Congress Cataloging in Publication Data: Munsterberg, Hugo, 1916– / The Japanese print. / Bibliography: p. / Includes index. / 1. Color prints, Japanese. / I. Title / NE 1310.M86 1982 / 769.952 / 81–16195 / ISBN 0–8348–0167–1 / AACR2

For Meredith Weatherby,
who, as editor, translator, and
publisher, has added so much to our
understanding and appreciation
of Japanese art

Contents

Preface

THIS BOOK IS INTENDED to serve as an introduction to Japanese prints for the student of Japanese art or the beginning collector. While the paintings and the illustrated books of printmakers are mentioned only in passing, the account of the Japanese print is not limited to the history of ukiyo-e but includes a discussion of the Buddhist prints of the medieval period and the prints of the modern age starting with the Meiji era and coming up to the present. No work of this type would be possible without the scholarly contributions of many colleagues, both Japanese and Western, who have done research in this field of Japanese art history. Among contemporary scholars to whom the author is especially indebted are Muneshige Narazaki, Jack Hillier, and Richard Lane, all of whom have made invaluable contributions to the study of ukiyo-e. He is also very grateful to the many private collectors and museum curators who permitted him to study the treasures in their care. For assisting him in his study of the modern print, he is deeply indebted to Miss Mioko Onchi. For research in the influence and appreciation of the Japanese print in the West, he wishes to thank Miss Deborah Brown. He also wishes to thank Miss Kaethe Shaw, who typed the manuscript, often written in an illegible hand, and made many helpful editorial suggestions, and Miss Sara Frear, who typed the finished copy. Finally, the author would like to thank those who so graciously made photographs of prints in their possession available for reproduction.

It should be noted that Japanese personal names in this book, with the exception of those of modern authors whose works are cited, are given in Japanese style: surname first, given name last.

THE JAPANESE PRINT

1 Discovery and Appreciation

OF ALL THE ASPECTS of Japanese art, woodblock prints have had the greatest appeal for the Western world. In fact, this art form has enjoyed greater popularity in Europe and America than it ever has in Japan itself, and it is fair to say that only after Western artists, collectors, and scholars praised Japanese prints to the skies did the Japanese themselves begin to appreciate the unique artistic heritage that was theirs. As the dean of Japanese ukiyo-e scholars, Dr. Seiichiro Takahashi, put it: "It is hardly necessary to mention that it was the Americans and Europeans who took the trouble to find rare and beautiful works of art among the piles of these inexpensive commercial goods. . . . The Japanese are a kind of people disposed often to remain unaware of the real value of things Japanese until such is pointed out by foreigners, while extolling some trivial objects as peerless."[1] This was certainly the case with Japanese prints, which were only recognized as a major art in Japan after they were discovered in the West.

Although the great vogue for Japanese prints in Europe dated only from the second half of the nineteenth century, a few examples of this art form had actually reached the West considerably earlier. It was probably through the Dutch East India Company, which had a monopoly on the Japanese trade with the West, that the first Japanese prints reached Europe during the eighteenth century. James A. Michener reports an instance of such an early collection in his book *The Floating*

1. Seiichiro Takahashi: *The Evolution of Ukiyo-e: The Artistic, Economic, and Social Significance of Japanese Woodblock Prints.* Yokohama, 1955; page 122.

World, where he relates that "in 1775 a Swedish naturalist, Carl Peter Thunberg, spent a year in Nagasaki working with the Dutch. . . . He made a collection of ukiyo-e, including some excellent Harunobu and Koryūsai prints which are now in the National Museum, Stockholm."[2] Several Dutch officials also brought back prints from their sojourns in Japan, where they had an outpost on the island of Deshima in the bay of Nagasaki in Kyushu. The most important of them was Isaac Titsingh, who spent fourteen years in Japan and brought back with him upon his return to Europe nine woodblock engravings printed in colors. It is believed that some of them were by Utamaro, suggesting that already at this early date some of the masterpieces of ukiyo-e were reaching the West. This small collection was known in Paris as early as 1806 and was sold there after Mr. Titsingh's death in 1812. Some of the prints eventually ended up in the collection of the French artist Bracquemond, who is usually credited with discovering Japanese prints.

In the early nineteenth century two Dutch officials, J. Cock Blomhoff, who was *kapitan,* or head, of the Dutch settlement on Deshima from 1817 to 1823, and F. van Overmeer Fisscher, who was employed by the Dutch East India Company as an accountant and store manager from 1819 to 1850, formed collections of Japanese woodblock prints largely for ethnographic purposes in order to illustrate the life, customs, and arts and crafts of the Japanese people. The most important collector, however, was the German scholar and physician Philipp Franz von Siebold, who served in Japan from 1826 to 1830 and wrote the first complete and accurate description of Japan under the title *Nippon.* He also visited the country again in his old age during the years 1859 to 1862 His collection comprised some two thousand prints, which he carefully catalogued and deposited in the National Museum of Ethnology in Leiden, Holland, opened to the public in 1837. It is still one of the best and most comprehensive collections in existence. Since he often bought two copies of the same print, one for display and the other to be placed in storage, some of the prints from his collection are in mint condition, with the colors as fresh and vivid as they were when they were first produced in the late Tokugawa period. A deluxe publication in three magnificent volumes of his superb collection was issued in 1979 to commemorate the one hundred

2. James A. Michener: *The Floating World.* New York, 1954; page 238.

and fiftieth anniversary of Siebold's stay in Japan. While the bulk of the prints are by late ukiyo-e artists such as Toyokuni, Kunisada, Eizan, and Eisen, the work of such giants as Utamaro, Hokusai, and Hiroshige was included as well.

In France, where the artistic quality of Japanese woodblock prints was first fully appreciated, the earliest to do so was apparently the gifted young etcher Félix Bracquemond, who discovered a copy of a volume of Hokusai's *Manga* in the shop of his printer Delâtre in 1856. It is said that the book had been used as part of the packing material for a porcelain shipment, although this may well be a romantic story with little basis in fact. In any case, while Delâtre was not willing to part with his copy, Bracquemond soon after was able to acquire another copy from the printmaker Eugène Lavieille, which he shared with his friends Philippe Burty, Zacharie Astruc, and Édouard Manet.[3] In the following years Bracquemond assembled an extensive collection of Japanese prints that was particularly strong in Utamaro and Hiroshige, who were his favorite artists.

Soon the interest in Japanese prints spread, and Oriental import shops like Mme. de Soye's La Porte Chinoise, founded in 1862, made them available to eager collectors, artists, and connoisseurs. But it was not until the Paris World Exposition of 1867 that they became well known among the general public. Interestingly enough, the ukiyo-e artists who were exhibited there were not the late-eighteenth-century and early-nineteenth-century masters whom we now consider the outstanding figures in this art form but artists who were active in the late nineteenth century: men like Kuniteru, Sadahide, Hiroshige III, and Kunisada II. Nonetheless, their work was sold without difficulty at the end of the exposition. In England, too, the interest in Japanese prints had developed by the 1860s, when a group of them were shown in the London International Exhibition of 1862. They were part of the collection of Japanese arts and crafts formed by Sir Rutherford Alcock, who had been resident minister of the British government in Edo, and were very late ones by the so-called decadents of the ukiyo-e school. Other examples of Japanese woodcuts, largely landscapes, had already been known from reproductions in books and magazines. As early as 1865 the writer K. Cornwallis reported in his book *Two Journeys to Japan* that he visited Shimoda and bought woodblock prints there, and

3. C. F. Ives: *The Great Wave*. New York, 1974; page 11.

in 1860 the British magazine *Once a Week* published an account of a trip to Japan that was illustrated with reproductions of the work of ukiyo-e artists, mainly Hiroshige. A year later, in 1861, Captain Sherard Osborn, in his *Japanese Fragments,* mentioned Japanese prints and reproduced six Hiroshige landscapes that were colored by hand. He also used various smaller cuts in the text: illustrations based mostly on Hokusai's *One Hundred Views of Mount Fuji.* The first public lecture on Japanese prints in London was held on May 1, 1863, at the Royal Institute, where Mr. Joe Leighton gave a talk on the art displayed at the Japanese Court of the International Exhibition during the previous year.

In the United States, Japanese color prints first became known through Commodore Perry's expeditions of 1853 and 1854. Perry himself brought back as souvenirs several prints that interested him for their technique and subjects rather than as works of art. Among them was a picture of the Yodo River from Hiroshige's ten-piece set *Places of Note in Kyoto,* which was first issued in 1834 and is considered among the artist's finest series. He also purchased the Hiroshige triptych *Crossing the Ōi River on Foot,* which had just been published, and an illustrated storybook, *The Life of Tōgō Asakawa,* by Yoshikatsu, a follower of Kuniyoshi. Furthermore it is interesting to note that the first color reproductions of ukiyo-e prints outside of Japan were published in the account of Perry's expedition, which was brought out for the Department of the Navy by the Congress of the United States in 1856. It contained three color plates after views of Kyoto by Hiroshige. Two years later, in 1858, another American, the painter John La Farge, bought his first Hokusai album and started collecting Japanese prints, which he admired for their decorative quality and sense of design. His essay on Japanese art, in which he singled out Hokusai for praise, was published as early as 1869 and was the first Western writing to deal more fully with this subject. Two other Americans who were early appreciators of Japanese prints were Russell Sturgis, who had started his collection in 1869, and Jackson Jarvis, who had discovered Japanese art in the sixties but was limited in his knowledge because he had seen little more than the work of Hokusai.

Among the enthusiasts for Japanese prints in Paris were many of the leading artists of the day. The earliest to discover them were painters such as Stevens, Whistler, Diaz, Fortuny, and Legros, followed in quick succession by Manet, Tissot, Fantin-Latour, Degas, and Monet.

By 1868 Manet introduced a Japanese print in the background of his painting of Zola, and Monet's early work clearly reflected the influence of Hiroshige's landscapes. After the great exposition of 1867 nine of these friends of Japanese art formed the Société du Jinglar, named after a Japanese rice wine. They met dressed in kimonos instead of frock coats and ate with chopsticks instead of knives and forks.

During the eighties and nineties this movement, now known as Japonism, spread even further, with virtually all the leading artists of the impressionist and post-impressionist movement becoming devotees and collectors of Japanese prints. Especially Utamaro, for his elegant women; Sharaku, for his expressive actor portraits; Hokusai, for his depiction of Japanese life; and Hiroshige, for his atmospheric landscapes, became great favorites whose work was eagerly collected. The movement also exerted a profound influence on French art of the late nineteenth century. The sense of design exhibited by the great Japanese printmakers, their emphasis on two-dimensional space, their strong feeling for decorative pattern, the boldness of their composition, their clearly defined forms, and their subtle colors were qualities much admired and frequently imitated.

This great vogue for Japanese woodblock prints was very much stimulated by the Japanese ukiyo-e expert Hayashi, who was responsible for bringing many fine prints to Paris, and above all the dealer S. Bing, whose shop was visited by Bonnard, van Gogh, Gauguin, and Toulouse-Lautrec, among others. The high point was reached in 1890, when the École des Beaux Arts mounted a major exhibition of Japanese prints comprising over one thousand pieces from outstanding private collections. This show created a sensation and had a great influence on several of the leading artists of the day. Mary Cassatt, who visited it twice, once in the company of Degas and the other time with Berthe Morisot, began collecting Japanese prints and created her own first graphic works depicting young girls in a style clearly reflecting the influnece of Utamaro, whom she greatly admired. Her friend Degas, who had introduced her to Japanese woodblock prints, was also deeply impressed with their beauty. He always kept albums of them in a vitrine in his dining room and had a diptych of bathers by Kiyonaga above his bed. Another artist of this group who developed a great admiration for these works was Pissarro, whose views of Paris seen from above clearly reflect the influence of Hiroshige, whom he admired very much.

Even greater, however, was the impact of ukiyo-e prints on a somewhat younger generation of French artists, whose entire outlook and style of painting were profoundly altered by their encounter with Japanese art, particularly Bonnard, Toulouse-Lautrec, van Gogh, and Gauguin. Bonnard became known as the true Japanese Nabis, so filled was he with enthusiasm for these prints, and his own work, especially his color lithographs of 1899 with street scenes from Paris, clearly reflected the strong effect that Hiroshige's work produced on him. Equally under the spell of Japanese printmakers, especially Utamaro, was Henri Toulouse-Lautrec, who was particularly fond of the erotic prints of the *shunga* type. He owned a copy of Utamaro's famous album *The Poem of the Pillow,* which he received from the Goncourt brothers. His own prints of the women of the Paris brothels clearly reflect his admiration for the Master of the Green Houses, and his posters, with their bold patterns and strong lines, bear the impact of Japanese art. As Miss Ives rightly says, "The Japanese woodblock print is the determining influence on the French age of the poster—the 1880s and 1890s. The poster stress on line and its broad unmodeled forms imposed maximum readability on advertising design."[4]

Van Gogh actually copied ukiyo-e prints even down to their inscriptions in Japanese, the most notable being his version of Hiroshige's *Sudden Shower at Ōhashi,* and when he arrived in Arles he wrote to his brother that "this is a landscape out of Hiroshige." His own work, with its brilliant colors, distinct outlines, and strong, flat patterns, clearly shows the great influence that Japanese printmakers had on him. As he once said, he regarded them as equal to the best of the European masters. Even more immediately influenced was Gauguin, who had Japanese prints with him at Pont-Avon and Hokusai and Utamaro prints on the walls of his Paris studio. He took a group of ukiyo-e prints with him to the South Seas as part of his reference collection. His own woodblock prints clearly indicate in both their technique and their design the Japanese influence, especially that of Hokusai's *Manga,* and his paintings of the Tahiti countryside are unthinkable without the example of Hokusai's *Thirty-six Views of Mount Fuji.*

At the same time European writers began to study the history of ukiyo-e and to issue the first scholarly catalogues, articles, and books. Pioneers among them were the brothers Goncourt in France, who

4. Ibid., page 20.

had formed a collection of Japanese prints as early as the sixties. In 1891 Edmond de Goncourt published his *Outamaro, le peintre des maisons vertes,* which was the first monograph on one of the masters of the Japanese print. It was followed in 1896 by his book on Hokusai. Prior to that, Louis Gonse had already discussed Japanese woodblock prints in the first volume of his work *L'Art japonais* (1883), in which he had praised Hokusai to the skies as the very culmination of Japanese art. Bing had reproduced many outstanding prints in the pages of his magazine *Le Japon artistique,* which was published between 1889 and 1891.

In Great Britain, Professor William Anderson was a pioneer of ukiyo-e studies, discussing this art form in *Pictorial Art of Japan* of 1886 and in his catalogue of the holdings of Chinese and Japanese paintings in the British Museum. The earliest book of his devoted entirely to ukiyo-e prints was his *Japanese Wood Engravings: Their History, Technique, and Characteristics* (1895), which was followed in quick succession by Edward Strange's *Japanese Illustrations: A History and Description of the Arts of Pictorial Wood-cutting and Color-printing in Japan* of 1897 and the German scholar Woldemar von Seidlitz's *Geschichte des japanischen Farbenholzschnittes,* which was first issued in 1897 but appeared in many later editions and was translated into French and English. In the United States the greatest contribution was made by Ernest Fenollosa, who had spent many years as professor at Tokyo University and later became curator of Oriental art at the Boston Museum, with his *Masters of Ukiyo-e,* published in New York in 1896.

Because of this great interest and enthusiasm for Japanese prints, important collections of them were formed in both Europe and America long before Japan itself became aware of their aesthetic and historical significance. The most outstanding public collection was that at the Boston Museum, which acquired 10,000 prints from Fenollosa and is to this day the best and most extensive collection of ukiyo-e in the world. Other fine collections were formed in London at the British Museum, which in 1906 acquired the collection of Arthur Morrison, consisting of no fewer than 1,851 prints, as well as in Paris, Berlin, Hamburg, and Dresden. There were also numerous private collections, notably in Paris, among which the Vever Collection was probably the most illustrious.

While in their native country masters like Harunobu, Kiyonaga, Utamaro, Sharaku, Hokusai, and Hiroshige were still looked down

upon for catering to the ordinary people and portraying such vulgar subjects as courtesans, actors, and genre scenes from the life of the common people, Westerners rightly saw these artists as the very embodiment of what was most original and most typically Japanese in the art of that country. As Louis Ledoux put it so well in *The Art of Japan,* "prints made an immediate, irresistible appeal to Europe and America. They are distinctly Japanese in scope and feeling, they have humor, gaiety, the charm of Japan; they poke fun unblushingly at old solemnities, they show the young girls of the bourgeoisie, flower-like in their lighthearted pastimes, the courtesans and actors and merry-makers of the world that had gone, and they depict all this with a consummate mastery of form and line and color that was the heritage of a thousand years of technical achievement."[5]

5. Louis V. Ledoux: *The Art of Japan.* New York, 1927; page 30.

2 Buddhist Prints of the Medieval Period

THE ART OF MAKING woodblock prints goes back to the very beginnings of Japanese Buddhist culture, certainly no later than the Nara period (646–794). The earliest surviving printed sheets consist of Buddhist charms and amulets of which no fewer than one million copies were distributed to Buddhist temples throughout Japan by order of the empress Shōtoku in A.D. 770. The origin of this art form is to be found in China, where such printed designs and inscriptions had existed for many centuries. The oldest reference to printed Buddhist pictures occurs in the writings of the famous Chinese pilgrim I-ching, who in the late seventh century visited India and reported that Buddhist prints were being made there.

In Japan no pictorial prints dating from earlier than the Heian period (794–1185) are preserved. But since Sir Aurel Stein discovered at Tun-huang a Diamond Sutra with a woodcut frontispiece dated 868 (it is now in the British Museum), it can safely be assumed that such Buddhist pictures were also known in Japan at the time. That the technique of reproducing pictorial designs by printing from carved blocks was known and employed in Nara-period Japan is also indicated by the fact that printed and dyed textiles are found in the Shōsō-in, the storehouse of the Tōdai-ji, in Nara, where they were deposited by the widow of the emperor Shōmu during the eighth century.

The oldest surviving printed images are dated 1162. They represent Bishamonten, Guardian of the North, a very popular Buddhist deity (Plate 1). Although crude in execution and very simple in style, they have a striking simplicity and power that appeals to the modern taste with its liking for the primitive and for folk art. The great modern

Buddhist-print artist Munakata Shikō, for example, was very fond of this type of graphic art and freely admitted that he had been much influenced by these early prints of medieval Japan. While no doubt many other printed images and charms were produced during the Heian period, the bulk of the early prints that have come down to us date from the Kamakura period (1185–1336). Several outstanding examples have been found at the Kōfuku-ji, one of the five great temples of Nara, while other interesting printed sheets have been discovered inside of carved wooden statues.

All kinds of deities, both Buddhist and Shinto, were represented in this manner. Among the former, the historical Buddha Shakyamuni and Amida, the Buddha of the Western Paradise, were the most common, as well as Kannon, the Bodhisattva of Mercy and Compassion; Fudō, the protector of Buddhism; and Shōtoku Taishi (Prince Shōtoku), the first great patron of the faith in Japan. Other designs that proved popular were the footprints of the Buddha, symbolizing his earthly pilgrimage (Plate 2), and pagodas standing for his death, or Nehan (Nirvana). Some of the larger prints, which were usually hand-colored, also represent paradise scenes, the Nirvana of Shakyamuni, and the mandalas, or magic diagrams, of the Shingon sect.

The prints made under Shinto inspiration are very much in the folk-art vein and represent the gods of good fortune, such as Ebisu and Daikoku, or sacred animals like the horse and the cow. There is also at least one Christian print, dated 1580 and executed through a combination of metal and woodblock plates.

The purpose of making the printed images and emblems was no doubt magical, expressing the hope that they would bring protection and good fortune to those who acquired them. In fact the very art of producing them was considered blessed, and prayers and the chanting of sacred sutras often accompanied their manufacture. The larger prints could also take the place of painted or sculptured icons, serving as cheap substitutes for those who could not afford the more costly originals. Just as sacred prayers were repeated over and over again, so some of the images were printed many times on one sheet, no doubt in the hope of increasing the efficacy of the charm. This was sometimes done over a period of time, so that the devotional offering extended over many days. These Buddhist prints and charms also served to be carried as talismans by the living or to smooth the way into paradise for the dead, a practice that still survives to the present day, when

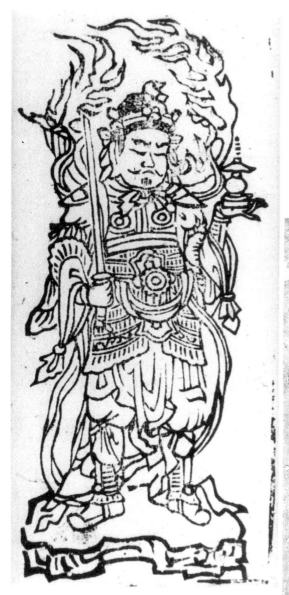

1. *Buddhist print picturing deity Bishamonten. Heian period, 1162. Museum of Fine Arts, Boston.*

2. *Buddhist print showing footprint of the Buddha. Kamakura period, thirteenth century. New York Public Library; Astor, Lenox, and Tilden Foundations.*

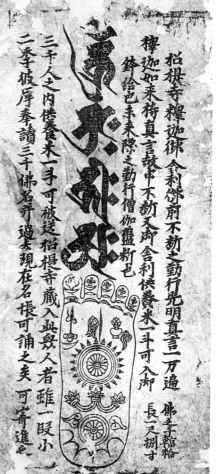

such protective and lucky pictures or inscriptions are sold at temples and shrines. Another important purpose in the sale and distribution of this type of printed sheet has always been, as is indicated by their inscriptions, to raise money for the sacred establishments, since they are always in need of funds to repair their buildings and provide for their clergy.

Although the best of these early woodblock prints are today highly regarded as works of art and sought after by museums and private collectors, they were no doubt in their own age primarily looked upon as aids to devotion rather than as objects of aesthetic appeal. Printed in black or, more rarely, in dull red ink on thin mulberry paper, they have a certain simple yet strong visual beauty that is pleasing, but even the finest never exhibit the technical mastery and artistic excellence of the contemporary painting or the sophistication of the prints of the Edo period (1603–1868). The tools used in making them were very crude, consisting mainly of the cutting tools used by sculptors of the time. Although the technique came from China, along with many other features of Buddhist culture, it was first introduced from Korea. The great majority of designs were printed on single sheets, but for some of the larger prints several sheets were needed, and especially during the later phase of this art, notably the fifteenth and sixteenth centuries, printed books and scrolls also became popular. For the smaller images stamps and seals were also often employed. Many of the figures were printed only in outlines and were then filled in with watercolors so that they looked much like paintings. Modern collectors, however, tend to prefer the plain black-and-white prints, which have a strength and directness that the elaborately colored prints do not possess. While technically vastly inferior to the type of illustrated books and pictorial prints made by the artists of the Edo period, these prints must be looked upon as their forerunners.

Indeed they are the early woodblock prints, and those of the ukiyo-e school are related to them not only in terms of the medium employed but also in terms of the subject matter portrayed by some of the earlier printmakers. A case in point is seen in the designs printed on a group of folding fans that were dedicated to the Shitennō-ji, a famous Osaka temple, during the late Heian period. There were probably originally over two hundred such fans, of which one hundred and twenty-six remain. Of these at least fifty-six have printed contour lines and were painted in colors. The scenes depicted are taken from the life of the

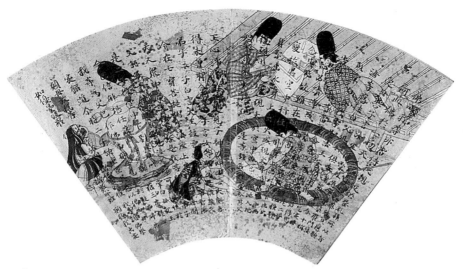

3. Fan print with genre scene and text from Lotus Sutra. Heian period, twelfth century. Tokyo National Museum.

time, representing both nobles and commoners in their various activities (Plate 3). Strangely enough, over the faces of the fans are written Buddhist texts, largely from the Lotus Sutra, that have no relation to the pictures shown. No wholly satisfactory explanation has so far been offered. The contrast between the vivacious genre scenes and the holy writing is striking and reflects two very different aspects of Japanese life and thought. There can be no doubt that these fans represent an important landmark in the development of Japanese woodblock printing and foreshadow the kind of genre prints depicting scenes from ordinary Japanese life that were to be the most characteristic subject matter of the prints of the ukiyo-e school. In consequence there is a direct link in terms of both technique and subject matter between these medieval woodblock prints and those of the Edo period.

3 Moronobu and the Origins of Ukiyo-e

THE ARTISTIC SCHOOL that developed the woodblock print into a major art form was the ukiyo-e school. The term *ukiyo* itself was originally a Buddhist one, referring to the fleeting secular world in contrast with the spiritual reality of Buddhism. During the Edo period, however, *ukiyo* was used somewhat differently to describe the floating world of pleasure and amusement, often of an erotic type, especially that of the red-light district of Edo, the Yoshiwara, with its beautiful women, handsome men, and Kabuki actors. The suffix *e,* which means painting, was added around 1680, and from then on ukiyo-e was the term used to describe a school of genre painting and printmaking that flourished for some two hundred years between 1680 and 1880.

While today ukiyo-e is largely thought of as a graphic-art form, it was originally a school of painting that traced its origin to the traditional Tosa and *yamato-e* schools, which, from as early as the Heian period, had depicted narrative scenes often taken from ordinary life. This type of painting continued to flourish right into the Edo period. It also reflected the Kanō school of painting, which had produced some fine examples of genre scenes during the sixteenth century. In fact some Japanese scholars look upon these paintings as the forerunners of the ukiyo-e, and there can be no doubt that several of the leading artists of the ukiyo-e school were trained in the Tosa and Kanō traditions.

In addition to painting, the art form that played an important role in the evolution of the ukiyo-e school was the illustrated book, which had a long history going back to the medieval period. The earliest such books, which can be considered as forerunners of the mature ukiyo-e prints, were a group of erotic albums of which the *Pillow Book of the*

Yoshiwara, or *Yoshiwara-makura,* of 1660 was the first. Single prints only came into existence somewhat later, and it is not until 1680 that we can talk of a clearly recognizable and well-established school of painting, book illustration, and printmaking that can be properly referred to as ukiyo-e.

The man responsible for this development was Hishikawa Moronobu, an artist of genius, who is today rightly regarded as the founder of the ukiyo-e school, even if others had already made woodblock prints of the same type a decade or two before he did. He was born in Hoda, in what is today Chiba Prefecture, called Awa Province at the time. It is located in the environment of present-day Tokyo (formerly Edo) on the far side of Tokyo Bay. The exact date of his birth is not known, but since he came to Edo in 1662 and his first dated work comes from 1672, it seems likely that he was born during the 1630s. His father was a textile maker who was well known for his tapestries, which were much admired. There can be little doubt that the young Moronobu was trained in his father's workshop, and it is interesting to note that Moronobu's son Morofusa, after a few years as a painter, returned to his grandfather's profession. Judging from Moronobu's work, it is also believed that he must have been trained by artists of the Tosa and Kanō schools, for he exhibited great skill as a painter and illustrator from the very beginning of his artistic career.

His most creative period was the decade of the 1680s, during which he produced a large number of paintings, illustrated books, and separate prints that are to this day considered among the masterpieces of ukiyo-e. Employing a strong line, fine decorative patterns, and a beautiful sense of design, he elevated woodblock printing to a position it had never enjoyed before. In fact it can be said that he was responsible for turning a school that had been primarily devoted to painting into one that excelled in producing woodblock prints. While it is true that all the great masters of ukiyo-e produced paintings as well as prints and that some of them were very accomplished painters as well as graphic artists, it cannot be denied that they did their most significant work in the woodblock medium. The reason for their turning to the print was no doubt originally a purely economic one, for it enabled the artist to mass-produce his work inexpensively. Once having taken this step, however, printmakers like Moronobu were able to transform the woodcut into a medium well suited to their purposes.

The themes portrayed by Moronobu were largely taken from the life of the Yoshiwara district of Edo, many of them falling into the category of the so-called spring pictures, or *shunga,* presenting erotic scenes. These were usually issued in albums of twelve, with the first picture, and possibly one or two others, quite innocent while the others were frankly erotic, depicting various forms of sexual intercourse in a very explicit way. Moronobu's favorite subjects, however, were the proud and beautiful women of the amusement district, whose physical attraction and elegance he never tired of celebrating. While most of them were prostitutes, or, to use the more polite Victorian form preferred by most of the English writers on ukiyo-e, courtesans, they were nevertheless often women of real beauty and dressed in the most magnificent kimonos. They were much admired by Edo society and were indeed considered goddesses by their customers. Shown singly or in groups attended by their maids, they are seen walking the streets of the Yoshiwara district or going on rare outings to the countryside, receiving their customers, or idling away their time in the "green houses," as the bordellos of Edo were called. For the well-to-do townsmen or amorous samurai who frequented this district, where alone they could pursue romantic adventure in a society in which all marriages were arranged, these courtesans embodied the very essence of this age, which is known as the Genroku era (1688–1704) and is celebrated for its elegance and splendor.

At least one hundred and fifty illustrated books by Moronobu have come down to us, but even this large number may not constitute his entire output, for little effort was made to preserve this type of art. In addition to the *shunga* albums and those celebrating the courtesans of the day, there were guidebooks to the sights and pleasures of Edo, including the entertainments of the Yoshiwara district (Plate 4). They were no doubt intended to advertise the attractions of the city and to introduce potential customers to the alluring inmates of the green houses. They would also have served as much-cherished souvenirs for those who had tasted the joys of the Yoshiwara and could be relished by those not prosperous enough to afford these pleasures.

While this type of subject was the preferred one and plays a central role in Moronobu's art, he also produced illustrated books and single prints depicting scenes from contemporary life, as well as those depicting legends, love stories, and poetry. The earliest of these books may come from the late 1660s, although no book dated prior to 1672

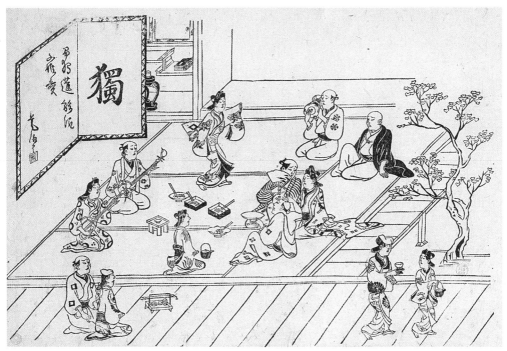

4. *Hishikawa Moronobu:* Courtesans, Guests, and Musical Entertainers *from* The Style and Substance of the Yoshiwara. *About 1680. Metropolitan Museum of Art, gift of Samuel Isham, 1914.*

has come down to us. By 1674 he had become a well-established artist who was the leading figure in this field. His most creative period, however, was during the 1680s, when he produced his finest work. By the end of this decade he seems to have retired, for few of his works date from the nineties. Since we know that he died in 1694, it appears that his productive period lasted for about two decades.

All of Moronobu's prints were executed in black and white, and he was a master in getting the maximum effect from the bold contrast between the white of the soft, absorbent paper and the heavy calligraphic lines and black pattern of the areas of ink. He was also superb in his compositions and in rendering his figures in space, achieving ever novel and arresting effects. While both contemporaries and later collectors sometimes colored these prints, it is generally felt that the black-and-white prints are more striking than the colored ones.

MORONOBU AND UKIYO-E *19*

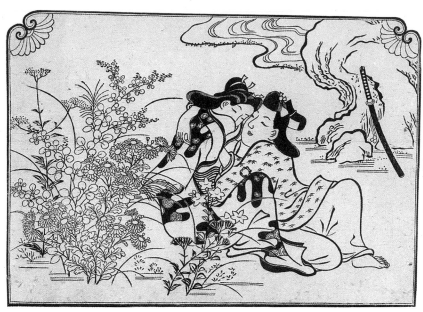

5. *Hishikawa Moronobu:* Lovers. *About 1680. Metropolitan Museum of Art, Harris Brisbane Dick Fund, 1949.*

A good example of Moronobu at his best is his portrayal of lovers in intimate embrace, one of a series of twelve prints believed to date from the high point of his career in the early eighties. A typical work of his belonging to a *shunga* album shows a young samurai and his ladylove in a romantic setting in a garden with autumn grasses and flowers and presents the erotic content of the scene in a very delicate manner (Plate 5). The use of the woodcut medium shows Moronobu's supreme mastery of this art form and surpasses anything else that had been achieved before this time.

Although Moronobu had numerous followers, including his son Morofusa and his son-in-law Moronaga, who continued in his footsteps, none of his immediate circle could replace him at his death. Morofusa, after continuing as a printmaker for about a decade and producing some rather feeble works that were little more than pale reflections of his father's prints, gave up printmaking entirely by the end of the century. Moroshige, Moronobu's most brilliant pupil, did some fine work, especially in the *shunga* field but was not the equal of Moro-

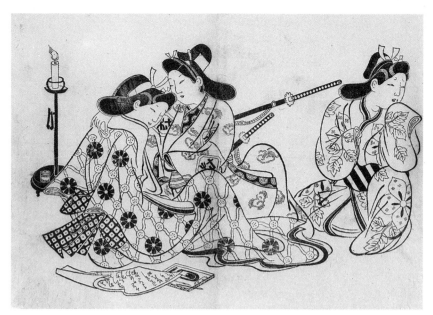

6. *Sugimura Jihei:* Lovers and Attendant. *About 1690. Metropolitan Museum of Art, Harris Brisbane Dick Fund, 1949.*

nobu. He in turn was the teacher of several other artists who in order to show their relationship to him used the first character of his name in their own. The best of them were his son Moromasa along with Morotane and Morotsugu, who worked during the early eighteenth century. None of them were artists of note.

The only one of Moronobu's followers who was really an outstanding artist in his own right was Sugimura Jihei, a rather shadowy figure whose identity and artistic personality have been rediscovered by Japanese art historians only in recent years. Today he is considered one of the major figures among the so-called primitives of the Japanese woodblock print. In fact some collectors even prefer him to Moronobu himself. Before the well-known ukiyo-e scholar Kiyoshi Shibui established that these prints were made by Sugimura, they were usually attributed to Moronobu. His most important and artistically most successful works belong to the *shunga* genre and are even more explicit than those of his master. Several of them are large in size and show a power of visual expression that is truly impressive (Plate 6). His best

work dates from the late eighties, but he continued into the nineties.

By the end of the seventeenth century both Moronobu and his most immediate followers had died or ceased working, but his influence continued to be strong, as seen in the works of the leading ukiyo-e artists of the next generation: Kiyonobu, Kiyomasu, Masanobu, and Kaigetsudō. Although none of them belonged to the Hishikawa school, they nevertheless were spiritual heirs of Hishikawa Moronobu, who had established the artistic tradition within which they worked. In fact it can be said that the entire ukiyo-e school of woodblock printmaking owes its very existence to this great genius and that all of those who followed him were to a certain extent walking in his footsteps.

4 Actor Prints: Kiyonobu and the Torii School

NEXT TO COURTESANS, the most popular subjects of the ukiyo-e artists were scenes from the Kabuki theater. This dramatic art form, which had originated at the beginning of the seventeenth century in Kyoto, soon became a great popular favorite and, in spite of all attempts on part of the government to curtail or even to suppress it in premodern times, has continued to flourish to the present day. While in its earliest manifestation it was little more than a dance with erotic overtones derived from Shinto rituals and folk dances, the mature Kabuki theater as it developed in Edo during the Genroku era was a very sophisticated form of theater featuring highly skilled actors.

In contrast with Noh, which was connected with Buddhism and was primarily favored by the aristocracy, Kabuki was from its very inception the theater of the common people, for whom its often melodramatic plots, violent action, and splendid costumes had great appeal. Like ukiyo-e it was a plebeian type of art, and it is therefore not surprising that these two forms of artistic expression should be drawn to each other, since they appealed to the same public.

Many of the most celebrated printmakers, such as Kiyonobu, Shunshō, Bunchō, Sharaku, Toyokuni, and Kunisada, specialized in depicting scenes from the Kabuki theater, and almost all of the ukiyo-e artists made at least a few theatrical prints. In the earlier phase of this art form usually only one or two figures depicting popular actors of the day in characteristic roles were represented. Later, entire scenes from favorite plays were often shown, and in the late eighteenth century, under Sharaku's influence, close-ups of actors' faces became popular. While the portrayals of the matinee idols of Edo were usually rather

generalized, beginning with Shunshō, and even more so in the work of Sharaku, a real effort was made to depict the individual actor as he actually looked.

Like all others, these prints were purely commercial products, usually commissioned by a publisher and sold at the theater or in bookstores that handled such works. Just as visitors to the Yoshiwara bought courtesan prints to recall their sojourns in the red-light district, so the enthusiasts of the Kabuki theater bought pictures of their favorite actors as souvenirs of the performances they had attended. The prints were usually made in series depicting highlights from a particular drama or showing a celebrated actor in his most memorable roles.

The man responsible for starting this type of print production was Kiyonobu, the founder of the Torii school. A native of Osaka, he is believed to have been born in 1664 about a generation after Moronobu, who no doubt influenced him greatly. His father, Torii Kiyomoto, whose pupil he was, was well known as a designer of theatrical posters, but it was not until Kiyonobu, in his early twenties, moved to Edo in 1687 that he turned to the woodblock medium. At first he illustrated novels and dramas in the style of Moronobu, but by 1700 he had begun to make albums and individual prints. His favorite subjects were the actors of the Kabuki theater, but he also portrayed courtesans, episodes from contemporary life, and erotic scenes.

His output was large and at its best was of a very high artistic quality, so that he is today regarded as one of the greatest and most influential of all ukiyo-e artists. Although a primitive from a technical point of view if his works are compared with the far more sophisticated prints of his later followers, he towers above most of them in the boldness of his lines, the strength of his designs, and the grandeur of his conceptions. Especially his large *ōban*-style prints dating from the early years of the eighteenth century are among the masterpieces of ukiyo-e. Originally printed in black and white, they are today often hand-colored. Since few of them have survived in good condition, they are now among the most sought after and expensive of all early prints.

A good example of this type of print for which Kiyonobu is famous is the one depicting the Kabuki actor Sawamura as a woman dancer, a superb impression of which is now in the collection of the Metropolitan Museum of Art in New York. Its subject is one of the female impersonators characteristic of Kabuki, in which no women were permitted on the stage. The artist has emphasized the kimono with its

strong decorative design and the powerful sweep of the calligraphic lines. The slight touches of red and yellow that have been added by hand work well with the bold black and white of the printed design (Plate 7).

Very few artists of ukiyo-e have exerted a greater influence than Kiyonobu. As the founder of the Torii school, he had hundreds of followers not only during his own lifetime but also for several generations after him. Among the most outstanding were such artists as Kiyomasu, Kiyomitsu, Kiyohiro, and Kiyonaga. Some of his pupils worked in a style so close to his own that it is often difficult, especially if a print has no signature, to tell if it was made by Kiyonobu himself or one of his many disciples. Although he died in 1729, his style continued to inspire artists for the next generation, at least one of whom also used the Kiyonobu signature.

Among Kiyonobu's contemporaries who worked in the same style and treated similar subjects, by far the most outstanding was Kiyomasu. He too was a member of the Torii family, but just what the relationship between the two was is not known with certainty. It has been suggested that he might have been a son of Kiyonobu, but since their work overlaps and it is thought that Kiyomasu died either in 1716 or in the early 1720s, this seems unlikely. A more plausible theory is that he was Kiyonobu's younger brother or, as has been suggested, perhaps a member of another branch of the Torii family. While almost nothing is known about his life, there can be no doubt that a clearly defined artistic personality referred to as Kiyomasu, who worked between the late 1690s and early 1720s, did exist.

The work of this artist falls into two very distinct groups, one executed in a style almost indistinguishable from that of Kiyonobu, so that there is often considerable question if a given print is by one or the other of these artists, and another in a powerful and dramatic style that is uniquely his own and cannot be mistaken for Kiyonobu's. His prints represent scenes from the Kabuki theater as well as from the Yoshiwara district. He also produced a unique group of striking birds-of-prey prints that are believed to be woodblock reproductions from a book on falcons and falconry illustrated by a Kanō-school artist. In spite of a rather brief career, for it is believed that he died young, quite a few of his prints have survived: more than by Kiyonobu. This may be explained by the fact that Kiyonobu, as head of the Torii school, painted posters and playbills that have not come down to us.

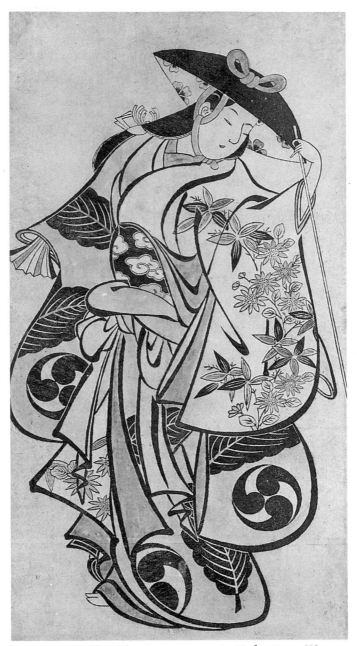

7. *Torii Kiyonobu I:* The Actor Sawamura Kodenji as a Woman
Dancer. *About 1710. Metropolitan Museum of Art, Harris Brisbane
Dick Fund, 1949.*

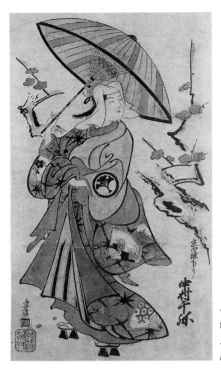

8. *Torii Kiyomasu I:* The Actor Naka-
mura Sen'ya as a Woman. *Dated 1716.*
Metropolitan Museum of Art, Harris Bris-
bane Dick Fund, 1949.

Kiyomasu's woodblock prints consist both of single prints and of
illustrated books, with those in the large *ōban* format, 58 by 32
centimeters, the most impressive, although many of his finest works
are in the more common *chūban* size, measuring 26 by 19 centimeters.
They are always printed in black and white, a technique known as
sumizuri-e. Hand-coloring, however, was often added. The dominant
color was a red called *tan,* which varied from orange to a deep dark
red, and these prints are therefore called *tan-e.* Green, yellow, brown,
and mauve were sometimes also used. This type of print continued
to be made into the middle of the eighteenth century. At their best,
tan-e prints are exquisite.

Kiyomasu's more conventional style, recalling Kiyonobu but per-
haps with a somewhat gentler and softer touch, is well illustrated in
the print depicting the actor Nakamura Sen'ya as a woman walking
near a plum tree (Plate 8). A charming work, it shows Kiyomasu as a
beautiful draftsman and fine designer but basically adds little to the
achievement of his great predecessor. In his more dramatic prints,

however, such as the famous portrayal of Ichikawa Danjūrō I, founder of the Ichikawa line of actors and one of the most celebrated actors of the day, as Soga no Gorō uprooting bamboo (now in the Tokyo National Museum), he exhibits an intensity of emotion and vigor of calligraphic line not seen in ukiyo-e before (Plate 9). This and other less dramatic prints, like the one of the actor Yoshizawa Ayame as a samurai, have an expressive power and bold coloring that makes them unique, far surpassing the work of his contemporaries (Plate 10).

Even more mysterious and controversial than the relationship between Kiyonobu and Kiyomasu is the question of the identity of the artists who also signed themselves Kiyonobu and Kiyomasu but who today are generally regarded as being followers of these two great masters. Modern scholarship, in order to distinguish their work from that of their predecessors, has called them Kiyonobu II and Kiyomasu II and has suggested that they may have been sons of Kiyonobu I and Kiyomasu I who were active from the 1720s to around 1760. Kiyonobu II probably collaborated with his father during his early years, so that it is very difficult to tell their work apart, and it was no doubt after his father's death that he took over the name Kiyonobu. But the family genealogy of the Torii school given in the *Ukiyoe Ruikō* lists no fewer than five artists using the Kiyonobu signature. Thus there actually may have been more than two printmakers using this name.

The work itself, although often pleasing, never has the power of either of the two great artists of the earlier generation, who may have been the father and uncle of Kiyonobu II. None of it is in the large format, and the line and designs completely lack the force the older masters had (Plate 11). The best of it is quite appealing, as can be seen in an attractive example by Kiyomasu II (Color Plate 1), but it actually shows little originality or strength, reflecting the weak, derivative quality of the printmaker's art. It has been suggested that this was partially due to the nature of the period, when the government imposed serious restrictions in terms of size and use of materials.

In addition to these two printmakers directly descending from Kiyonobu there were several other prominent members of the Torii family who followed in the footsteps of the founder of the school. They are usually clearly recognizable not only by their style and subject matter but also by the fact that they employed the first character of Kiyonobu's name in their own. Notable for his *uki-e* prints using Western-style linear perspective is Kiyotada. Others are Kiyoshige,

9. *Torii Kiyomasu I:* The Actor Ichikawa Danjūrō I as Soga no Gorō. *About 1710. Tokyo National Museum.*

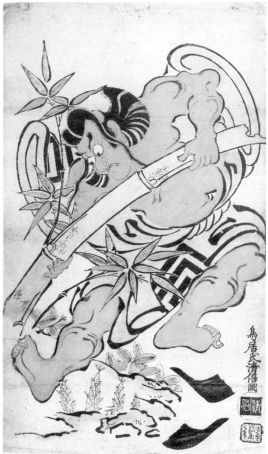

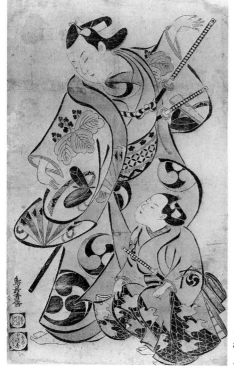

10. *Torii Kiyomasu I:* The Actor Yoshizawa Ayame as a Samurai. *About 1710. Metropolitan Museum of Art, Frederick Charles Hewitt Fund, 1911.*

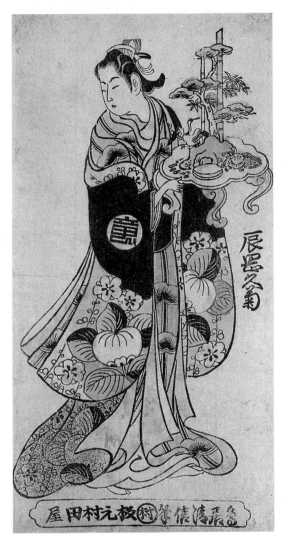

11. *Torii Kiyonobu II:* The Actor Tatsuoka Hisagiku as Kurenai. *About 1740. Metropolitan Museum of Art, Harris Brisbane Dick Fund 1949.*

whose large pillar prints are outstanding, and Kiyotomo, whose work resembles that of Kiyonobu II and who is believed also to have been a pupil of the first Kiyonobu. None of these artists, however, were worthy sucessors of the first generation of the Torii family, and one must look to Okumura Masanobu, who established his own school, to find a major figure that enhanced ukiyo-e and added new contributions to this art form.

5 The Kaigetsudō School and Sukenobu

ONE OF THE CHIEF SUBJECTS of ukiyo-e from the start had been the portrayal of the beauty of Japanese women, especially those of the Yoshiwara district. The leading artists of the school such as Moronobu, Kiyonobu, and Kiyomasu, had produced many fine prints in this genre, but it was Kaigetsudō and his followers who brought this type of print to perfection and who were to create the most memorable images of the courtesans of the Genroku age. The tall and stately beauties they portrayed had a grandeur, an even haughty demeanor, that transformed them from ordinary prostitutes into grand ladies of pleasure engaging the romantic fantasies of the men of Edo.

Although they too, like all the so-called courtesans depicted in the woodblock prints, were women who could be bought, they were in no way the equivalents of the common prostitutes of today's Western world. In a society that was very repressive and in which all marriages were arranged, these women performed an important and socially accepted function of enabling men, restricted in their domestic life, to find adventure and romance. It also enabled the newly rich merchants, who became ever more important figures in Japanese society, to display their wealth and squander their riches on beautiful women of their choice.

The loveliest of these women, dressed in magnificent kimonos, were no doubt gorgeous to behold, and the man lucky and prosperous enough to have gained their favor was envied by his friends. Perhaps their position was more like that of film stars and popular entertainers of today, for they often enjoyed great fame for their beauty and accomplishments. It was these women who were immortalized by the

artists of the ukiyo-e school. This of course applied only to the choicest and most eminent of their profession, for the Japanese society of the time was strictly hierarchical in this area as in all others. The most highly ranked and accomplished were the geisha, who were not prostitutes at all, although they were nevertheless usually kept women, but were skilled entertainers who danced, sang, played musical instruments, and engaged in games. The lowliest were the so-called bathhouse girls, who corresponded to the streetwalkers and massage-parlor attendants of today. The women portrayed in the prints of the Kaigetsudō school would no doubt have belonged to the upper class of courtesans, who, while paid for their companionship, had a certain amount of freedom in accepting or rejecting lovers and who could demand large sums for being a man's mistress. In fact, within the narrow world of the amusement district, in which they were all virtually imprisoned, they were well known and much admired personages whose position was a very prominent and much-envied one.

The man responsible for founding the courtesan-portrait school of ukiyo-e artists was Kaigetsudō Ando, who is believed to have lived from 1671 to 1743. His creative period, however, probably lasted for only a little more than a decade, from the beginning of the eighteenth century to 1714, when his career was cut short quite suddenly by his involvement in a scandal. It appears that he had been one of the accomplices in a love affair between a highly placed court lady and a handsome actor, which of course in Tokugawa Japan was strictly forbidden, since they belonged to such different social classes. The main culprits were exiled, and Ando was sent to the island of Ōshima. Although he was later permitted to return to Edo, it is believed that he did not take up his career as an artist again. During his relatively brief period of artistic activity he produced a remarkable body of work and was able to establish a school of painting that lasted to the middle of the eighteenth century and has influenced *bijinga,* or the painting of beautiful women, to the present day.

It appears from the surviving works that the founder of the Kaigetsudō school limited himself to painting, as did several of the leading ukiyo-e artists, and that all the prints that have survived are by his followers. It used to be believed that he employed pseudonyms in signing woodcuts, but modern scholarship has firmly established that several other artists calling themselves followers of Kaigetsudō were active during these years. Strangely enough, these prints, which no

doubt at the time seemed merely a minor byproduct of what was primarily a school of painting, are today far more valuable and sought after than the paintings themselves. Whether this is justified or not, as our leading ukiyo-e scholar Dr. Richard Lane would contend, is ultimately a question of personal judgment, but there is no question that the present state of affairs would come as a great surprise to Kaige-tsudō Ando himself and even to his followers, who were responsible for making the prints.

The three artists who designed the woodblock prints of this type were Anchi, Doshin, and Dohan. Since the first is the only one using the first character (an) of the name Ando, it has sometimes been suggested that he might have been closest to the master, perhaps a son or adopted son, but there is no conclusive proof for this theory. The other two employed the second character, do, in choosing their artist's names. It is believed that they may have made two or three sets of prints each, perhaps containing twelve designs, but only twenty-three prints survive today, some of them only in single copies. In fact, the total number of Kaigetsudō woodcuts in existence is only forty-three, which accounts for their extreme rarity and the high prices paid for them if they come on the market at all. At the time when they were made, they were no doubt sold for but a few pennies and considered merely a very minor offshoot of the far more valuable paintings. The exact date of their production is not known with certainty, but it is thought that they were made between 1712 and 1716. They are printed in black and white, or sumizuri-e, but were sometimes hand-colored in the tan-e style. Their format is the large ōban size resembling hanging scrolls, which they no doubt were intended to imitate.

Of the surviving prints the largest number, comprising about half the total, are by Dohan, who is, however, generally considered to be the least distinguished of the three artists. They are so close in style that without the signatures it would be difficult to differentiate between them, since they all represent the same tall, handsome, magnificently dressed Edo courtesan usually standing—or, more rarely, seated—against a plain background. Anchi is the one whose women are the most charming and seductive and is therefore a favorite of many connoisseurs, while Doshin is particularly outstanding for the stateliness of his women and the beauty of their kimono designs. Indeed it is these designs that are among the most notable features of

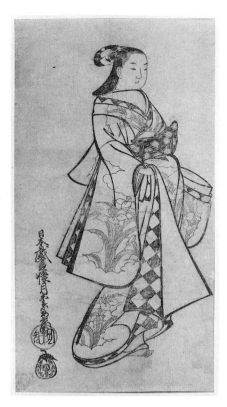

12. *Kaigetsudō Anchi*: Courtesan. *About 1710. Metropolitan Museum of Art, Harris Brisbane Dick Fund, 1949.*

the prints, reflecting the great importance the Japanese have always attached to beautiful garments. The design patterns of the gorgeous kimonos are mainly taken from the flowers of the various seasons, giving rise to the theory that these prints were made in sets, with one print for each month of the year (Plate 12).

The finest group of the Kaigetsudō prints, comprising no fewer than six of the known works, was in the collection of the late Louis Ledoux, one of the great collectors of Japanese prints. They are now in the Metropolitan Museum of Art in New York. Since all of them are so superb, it is difficult to choose among them, but in the eyes of this author the Doshin group, of which only one other copy, now in the Boston Museum, is known, is the most outstanding, combining a powerful yet sensitive use of bold line and beautiful pattern of blacks and whites. In the one illustrated in this book (Plate 13) the proud and majestic courtesan is shown dressed in a magnificent garment

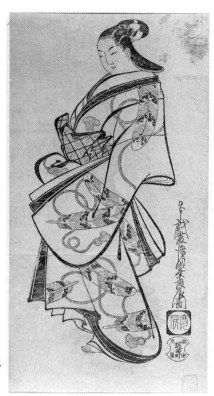

13. Kaigetsudō Doshin: Courtesan.
About 1710. Metropolitan Museum of
Art, Harris Brisbane Dick Fund, 1949.

decorated with large hawk feathers, suggesting that it is connected
with September, the month of falconry. It is inscribed "Nippon giga
Kaigetsu Matsuyo Doshin zu," or "Doshin, humble follower of Kai-
getsu, who drew this for fun in the Japanese [or *yamato-e*] style."

While the Kaigetsudō school gave expression to the ideal of
feminine beauty prevailing in Edo during the opening years of the
eighteenth century, a very different artist, reflecting the aesthetic
ideal of the old imperial capital, was active in Kyoto. His name was
Nishikawa Sukenobu. He was an almost exact contemporary of Ando's,
for he lived from 1671 to 1750. In contrast with the Edo master, who
had been primarily a painter, Sukenobu was first and foremost an
illustrator to whom some two hundred volumes are attributed.
Among his early works are pictures designed for novels and Kabuki
texts, while his later work comprises many genres, such as the
history and mythology of Japan, contemporary life, *shunga,* and kimono

THE KAIGETSUDŌ SCHOOL 35

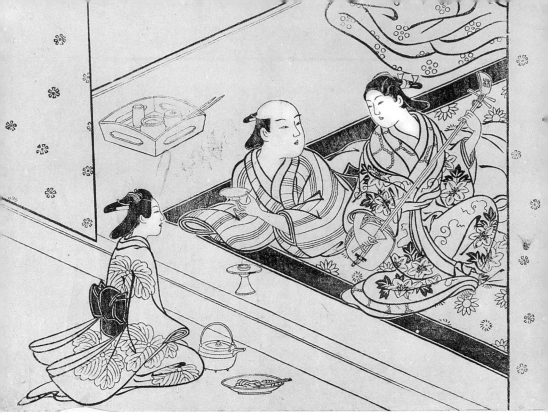

14. *Nishikawa Sukenobu:* Young Man with Samisen-playing Sweetheart and Attendant. *About 1740. Metropolitan Museum of Art, H. O. Havemeyer Collection, bequest of Mrs. H. O. Havemeyer, 1929.*

designs. Few of them are single prints, but he produced some albums consisting of *ōban*-size prints.

In contrast to the tall, aloof courtesans that Ando and his followers favored, Sukenobu was the artist of the lovely Japanese girls as they are still encountered in the streets of Kyoto to this day. Some of them might be courtesans, but most of them are just ordinary, middle-class girls exuding all the charm and grace for which Japanese women are known the world over. Rendered in a very delicate style with fine lines and use of sensitive decorative designs, Sukenobu's prints are among the most delightful of all Japanese prints and of surprisingly even quality in spite of his huge output (Plate 14). They inspired those of several pupils, of whom his son Suketada is the best known, but, above all, they influenced the work of two of the greatest ukiyo-e masters, Harunobu and Shunshō.

36 THE KAIGETSUDŌ SCHOOL

6 Masanobu and the Color Print

THE LEADING ARTISTIC FIGURE of the generation following the great masters of the Genroku era and one of the most influential artists in the entire history of ukiyo-e was Okumura Masanobu. Born around 1686 and dying in 1764, he had a career spanning six decades and covering the entire development of Japanese prints from the early black and whites in the *sumizuri-e* style to the early color prints of the *benizuri-e* type. In fact he took credit for several of the important technical inventions of his period, notably the two-color printing process. He was also instrumental in popularizing the pillar print, or *hashira-e;* the lacquer print, or *urushi-e;* and the so-called perspective print referred to as *uki-e*. His output was vast but uneven, comprising not only single prints but also *shunga* albums, illustrated books, and paintings. In addition to being an artist he was a bookseller and publisher who brought out many of his own works.

As a young man in the early years of the eighteenth century, he followed in the footsteps of Moronobu, Kiyonobu, Kiyomasu, and Kaigetsudō, but he soon developed his own style. A very versatile and immensely productive artist, he tried his hand at every type of subject treated by the ukiyo-e artists: courtesans, Kabuki actors, erotic scenes, and illustrations from Japanese literature and legend. At this early stage of his career his prints were executed in black and white, but hand-coloring in the *tan-e* manner is often added. While not as yet very innovative in either style or technique, these early works of Masanobu often have a grace and liveliness that makes them distinctive, and the best of them are often equal to the finest produced by his predecessors Moronobu and Kiyonobu. However, by 1620, when he was in his

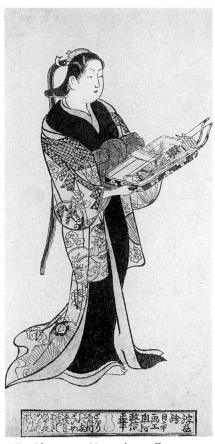

15. *Okumura Masanobu:* Courtesan
with Tray. *About 1730. Metropolitan
Museum of Art, Harris Brisbane Dick
Fund, 1949.*

early thirties, he began to experiment with lacquer prints, in which a
varnish-like black ink and metallic powder, usually brass, were em-
ployed to achieve the effect of lacquer and gold dust. Unfortunately
few of these prints preserve their original appearance, since the
metallic powder has worn off, but those that do preserve it have a sub-
tle and sparkling iridescence that is extremely attractive. Whether
Masanobu actually introduced this technique is not clearly known,
but he was surely one of the first to use it extensively (Plate 15).

While he was probably not the inventor of the Western-style perspective print, as he claimed, he certainly contributed toward the development of this form. The use of the European linear perspective became popular during the middle years of the eighteenth century, especially in the depiction of the interiors of Kabuki theaters and other places of entertainment. Derived no doubt from Dutch engravings and books that reached Japan through the port city of Nagasaki, which at the time was the only place where Japanese were able to encounter Western art, they were felt to be very exotic and opened up a novel way of representing space in depth for the Japanese artists. Masanobu's work in the genre is not only artistically very inventive and well realized but also gives a vivid picture of the theater of this period, the plays produced, the leading actors of the day, the arrangement of the interior and stage, and the Kabuki audience.

Masanobu's most important contribution, however, was no doubt in the field of *benizuri-e,* or pink-printed pictures. This development took place around 1741 and proved to be the most significant and far-reaching innovation in the history of ukiyo-e. Although color printing had been known in Japan before that time, it had been used only sparingly. It was only after the invention of the *kentō* mark, which enabled the printer to line up the several blocks needed for the multiple color print, that this process could be used widely and more inexpensively. This mark took the form of a right angle cut at one corner into the key block, and often with a line at the other corner, and into a corresponding position in all the other blocks employed, thereby ensuring that the colors did not overlap. Although Masanobu claimed credit for the process, it is more likely that some publisher or printer rather than an artist was responsible for this technical innovation. The colors employed were usually *beni*—a rose pink made of safflower—and a green called *ichiban rokushō,* or first washing of verdigris. The choice of color proved particularly fortuitous, and while the pink is often faded, especially if the print was exposed to light, the well-preserved examples of this type of print are among the loveliest of all Japanese woodblock prints (Plate 16). While the early examples dating from 1640 to 1644 are usually restricted to these two colors, in some cases, during the later phase of this development, yellow, blue, and gray were either added or substituted. By the late 1750s three or four colors were achieved by using several blocks or by printing one color over another in order to produce a third one.

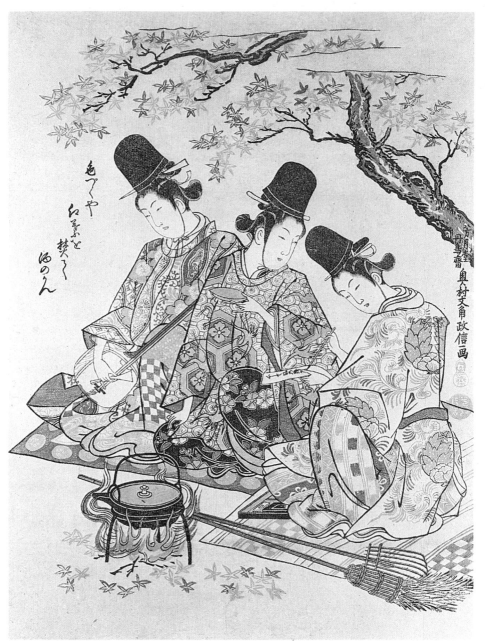

16. Okumura Masanobu: Three Women in Dress of Palace Guards. *About 1750.*
Metropolitan Museum of Art, Harris Brisbane Dick Fund, 1949.

40 MASANOBU AND THE COLOR PRINT

The other type of print in which Masanobu excelled was the narrow *hashira-e,* which in his day usually measured 67 by 13 centimeters but was even narrower in some examples. This format was designed to decorate a pillar of the Japanese house and was therefore referred to as a pillar print. It was a peculiarly Japanese art form in which some of the greatest Japanese artists, such as Harunobu, Koryūsai, Kiyonaga, and Utamaro, did some of their best work. It presented the artist with the difficult challenge of how to fit the design, usually a woman or lovers, into the narrow space of the vertical surface. Masanobu, with his usual verve and inventiveness, created some of his most memorable pictures in this manner, cutting off the forms or adjusting them to the long, narrow shape at his disposal. Related to this type of print are the so-called *kakemono-e,* which are also vertical but broader, usually measuring 68 by 27 centimeters. As the term kakemono suggests, they were intended to be mounted as hanging scrolls and served as a cheap substitute for painted ones.

Although Masanobu exerted a tremendous influence both on his contemporaries and on those who followed him, he had few direct followers, perhaps because he was too busy with his own multiple activities. The only significant artist who seems to have been a pupil of his was Okumura Toshinobu, who may have been his adopted son. He was active from about 1717 to the 1740s and produced primarily small lacquer prints representing actors or girls. Within these limitations his work is of very high quality, sometimes even equaling Masanobu's own, but the prints are somewhat more delicate and poetic.

An artist of a somewhat younger generation who also owed a great deal to Masanobu, although he was a pupil of Nishimura Shigenaga, an influential teacher and innovator of the early eighteenth century, was Ishikawa Toyonobu, who lived from 1711 to 1785. There is a question about his early years, some scholars having suggested that he is identical with Shigenobu, which would explain why his work is known only from the 1740s on, but this matter is by no means resolved. The work known to be by this artist is of excellent quality and was a favorite of such discriminating connoisseurs as Louis Ledoux, who had several of Toyonobu's masterpieces in his collection. Toyonobu excelled both in the hand-colored and in the early color-printed woodcuts. In fact some of his prints in the *benizuri-e* technique are among the masterpieces of ukiyo-e. He was also noted as a painter and illustrator and is

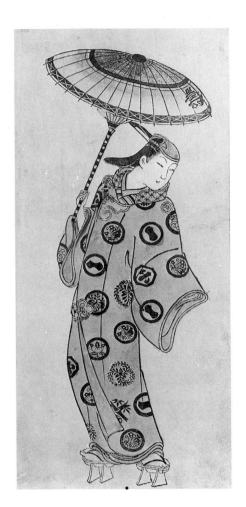

17. *Ishikawa Toyonobu:* The Actor Ichikawa Monnosuke as a Dandy. *About 1745. Metropolitan Museum of Art, Harris Brisbane Dick Fund, 1949.*

rightly considered one of the finest printmakers active during the middle years of the eighteenth century.

The subjects he portrayed were the familiar ones of actors, courtesans, and scenes from contemporary life treated with a grace and charm equaled by very few other artists. His designs and compositions were always tasteful, and his use of color in his later work was exquisite (Plate 17). His most original contribution, although he cannot be credited with creating this genre, was the portrayal of girls taking a bath or in a partially disrobed state. Although the prints are never as sexually explicit as the *shunga* prints, they have erotic overtones of a

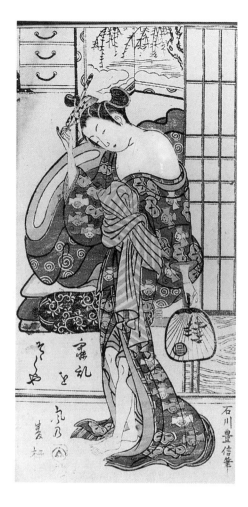

18. Ishikawa Toyonobu: Courtesan in Night Attire. *About 1750. Metropolitan Museum of Art, Frederick Charles Hewitt Fund, 1911.*

more suggestive and delicate type. Since Japanese artists were not accustomed to rendering the female nude as their Western colleagues did, the prints have a kind of naiveté that gives them a very charming, primitive quality. Particularly attractive is the contrast between the brightly colored kimonos and the soft white flesh of the nude female body (Plate 18).

Of Toyonobu's contemporaries the most important was Torii Kiyomitsu, the leading artist of the third generation of the Torii school. He lived from about 1735 to 1785 and was the son of Kiyomasu II. Most of his work was devoted to scenes from the Kabuki theater with

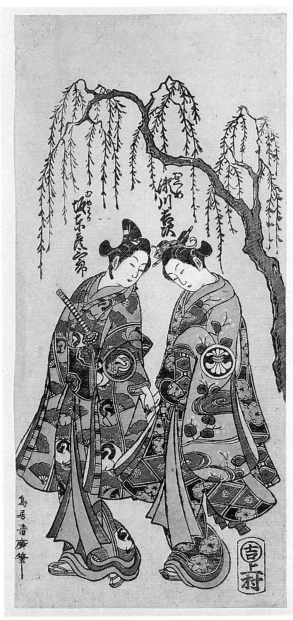

19. Torii Kiyohiro: The Actors Bandō Hikosaburo and Segawa Kikunojō as Lovers. *About 1740. Metropolitan Museum of Art, Harris Brisbane Dick Fund, 1949.*

the actors shown against a background setting, usually in a small narrow format, but he treated other subjects as well. Working during the middle decades of the century, he produced primarily *benizuri-e* with delicate colors and lovely designs (Color Plate 2). His output was very large, especially in the field of theatrical prints, the specialty of the Torii school, of which he was the last traditional master. The quality of these prints, however, is rather uneven. He had many pupils, among whom were Kiyosato, Kiyotsune, Kiyohisa, and the famous late-eighteenth-century artist Kiyonaga, who, however, moved in a very different direction.

Little is known about Torii Kiyohiro, another outstanding print-maker of the Torii school. Even the exact dates of his life are uncertain. It is believed that he was a fellow pupil of Kiyomitsu's in the atelier of Kiyomasu II. His main period of activity came during the 1750s and 1760s, and he was greatly influenced by both Toyonobu and Kiyomitsu. His work, rather rare, has always been highly regarded and most sought after. Almost all his prints are done in the rose-and-green color scheme, which he handled with exquisite taste and delicacy. At his best he is one of the most subtle and aesthetically pleasing of the print-makers working in this manner (Plate 19). With him the *benizuri-e* type of color print experienced one last, delightful flowering before Harunobu replaced it with the full-color print in 1765, at which time Kiyohiro seems to have retired to the sidelines. Although a few two- and three-colored prints were made even after this date, it was obvious that the days of this type of print had passed.

7 Harunobu and His Followers

THE MULTICOLORED PRINT in its fully developed form dates from 1765, when the first polychrome wood engravings were issued. They were known as *nishiki-e,* or brocade pictures, suggesting that they possessed the same richness and variety of color as the gorgeous brocades made by the celebrated craftsmen of the textile arts. The printmaker responsible for this breakthrough was Suzuki Harunobu, one of the finest, most original, and most productive of all ukiyo-e artists, a man who today is rightly regarded as one of the six great masters of ukiyo-e. Some critics, in fact, would give him first place among all the many artists of the ukiyo-e school.

The reason for the creation of this type of print had less to do with Harunobu's genius than with the patronage of certain well-to-do dilettantes who had commissioned him to make some unusual New Year's cards. Known as *surimono,* these greeting cards could also function as illustrated calendars, or *egoyomi,* for in many cases they indicated the short and long months of the lunar year. The first of this type of *surimono* was commissioned for the new year of 1765. Harunobu was chosen as the artist most likely to create woodcuts of the high technical standards and artistic sensibility that the patrons ordering the cards required (Plate 20). Since they were men of wealth and taste, no money was spared to produce the very best woodblock prints that Harunobu was capable of making. The commercial publishers of previous prints had been primarily interested in making money and thus had often used thin, cheap paper and crude pigments. On this occasion, however, only the best paper and colors were employed, and instead of catalpa wood, which had often served for the blocks,

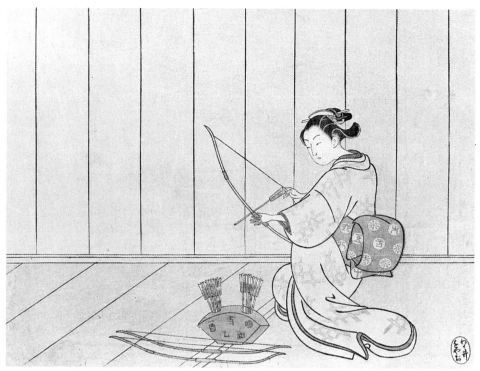

20. *Suzuki Harunobu:* The Archery Gallery. Egoyomi. *Dated 1765. Collection of the Newark Museum.*

the harder and superior cherry wood was used, with as many as ten separate blocks' being cut. Although this development was not a sudden one, having been anticipated by earlier artists, it was Harunobu who in the winter of 1764–65 brought it to a glorious culmination and by doing so completely revolutionized the art of Japanese woodblock printing. It is not known in which year Harunobu was born, but it is believed to have been around 1725, for it is said that he was in his mid-forties at his death in 1770. This would mean that he was a man of forty when he made the first polychrome prints. At that time he could already look back upon a long and distinguished artistic career, but without the artistic achievements of his late years he would not today loom as one of the giants of ukiyo-e. Traditionally it has been said that Harunobu studied under Shigenaga, but the evidence certainly suggests that his true teacher was the great Kyoto illustrator Sukenobu. Recent

Japanese scholarship even suggests that he might actually have studied under Sukenobu. Not only is the style and spirit of Harunobu's work clearly derived from Sukenobu's, but also certain compositions and designs are almost exact copies of those used by the older master. The other great influences on Harunobu were Kiyomitsu and Toyonobu, the two most prominent artists of his youth. In fact some of Harunobu's early prints, which are *benizuri-e* and depict scenes from the Kabuki theater, could well be taken for Kiyomitsu's work if they were not signed. The earliest of them date from the 1750s, and there can be no doubt that by 1760 he was an established artist whose depiction of graceful young women and actors enjoyed a considerable reputation.

His mature period, starting in 1765 and coming to an abrupt halt with his premature death in 1770, lasted only six years, but during this brief time Harunobu produced some of the greatest works in the entire history of ukiyo-e. It is estimated that his total oeuvre consists of about one thousand prints, of which about seven hundred date from this immensely creative stage of his career. The reason no completely accurate count can be given is that Harunobu sometimes did not sign his prints and that later artists, notably Harushige and Koryūsai, signed his name to their prints to ensure their own work a better reception, so that there is sometimes a real question if a given print is by Harunobu himself or by one of his followers. Whatever the exact number of prints from his artistic maturity might have been, his output in terms of both quality and quantity represents one of the most extraordinary achievements in the history of Japanese prints. Only a few other artists rivaled him, and Sharaku alone, in regard to brevity of time needed to produce his masterpieces, surpassed him.

While Harunobu's most dramatic and important achievement lies no doubt in the introduction of the *nishiki-e,* he is also a great innovator in several other respects as well as being a great designer and colorist. In contrast with previous artists who had usually shown the figures in isolation with little or no background, Harunobu most often shows them against a landscape or interior setting, and the spatial relationship of the figures and background is one of the most interesting and aesthetically pleasing aspects of his work. At the same time he enlarged the subject matter of ukiyo-e by not restricting himself to courtesans and actors, as most of his predecessors had done, and by depicting mostly charming young girls of the middle class in their daily pursuits

and amorous affairs, some of them distinctly erotic in character, for he too was a great master of the genre known as *shunga,* or spring pictures. But even when picturing courtesans he brings to his portrayal a kind of delicacy and charm unmatched by any of the other ukiyo-e artists. James Michener, who is not very fond of Harunobu, refers to his girls as little Lolitas, but this type of graceful, delicate, willowy beauty corresponds to a special kind of girl still encountered in Japan today and is modeled on the Chinese ideal of feminine loveliness as represented in the work of the Ming painters T'ang Yin and Ch'iu Ying. The most celebrated of these beauties whom Harunobu immortalized were the teahouse waitress Osen and the shop assistant Ofuji, who were all the rage of Edo at this time. No doubt they represented to Harunobu the very ideal of female charm and exquisite beauty as he and his age perceived it.

It would be difficult to select the most outstanding ones among the hundreds of fine prints that Harunobu produced. Every collector and connoisseur no doubt has his favorites, which for one reason or another have a particular appeal to him. The truth is that in spite of his huge output, comprising better than one hundred prints each year, the artistic level of his work is surprisingly uniform, with even the less inspired sheets having much to recommend them. There is also little change once the fully developed color print has been created. Only at the very end of his career does there seem to have been a decline, when the compositions became a bit crowded and the drawing weakened. This may well have been due to his deteriorating health rather than to any change in his basic aesthetic orientation.

The work consists of single prints or sets of prints usually of *chūban* size (approximately 26 or 27 by 19 or 20 centimeters), pillar prints, *shunga* albums, and illustrated books, all of a uniformly high standard of excellence. Particularly charming are the prints depicting lovers or young girls, which have a gentleness and sweetness not found in the work of any of the other printmakers. This, combined with a strong but sensitive line, a marvelous sense of pattern, and flat areas of color, used very effectively to suggest the sky or the setting, makes the prints always pleasing and often stunning. In spite of the homogeneity of the subject there is also a surprising variation in design, so that a large exhibition of Harunobu's work like that seen in London in 1964, marking the two-hundredth anniversary of the invention of the color print, and the great show in Philadelphia in 1970, commemorating the

bicentennial of Harunobu's death, were aesthetically very rewarding experiences.

The poetic mood of Harunobu's prints that permeates his entire work is particularly striking in his night scenes in which charming young girls are silhouetted against the dark sky or lovers are searching for fireflies. A beautiful example of such a print is the composition depicting an elegantly dressed young woman standing on a veranda, gracefully holding a paper lantern in her raised hand and looking up to a branch of plum blossoms illuminated by her light (Plate 21). Although the print is unsigned, the style of Harunobu is unmistakable, and the evocative and delicate feeling of the print is uniquely his. There may be other print artists who surpassed him in the grandeur of their conception, the sophistication of their design, or the expressive power of their images, but for sheer delicacy and charm Harunobu towers not only over all his contemporaries but also over all other artists of the ukiyo-e school.

Even more typical of the great bulk of his output are the scenes depicting two or more figures taken from the life of the time. A fine example of such a work is the one picturing a girl and a flute-playing *komusō* (mendicant Zen priest) whose face is reflected in a basin of water at the edge of a veranda (Color Plate 3). The gracefulness of the figures, the charm of the setting, and the interest of the situation itself are all characteristic of Harunobu's style. Particularly lovely also is his depiction of Murasaki Shikibu, author of *The Tale of Genji,* sitting on the veranda of the Ishiyama Temple at Lake Biwa with her writing paraphernalia in front of her. Although the great novelist lived during the Heian period, Harunobu shows her as a contemporary beauty of the Edo period (Plate 22).

Among the many artists who were influenced by Harunobu the two most important were Harushige and Koryūsai. The former, who is today better known by his later artist's name Shiba Kōkan, is one of the most curious and fascinating figures in Japanese art. Born in 1747 and dying in 1818, he was initially trained in the Kanō school and later in Chinese-style bird-and-flower painting, but by the late 1760s he became interested in ukiyo-e and may actually have studied under Harunobu. As he himself relates, at the death of his master in 1770 he made forgeries of Harunobu's work, which he actually signed with this artist's signature. An entry in his journal reads as follows: ''While I was studying painting under Sō Shiseki, an artist of the ukiyo-e tradi-

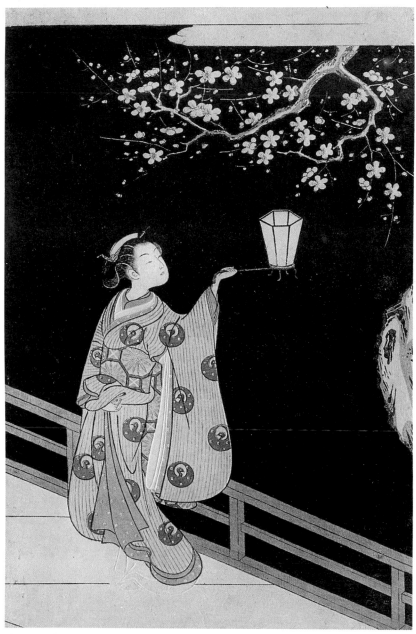

21. Suzuki Harunobu: Girl with Lantern on Veranda. *About 1765. Metropolitan Museum of Art, Fletcher Fund, 1929.*

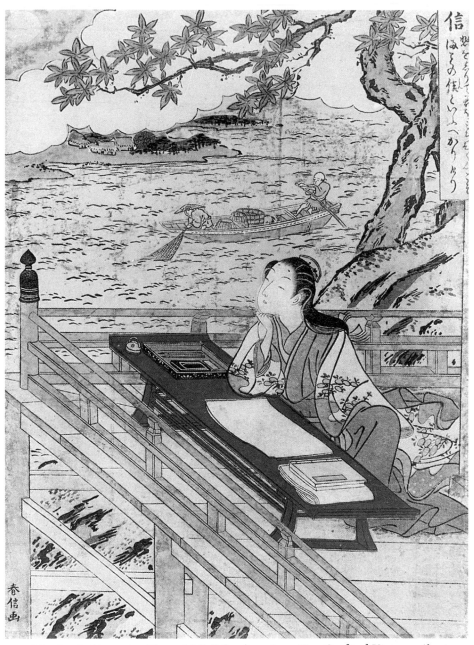

22. *Suzuki Harunobu*: Murasaki Shikibu *from the set* Five Cardinal Virtues. *About 1767. Loebl Collection, New York.*

tion named Suzuki Harunobu was illustrating the female modes and manners of his day. He died suddenly when he was a little over forty, and I began making imitations of his work, carving them on woodblocks. No one recognized my prints as forgeries, and to the world I became Harunobu. But I, of course, knew I was not Harunobu, and my self-respect made me adopt the name Harushige."[1] Because of this statement it is widely believed today that some of the prints attributed to Harunobu may actually be by Harushige and that others with no signature but in the style of Harunobu can be assigned to his follower. At the same time it cannot be denied that the work bearing Harushige's signature is artistically rather inferior to Harunobu's, lacking his sensitivity and unique charm. The lines are less inspired, the composition is often cluttered, and the treatment of space reveals the influence of Western perspective (Plate 24). This later trend was indeed to foreshadow the artist's mature style, for after 1774 he stopped working in the ukiyo-e style and became a pioneer of Western-style art in Edo Japan. Inspired by Dutch painting and engraving, he turned to copperplate etchings that not only employed a European technique but also depicted landscapes with Western-style shading and treatment of space in depth—prints that, although not very outstanding, represent an important landmark in the evolution of modern Japanese art.

A far greater ukiyo-e artist was Harunobu's friend and follower Isoda Koryūsai. Originally a samurai, he relinquished his rank and moved to Edo, where he became an ukiyo-e artist. The exact date of his birth is not known, but since he was a printmaker during the 1760s and 1770s, he must have been born a few years after his teacher. In his earliest work he employs the signature Haruhiro, indicating clearly that he regarded himself as part of Harunobu's school, but he is far better known as Koryūsai. While his reputation is somewhat overshadowed by that of his more illustrious mentor, many critics, like Hillier and Lane, regard him very highly and think that his best prints are among the masterpieces of ukiyo-e. His early prints are often difficult to distinguish from those of his teacher and at times even carry Harunobu's signature. A fine example of this type is a print of a girl taking a bath. It is signed by Harunobu, but, judging from the color scheme and the drawing of the female figure and face, it should be attributed to Koryūsai (Color Plate 4).

1. Calvin L. French: *Shiba Kōkan*. New York and Tokyo, 1974; page 29.

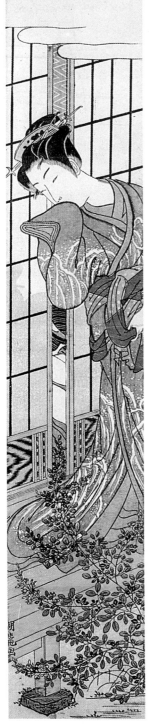

23. Isoda Koryūsai: Listening to the Revelry. *About 1770. Yale University Art Gallery, Frances Gaylord Smith Collection.*

24. Suzuki Harushige (Shiba Kōkan): Young Man and Courtesans. *About 1770. Museum of Fine Arts, Boston.*

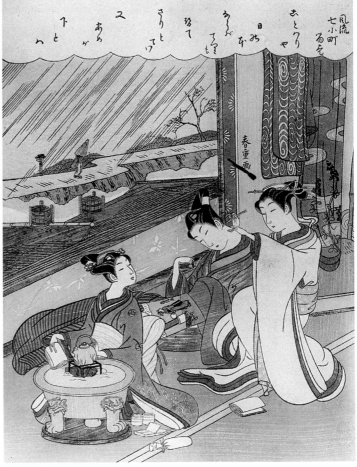

Koryūsai's most original work, however, was produced in three other artistic genres, namely, pillar prints, bird-and-flower prints, and *shunga*. The long, narrow print known as *hashira-e,* usually measuring 67 by 13 centimeters, was popular for decorating the wooden pillars of Japanese houses and could also be mounted as a hanging scroll. It is a difficult format for the artist, but Koryūsai handled it with great skill and elegance, fitting interesting and imaginative compositions into the space at his disposal. He ranks among the great masters of this genre (Plate 23). In terms of new subject matter he made his greatest contribution in the *kachō,* or bird-and-flower category, which had existed for many centuries in Chinese painting and had also been known in Japan, although Koryūsai was the first to use it extensively. The field in which he excelled most, however, was that of erotic prints, in which he even surpassed Harunobu, since he had an earthier, less ethereal temperament than Harunobu. His best work came from the first half of the seventies, but his later work was rather clumsy and uninspired, his forms becoming very massive and the lines too complex and realistic. By 1780 he had given up printmaking altogether and turned to the more prestigious and lucrative ukiyo-e painting, producing some outstanding works in this art form as well. By this time, however, Harunobu's influence had waned, and the rising star was Torii Kiyonaga, who brought to the Japanese print a completely new artistic style and a new ideal of feminine beauty.

8 Shunshō, Bunchō, and the Actor Print

OF ALL THE CONTEMPORARIES of Harunobu the most important and influential was Katsukawa Shunshō. Born in 1726, he was almost exactly the same age, but since he lived until 1792, his creative period lasted longer than that of Harunobu, who had died in his forties in 1770. His early training was received under Katsukawa Shunsui, who in turn had been a pupil of the most famous ukiyo-e painter, Miyagawa Chōshun. He turned to the production of actor prints in the mid-sixties, just when Harunobu introduced the *nishiki-e* color print, a genre at once taken over by Shunshō. By 1770 he had developed his own mature style, which represented one of the great achievements of eighteenth-century Japanese printmaking.

Up to this time the field of actor prints had been dominated by members of the Torii school, which, starting with Kiyonobu, had produced powerful and striking posters and woodblock prints depicting the famous actors of the time in their most characteristic poses. While the prints were often beautiful in their design and quite expressive as works of art, they were highly stylized, so that it was impossible to tell one actor from another unless a label or crest identified the subject. Shunshō introduced a new realism that completely revolutionized this art form, for he showed the individual actor as he actually looked, revealing his personality, his style of acting, and even his idiosyncrasies. From these new images the public was able to recognize at once its favorites, who were shown as they appeared not only on the stage but also behind the scenes in their dressing rooms preparing for performances or relaxing with friends and admirers.

Combining this new psychological approach with the greater range

25. *Katsukawa Shunshō:* The Actor Ichikawa Yaozō II as a Samurai. *About 1770. Metropolitan Museum of Art, Joseph Pulizer Bequest, 1918.*

of color and more emphasis on the stage setting, Shunshō produced prints that had an immediate and lasting success and are even today regarded by many critics as the finest Kabuki prints ever made. Since this development coincided with the second golden age of the Kabuki theater, Shunshō and his followers had a ready market among the lovers of this art form. His most creative period was the decade of the 1770s, when he poured out a steady stream of excellent prints, but it is believed that by the middle eighties he had given up printmaking for painting, which was better paid and enjoyed more prestige in the art world. He excelled in ukiyo-e painting, and many fine examples of this category of his oeuvre have survived. In fact he was a very versatile artist who, in addition to his actor prints, produced *shunga* and prints of courtesans, heroic and historical scenes, and, above all, sumo wrestlers. In the last of these genres he was the leading master. Although sumo had been depicted as early as 1750 in crude *urushi-e* prints of the *hosoban* format, he was the first to elevate this subject to an important place and to celebrate all the important wrestlers of the age. He showed these giants of men in the ring during their matches or relaxing with their female companions.

ACTOR PRINTS: SHUNSHŌ, BUNCHŌ *57*

26. *Katsukawa Shunshō:* The Actor Ichikawa
Monnosuke II in a Kabuki Drama. *About 1785.*
Metropolitan Museum of Art, Rogers Fund, 1914.

Of the many actor prints that Shunshō made, the most famous are
those portraying the great matinee idol Ichikawa Danjūrō V as Kama-
kura no Gongorō Kagemasa in the Kabuki play *Shibaraku.* This subject,
which he treated in numerous versions, brings out all of the qualities
for which Shunshō was justly famous: his wonderful sense of design,
with its sharp angles and bold patterns; the beauty of the color, with
its striking white squares against the deep brown of the garment; the
distorted and expressive face bringing out the emotional intensity of
the actor in this magnificent role. Never has the Kabuki been portrayed
with greater faithfulness and dramatic appeal. The narrow format of
Shunshō's prints, in which the forms are encased in the vertical,
shallow space of the picture, is particularly effective. In works like
these the artistic genre established almost a century earlier by the
members of the Torii school finds its fullest realization, and the even
more realistic and expressive work of Sharaku is anticipated. Yet the
Danjūrō portraits are but few among Shunshō's many striking actor
prints, for the hundreds he produced include a great number of other
fine ones in which he portrayed the full gamut of the Kabuki theater of
the time (Plates 25, 26).

In addition to being a great artist whose work represents a high point in the history of ukiyo-e, Shunshō was very important as a teacher whose pupils and followers included some of the most talented artists of the next generation. Since they all took the first character of his name, *shun,* for their own names, they are easily identified, although some of them later changed their names or at least their artistic styles. The most famous of them were Shunkō, who was his closest pupil; Shun'ei; Shunchō, who later became a follower of Kiyonaga; and Shunrō, better known as Hokusai, who went his own way and in the eyes of many critics even surpassed his master. But these are by no means all the printmakers who were inspired by Shunshō. Others include Shundō, Shunjō, Shunri, Shungyō, Shun'en, and Shunzan.

Of Shunshō's immediate followers who worked in his style and continued his work, the most important and original was without doubt Katsukawa Shunkō, who lived from 1743 to 1812. His best prints date from the time between the 1770s and the early 1790s. No record of his later years exists. It is reported, however, that he was affected by paralysis in his right arm, was only able to work with his left hand, and lived in semiretirement. His greatest contribution consisted of his introducing the prints showing close-ups of actors' heads, the *ōkubi-e* (big-head pictures) that Sharaku was to bring to ultimate perfection in the last decade of the century. Portraying the face of the actor rendered in a very bold style with powerful lines and striking expressions, these works are among the most impressive Kabuki prints of this age and at their best equal the finest work of Shunshō himself (Plate 27). Much of Shunkō's other work is rather conventional and follows very closely in the footsteps of his master. The same can be said of Shun'ei, a somewhat younger pupil of Shunshō. He is believed to have been born in 1762, his best work was done during the 1790s, and he died in 1819. He too excelled in scenes from the Kabuki theater in the manner of his teacher (Plate 28). In addition he made close-ups of actors' faces, portraits of wrestlers, and pictures of contemporary life. He was apparently an eccentric person. Prominent among the many friends whom he influenced was Toyokuni, who became the leading artist of actor prints in the nineteenth century.

A printmaker related to this group was Ippitsusai Bunchō, one of the most mysterious and fascinating of all ukiyo-e artists. The dates of his life are uncertain, but since his work was produced mainly between 1765 and 1780, he must have been almost an exact contemporary of

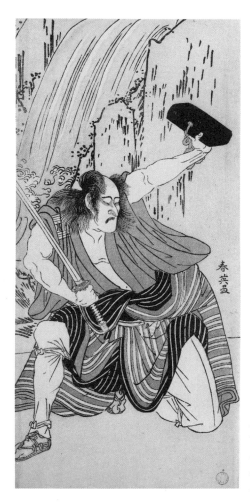

28. *Katsukawa Shun'ei:* The Actor Ichikawa Komazō II as a Man Armed with a Sword. *About 1780. Metropolitan Museum of Art, Rogers Fund, 1922.*

Harunobu and Shunshō. Unlike most of the artists of this school, who came from the middle class, he was of samurai background and had been trained in the academic Kanō tradition but in the sixties turned to the more popular ukiyo-e school. The dominant influences on his work were first Harunobu and later Shunshō. It has often been said that he combined the color and loveliness of the former with the realism and expressiveness of the latter, but he was above all a highly original artist who, although indebted to both Harunobu and Shunshō, created

ACTOR PRINTS: SHUNSHŌ, BUNCHŌ *61*

◀ 27. *Katsukawa Shunkō:* The Actor Ichikawa Danjūrō V as Kamakura no Gongorō Kagemasa. *About 1780. Metropolitan Museum of Art, Fletcher Fund, 1928.*

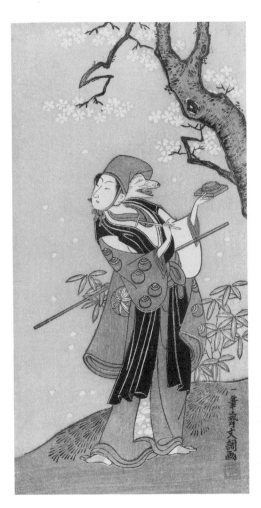

29. *Ippitsusai Bunchō:* Fox Dance *from the Kabuki play* The Thousand Cherry Trees. *About 1775. Metropolitan Museum of Art, H. O. Havemeyer Collection, bequest of Mrs. H. O. Havemeyer, 1929.*

his own distinctive artistic style. In view of the fact that he too portrayed largely actors and collaborated in 1770 with Shunshō on a set of three volumes of portraits of stage celebrities enclosed in fans, called *Ehon Butai Ōgi,* he is often listed as merely a follower of Shunshō. This, however, is misleading and fails to do justice to his unique artistic personality. In fact the matter of the true relationship between these two artists is not clear. There can be no doubt that Shunshō, as the head of the Katsukawa school and the teacher of dozens of younger artists, was by far more important in the history of ukiyo-e, but there are many connoisseurs who find the work of Bunchō more interesting.

Authors like Ficke, who regarded him very highly, have speculated about the kind of man he might have been, suggesting that he was "a dreamer of keen and attenuated beauty that had nothing in common with the normal wholesomeness of life" and that he was of "an unbalanced temperament" and "haunted with a perverse susceptibility."[1] All we do know for certain is that he was a refined and highly educated man who had literary as well as artistic talent, was skilled in writing satirical verse known as *kyōka*, and produced some three hundred prints largely depicting female impersonators of the Kabuki stage. His favorite was the handsome Kabuki star Segawa Kikunojō, whom he frequently pictured. Almost all his prints are in the *hosoban* format measuring 30 by 15 centimeters and portray either a single actor or two actors in a play. The quality that distinguishes his work from that of his contemporaries is a certain tense nervousness: a feature that makes his images somewhat disturbing, yet fascinating, and recalls the feeling one gets from the Mannerist paintings of the West. The prints have a peculiar charm that has both attracted and repulsed collectors, who see him as a strange and compelling genius (Plate 29).

From a formal point of view the element that makes Bunchō's prints so memorable is his use of line and color. His lines are very strong and tense, taking on a life of their own often not dependent on the contours of the natural forms, and his color produces strange and unusual harmonies, such as the combination of orange with gray, a dull yellow with a red and a blue, or pink with purple. The forms are fitted into the narrow vertical formats of prints, and this further enhances the dramatic intensity of the theatrical scenes depicted.

1. Arthur Davison Ficke: *Chats on Japanese Prints.* New York, 1915; page 190.

9 The Kitao School and Toyoharu

THE DECADE between Harunobu's death in 1770 and the emergence of Kiyonaga as the leading master of ukiyo-e in 1780 was a period of transition for *bijinga*. Koryūsai, who had carried on the heritage of Harunobu during the early seventies, had during the second half of the decade developed a more detailed and realistic style and gave up printmaking for painting in 1780. Shunshō, while primarily devoted to the actor print, had produced some fine courtesan prints as well, of which the set *A Mirror of the Beauties of the Green Houses* of 1776 (with Kitao Shigemasa) was the most notable.

But the printmakers who reflect the tendency of the new age most clearly are those of the Kitao school, notably Shigemasa and Masanobu. In their work the new ideal of female beauty finds expression that represents a turning away from the frail, delicate kind of girl favored by Harunobu and his followers to a fuller and more robust type of female figure that is much closer to what Japanese women actually look like. There is also a change in hair style and in depiction of the kimono. The hair is now arranged in the *bin* style, with two projecting side wings held up by a strip of thin bone referred to in Japanese as *bin-sashi*. The garments are far more elaborate and are rendered in a very detailed, realistic manner.

The leading artist of this period, who enjoyed far greater fame in his own lifetime than he does today, was Kitao Shigemasa. He was born in 1739 and died in 1820. The son of an Edo bookseller, he was a man of culture who wrote poetry and excelled in calligraphy in addition to being an accomplished painter, printmaker, and book illustrator. It is believed that he was largely self-taught, although there is a tradition

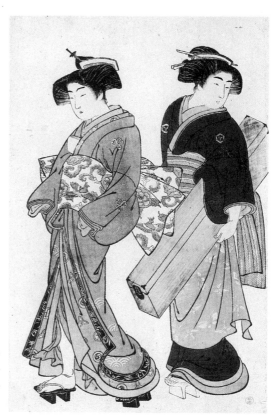

30. *Attributed to Kitao Shigemasa:* Geisha and Maidservant. *About 1780. Tokyo National Museum.*

that he had been a pupil of Shigenaga. There can also be no doubt that he had studied the work of Harunobu, who was the leading figure in ukiyo-e during his formative years. His output of single prints was rather limited, for he seems to have preferred making picture books, a form in which he excelled. The most famous of these is the one depicting the courtesans of the green houses, in which he collaborated with Shunshō, producing the first two volumes while Shunshō produced the third and fourth. Because of this his single prints are very rare today, and many of them are unsigned and can only be attributed to him on the basis of style.

Since he was an excellent draftsman and fine designer, Shigemasa's work is always accomplished, but it is often uninspired and lacks the unique quality that marks the prints of such great masters as Harunobu, Kiyonaga, and Utamaro. His favorite subjects were the beauties of the

THE KITAO SCHOOL 65

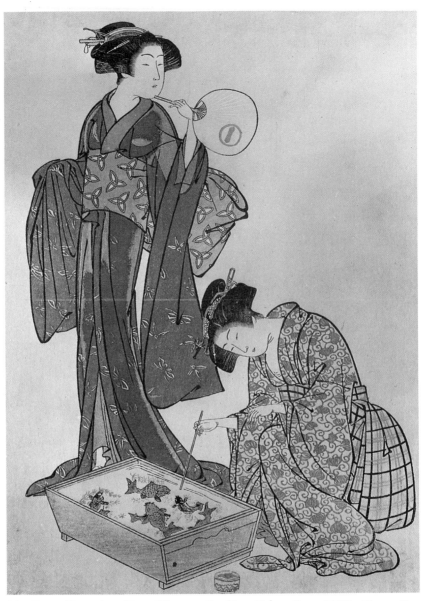

31. *Kitao Masanobu:* Two Women Feeding Fish. *About 1780. Metropolitan Museum of Art, Rogers Fund, 1927.*

Yoshiwara district, not only the courtesans but also the entertainers and geisha whom he depicted in his most famous series. Using subdued colors, with different shades of black, gray, and brown predominating and with striking but simple compositions, his best prints are lovely and reflect the Japanese artistic sensibility of the time more faithfully than do those of any of his contemporaries (Plate 30). As the founder of the Kitao school, he was also very influential as a teacher. Among the notable pupils who studied with him were Kitao Masanobu, Kitao Masayoshi, and Kubo Shumman, two of whom are today far better known than their teacher.

The greatest artist of the Kitao school was Kitao Masanobu, who is also known as Kyōden, an artist's name he took in later life when he turned from painting and print designing to writing, a field in which he is even better known today. While in English transliteration he seems to have the same given name as the great early printmaker Okumura Masanobu, the characters he used in writing the name are different ones, and he in any case has no relationship with the former. He was born in 1761 and lived until 1816, but since he gave up art for literature in 1785, his artistic career was relatively brief and his output very limited. His best work is highly esteemed, and he is considered the most brilliant of Shigemasa's pupils. Like his teacher, he specialized in the depiction of the courtesans of the Yoshiwara district, whom he portrayed with somewhat more grace and elegance than Shigemasa did (Plate 31).

Among Kitao Masanobu's works by far the most outstanding is the album called *A Mirror of the New Beauties Among the Yoshiwara Courtesans, with Poems in Their Own Handwriting*. Brought out in 1784 by the well-known publisher Tsutaya Jūzaburō, it consists of seven very large prints that are considered to be among the masterpieces of their genre. They present celebrated courtesans of the day surrounded by their attendants, and each is inscribed with a poem in the handwriting of one of the courtesans. These now very rare works are outstanding for their flowing lines and subtle coloring, which tends toward delicate pinks, greens, and yellows. The combination of the pictorial images and the calligraphy is particularly effective and gives the prints an appeal only rarely found in other works of their kind.

The other outstanding pupil of Shigemasa was Kitao Masayoshi, who was born in 1764 and died in 1824. The son of a tatami matmaker, he came from a working-class background. Nevertheless, he became a

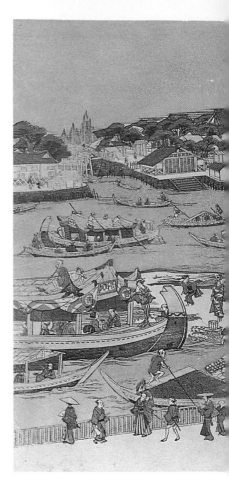

32. Utagawa Toyoharu: Summer Feasting on
the Sumida River. *About 1785. Metropolitan
Museum of Art, bequest of Henry L. Phillips,
1940.*

court artist of the daimyo of Tsuyama, although by that time he had
given up printmaking altogether and had turned entirely to genre
painting. At the very end of his life he became a lay priest and took the
name Shōshin. His productive period as a printmaker dates largely from
the eighties and early nineties, for by 1796 he had stopped working in
ukiyo-e and afterward underwent training in the Kanō school. He
worked in many different styles, both Japanese and Western, and pro-
duced a large body of work consisting of single prints, paintings, and,
above all, illustrated books. Today his prints are rather rare, the
best-known example being a print showing a man and two women on a
spring outing with one of the women resting on the shoulder of the
man in order to pick the branch of a willow. The style, drawing, and

68 **THE KITAO SCHOOL**

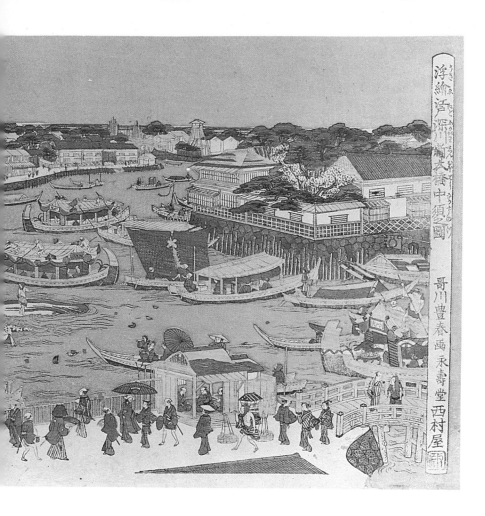

coloring of the figures recall the work of his teacher Shigemasa, but other prints of his are far more original in showing scenes from the Kabuki theater, with the landscape settings rendered in a Western manner.

This type of print was inspired by the Dutch engravings that were reaching Japan during the eighteenth century by way of the island of Deshima in the harbor of Nagasaki. It became the specialty of yet another artist of this period, Utagawa Toyoharu, the founder of the Utagawa school. Little is known about Toyoharu's birthplace or early years, but it is known that he was born in 1735, four years before Shigemasa, and studied Kanō-school painting in Kyoto. As a young man in his late twenties, he went to Edo, where he is believed to have

become a pupil of Shigenaga or Sekien, although this is not at all certain. In any case he turned to ukiyo-e around 1763 and became a leading member of this school. He died in his adopted city in 1814 at the age of seventy-nine.

His early work reflected the style of Toyonobu, Harunobu, and Shunshō, and he produced courtesan and actor prints of no great distinction. It was not until he turned to *uki-e,* or perspective pictures, in larger format that he emerged as a major artist who made a very original and distinctive contribution to the evolution of Japanese prints. It has rightly been said that he not only was the teacher of such influential artists as Toyohiro and Toyokuni but also was the founder of a school that included almost every major nineteenth-century printmaker. Nor can it be denied that the landscape prints of Hokusai and Hiroshige are unthinkable without his example. He was also one of the outstanding ukiyo-e painters. The prestige he enjoyed in this field is well illustrated by the fact that in 1796 he was the head of a group of artists who were asked to undertake repairs at the Nikko mausoleum of Ieyasu, founder of the Tokugawa dynasty.

His greatest achievement, however, is to be seen in his landscapes, to which he turned in the seventies. Depicting many aspects of the Japanese countryside as well as scenes from Holland and China, although he had actually never left Japan, he developed the perspective print far beyond the primitive stage seen in the prints of such early-eighteenth-century masters as Masanobu. He handled both the rendering of spatial depth and the modeling in light and shadow with great skill and showed a sophistication that the earlier printmakers lacked. His colors were very subdued, tending toward dark brown and dull greens and grays as well as mustard yellow and orange. His lines were very fine: a feature that no doubt represented an attempt to imitate the type of line found in the European prints. While not exactly in the main line of Japanese artistic development, Toyoharu's woodcuts nevertheless made an important contribution to the evolution of landscape prints (Plate 32).

Color Plate 1. Torii Kiyomasu II: The Actor Ichimura Uzaemon VIII as a Samurai with a Courtesan. *About 1750. Munsterberg Collection, New Paltz, New York.* ▶

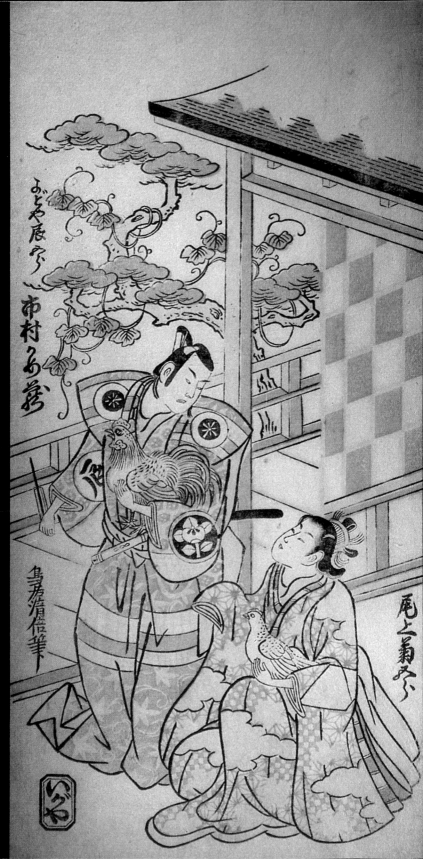

Color Plate 3. Suzuki Harunobu: Girl and Mendicant Zen Priest. *About 1765. Munsterberg Collection, New Paltz, New York.*

Color Plate 2. Torii Kiyomitsu: The Actor Ichikawa Raizō as a Seller of Ferns. *About 1760. Munsterberg Collection, New Paltz, New York.*

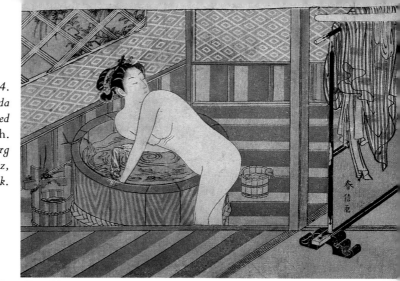

Color Plate 4. Attributed to Isoda Koryūsai but signed Harunobu: The Bath. *About 1770. Munsterberg Collection, New Paltz, New York.*

Color Plate 5. Torii Kiyonaga: After the Bath. *About 1785. Munsterberg Collection, New Paltz, New York.*

Color Plate 6. *Katsukawa Shunchō:* The Boy's Day Festival. *About 1780. Munsterberg Collection, New Paltz, New York.*

Color Plate 7. *Kitagawa Utamaro:* Frogs, Lotus, and Insect *from* Ehon Mushi Erabi *(Picture Book of Insects). Dated 1788. Munsterberg Collection, New Paltz, New York.*

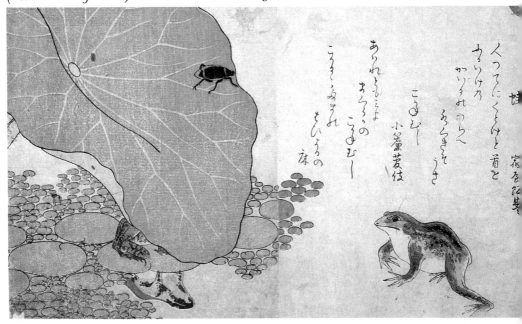

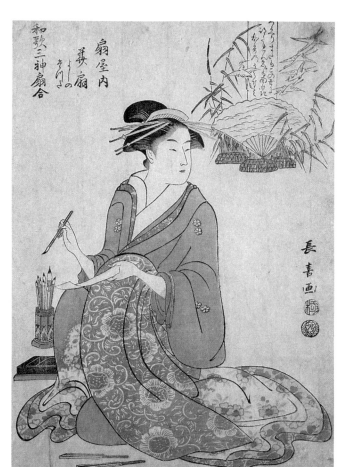

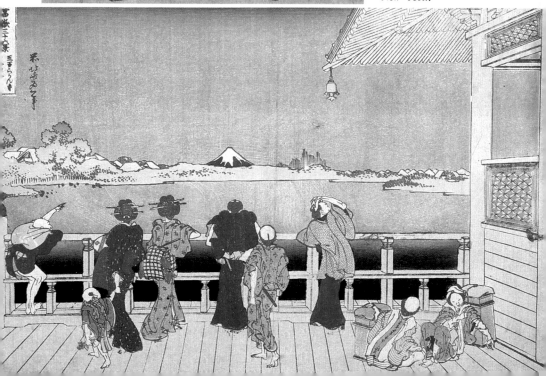

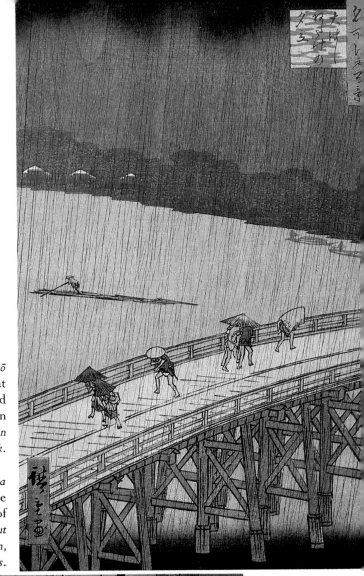

Color Plate 10. Andō Hiroshige: Sudden Shower at Ōhashi *from* One Hundred Views of Famous Places in Edo. *Dated 1857. Japan Gallery, New York.*

Color Plate 11. Utagawa Kuniyoshi: The Shubi Pine Tree *from* Famous Views of the Eastern Capital. *About 1833. Springfield Museum, Springfield, Massachusetts.*

Color Plate 12. *Kawahara Keiga:* Women of Holland. *Dated 1818. Kobe City Museum of Namban Art.*

Color Plate 13. *Toyohara Kunichika:* The Actor Nakamura Shin IV as a Snake Magician. *Dated 1878. Munsterberg Collection. New Paltz, New York.*

Color Plate 14. Kawase Hasui: The Shiba Zōjō Temple in Snow. *Dated 1925. Japan Gallery, New York.*

10 Kiyonaga and His Followers

THE DOMINATING FIGURE in the world of Japanese prints during the 1780s was Torii Kiyonaga, the last of the great masters of the Torii school, who lived from 1752 to 1815. The son of a bookseller, Kiyonaga was adopted by the Torii family and took up the hereditary occupation of this school in designing theater posters and actor prints. His teacher was Kiyomitsu, who represented the third generation of Torii masters, and upon Kiyomitsu's death in 1785 Kiyonaga became the fourth and last great artist of this line, for neither his own son Kiyomasa nor Kiyomitsu's grandson Kiyomine, who had been designated as his successor as Torii V, proved to be outstanding artists.

Kiyonaga's artistic career was a brilliant one, starting in 1767, when as a boy of fifteen he made his first actor print, and ending almost fifty years later, when he died in 1815 at the age of sixty-three. A prolific artist, he excelled not only as a printmaker but also as a painter and illustrator, his total oeuvre numbering over one thousand works, with many others no doubt not having survived. His early work is very much influenced by that of Kiyomitsu, whose pupil he had become at the age of twelve in 1764. During the 1770s he first came under the influence of Harunobu, whose use of the *nishiki-e,* with its brilliant colors, he took over, and then later in the decade, after Harunobu's death, Koryūsai and, above all, Shigemasa. While these prints were accomplished, they did not reveal his extraordinary talent, and it was not until the 1780s, in the Temmei era, that his artistic style evolved and he reached his maturity and became one of the six great masters of ukiyo-e. A man then in his late twenties, he emerged as the most outstanding and influential printmaker of this period and for the next

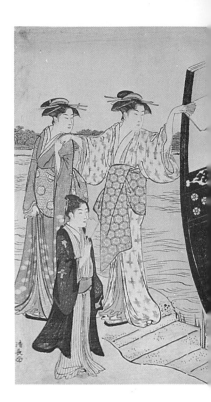

33. *Torii Kiyonaga:* Landing from a Pleasure Boat at Mukōjima. *Triptych. About 1785. Metropolitan Museum of Art, Rogers Fund, 1936.*

decade produced sets of prints that are considered among the master-pieces of Japanese art. While there has been some controversy about his position in the history of ukiyo-e, with authors like Ficke looking upon him as the very culmination of this school, while others like Richard Lane see a certain monotony and coldness in his work, there can be no doubt that he dominated the art of his age, as Harunobu had done in his period and Utamaro was to do during the next decade. Although he continued working up to the time of his death, his most creative period came during the 1780s, for after 1790 he turned largely to painting and the designing of posters for the theater.

His favorite subject during this second phase of his artistic career, the phase universally considered to be his greatest, was the elegant women and beautiful courtesans of Edo and their male consorts. In contrast with Harunobu, who had favored graceful girl-like women, and Shigemasa, who had portrayed typically Japanese women of medium build and rather plump proportions, Kiyonaga depicted tall,

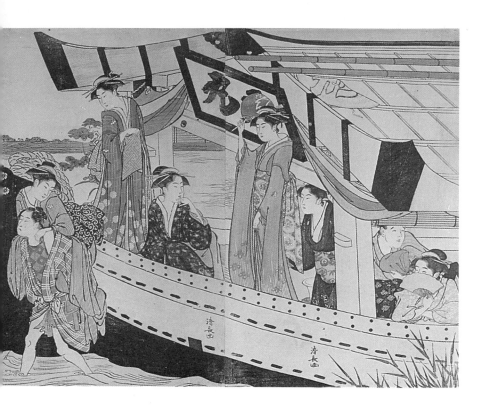

stately women who by Victorian writers like Fenollosa were compared
to Greek goddesses. His style combined realism with idealism, pro-
ducing a simple grandeur and perfection that indeed can be likened to
those of classical art, although his subject and his point of view are very
different from those of any artist of antiquity. A superb draftsman
and colorist, Kiyonaga produced a large number of prints of extraor-
dinary quality that today are highly prized by connoisseurs and
collectors. In fact the really first-rate prints, especially those issued in
the form of diptychs and triptychs, are now almost unobtainable.

It is difficult to chose among the many outstanding prints and sets of
prints Kiyonaga produced, but no one could contest that one of the
very finest is the series called *Minami Juni Kō,* or *The Twelve Months in
the South,* believed to date from around 1784. The subject is the
activities of the courtesans of the green houses of the Shinagawa dis-
trict, which Kiyonaga seems to have favored over the Yoshiwara, since
he also portrayed it in other prints. Today only ten of this set of prints

survive, but even so, Muneshige Narazaki, in speaking of them says: "If the whole set were to be gathered together, it would surely form one of the greatest works in the history not only of ukiyo-e but of Japanese art as a whole."[1]

Another celebrated work by Kiyonaga is the triptych showing women returning from a boating trip on the Sumida River at Mukōjima (Plate 33). The triptych, of which splendid impressions are owned by the Boston Museum and the Metropolitan, pictures the women in their gorgeous kimonos disembarking from a pleasure boat while three of their friends watch from the shore and a male attendant carries one woman on his back so that she will not get wet. Magnificent creatures with beautiful faces that nevertheless show little expression and with bodies far taller than is usual in Japan, these women seem to belong to another serene, harmonious world of ideal beauty very different from the everyday world of Edo of the time, which was actually one of hardship and widespread starvation. It is this ideal of feminine beauty that Kiyonaga depicts over and over again (Color Plate 5). It is also seen in his beautiful pillar prints, another genre in which he excelled.

While none of Kiyonaga's pupils or immediate followers were notable artists, there were two important printmakers who were very much influenced by him. The first of these was Katsukawa Shunchō, whose exact dates are not known but who flourished during the eighties and nineties of the eighteenth century. As his name suggests, he had been a pupil of Shunshō, and his earliest work reflects this influence. In his maturity he came under the spell of Kiyonaga, and this completely transformed his style. Once having adopted the imagery and manner of Kiyonaga, Shunchō continued to employ it for the remainder of his artistic life. In view of his dependence on his mentor and a certain lack of originality, Shunchō cannot be considered one of the great figures of ukiyo-e, even though individual works of his often equal or even surpass those of his master. This is particularly true in his poetic evocation of feminine loveliness, for while Kiyonaga's women were often cold and aloof, Shunchō's have a tenderness and grace that is extremely appealing. Employing a sensitive flowing line and perfect color harmonies, he achieves effects that make his prints among the most satisfying in the whole history of ukiyo-e (Color Plate 6). In prints like the one presented here he equals Kiyonaga, yet this is merely one

1. Muneshige Narazaki: *Kiyonaga*. Tokyo, 1969; page 44.

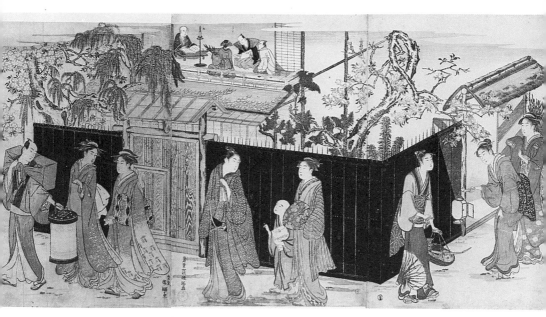

34. *Kubo Shumman:* Nighttime Departure from a Haiku Party. *Triptych. About 1790. Museum of Fine Arts, Boston; Spaulding Collection.*

of many executed by him in the form of single prints, diptychs, triptychs, and pillar prints, a format in which he was outstanding. In addition to being an artist he was a poet and an essayist, and it is said that after his retirement from printmaking he devoted himself to the writing of *kyōka,* the short humorous verse popular at that time.

The other follower of Kiyonaga who was a great artist in his own right was Kubo Shumman (also read Shunman), who lived from 1757 to 1820. He had started out studying Chinese-style ink painting under Katori Nahiko and then ukiyo-e under Shigemasa, but the decisive influence over his art came from Kiyonaga, whose style he adapted very successfully to his own ends. He was a far more original artist than Shunchō, and his work, though reflecting the art of Kiyonaga, never slavishly imitated it but showed a highly individual style. His prints, of which the six-sheet composition of the mid-eighties representing the Six Tama Rivers is the most remarkable, are noted for their subdued color harmonies featuring grays, pale green, and purple. The feeling of understatement and muted elegance so characteristic of his

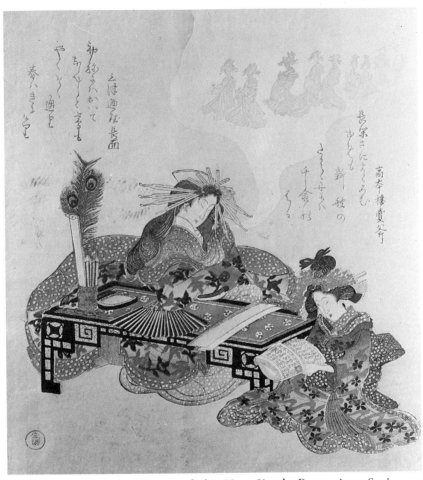

35. *Kubo Shumman:* Dreaming of the New Year's Procession. Surimono. *About 1790. Metropolitan Museum of Art, H. O. Havemeyer Collection, bequest of Mrs. H. O. Havemeyer, 1929.*

work is greatly admired by the Japanese (Plate 34). His prints are therefore much sought after and very rare, since his output was small, but in addition to these prints he produced a large number of *surimono,* illustrated books, and paintings and, especially in his later years, was active as a writer .of *kyōka* and fiction, often combining collections of light verse with pictures by his hand.

Of his works the most remarkable are probably his *surimono.* These

usually small-scale privately commissioned prints proved particularly congenial to him, and it is no exaggeration to call him the greatest master in this art form. There were of course others who worked in the genre, notably Harunobu, who is usually credited with having been the first major artist of this type of print, and Hokusai and his followers, who produced a large number of *surimono* during the first half of the nineteenth century. *Surimono* were printed for festive occasions, such as New Year's, which was and continues to be the most important holiday in Japan, and for name changes or other milestones in a person's life. The subjects treated were of all kinds, taken from daily life: the world of the courtesans, literature or history, nature, and still life. All *surimono* were exquisitely printed on the very finest paper and were almost always accompanied by poems. Many of them were in fact commissioned by poetry societies, which distributed them to their members. Among them are therefore some of the most carefully executed of all Japanese woodblock prints, and it is not surprising that they are favorites among many Japanese and Western collectors. A fine example of a *surimono* by Shumman is a small almost square print depicting an elaborately dressed courtesan who has fallen asleep and is dreaming of a New Year's procession, which is shown in dim grays in the sky, while her attendant is looking at a calendar in which the long and short months are listed. Above the figures are *kyōka* verses written in a very delicate cursive script that adds a great deal to the interest and aesthetic appeal of the print (Plate 35).

11 Utamaro, His Contemporaries, and His Followers

THE CULMINATING FIGURE in the evolution of the Japanese wood-
block print of the eighteenth century was no doubt Kitagawa Utamaro,
who lived from 1753 to 1806. Although he was only one year younger
than Kiyonaga, the period of his greatest florescence was a decade later
than that of his predecessor, for it was during the 1790s that he pro-
duced his best work. The prints of these years are regarded by many
critics as the finest *bijinga* in the entire history of ukiyo-e. His fame was
already great in his lifetime, and, as Jack Hillier reports in his admir-
able study of the artist, "a traveller in the northern parts of Japan in
these years, a man who was apparently a collector of prints, has left
it on record that in all the provinces of Japan Utamaro was considered
the greatest master of the land."[1] The record also shows that Uta-
maro's prints were already exported to China and bought by the Dutch
in Nagasaki during the artist's lifetime. The artistic eminence of his
work was at once realized when Japanese woodblock prints began to
be known in Paris in the second half of the nineteenth century. He
became a favorite of such notable artists as Manet and Cassatt, and two
of the very first books published on ukiyo-e were devoted to his work.
If one wishes to regard him as the greatest of all the masters of the
Japanese woodblock print, as some critics contend, it is a question of
personal taste, but that he, along with Moronobu, Harunobu, Kiyo-
naga, Sharaku, Hokusai, and Hiroshige, is one of the giants of ukiyo-e
is beyond dispute.

The exact date and place of Utamaro's birth are not known with

1. Jack Hillier: *Utamaro*. London, 1961; page 147.

certainty, but since it is said that he was fifty-three at the time of his death on the twentieth day of the ninth month of the year 1806, it is generally believed that he must have been born in 1753. There is also some controversy about his birthplace. One authoritative source says that he was born at Kawagoe in Musashi Province, while other sources suggest that he originally came from Kyoto. There can be no doubt, however, that he spent all his adult life in Edo. His early training was received under a painter of the Kanō school and under the well-known illustrator and man of letters Toriyama Sekien, but the decisive influence on his work came from the two great print artists of his youth, Shigemasa and Kiyonaga.

Utamaro's earliest known work is a theatrical book dated 1775. There are also some actor prints reflecting the influence of Shunshō that date from the late 1770s. At the time Utamaro signed himself Kitagawa Toyoaki, a name he later dropped. While perfectly competent, these early prints are not as yet outstanding and show little of the distinctive style and unique genius of his later work. There was a dramatic change when he established an association with the famous bookseller and publisher Tsutaya Jūzaburō, who became his patron and friend and with whom he lived from 1783 to the time of Tsutaya's death in 1797. The turning point came in 1781, when he took on the artist's name Utamaro and changed from actor prints and book illustration to depictions of the beauties of the Yoshiwara district as his major subject matter.

His work of the eighties, while not yet revealing his full potential as an artist, nevertheless already shows many elements of his mature style: his superb drawing, his subtle use of color, and his fine sense of design. At the same time it must be admitted that he was not yet a match for Kiyonaga, who was the dominant artistic figure of the period. Living close to the amusement district and spending a great deal of his time among the inmates of the so-called green houses, he devoted his art largely to the portrayal of the leading courtesans and geisha of the Yoshiwara. He shows them in all their moods and occupations, both in their professional activities, receiving and entertaining their customers, and in their moments of relaxation and amusement. Typical of such prints from his middle period are the lovely sheets from the series *Diversions of the Four Seasons,* believed to date from 1782 and 1783.

The most original and outstanding work of this phase of Utamaro's career, however, is seen in his illustrated books, notably his *Ehon*

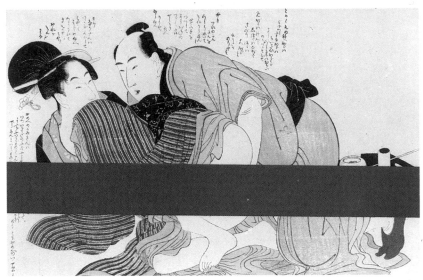

36. *Kitagawa Utamaro:* Lovers. Shunga, *shown here partially masked. About 1790.*
Ronin Gallery, New York.

Mushi Erabi, or *Picture Book of Insects,* of 1788; his *Gifts of the Ebb Tide*
of 1790; and the *One Hundred Birds Compared to Humorous Ditties* of 1791.
Published by his friend Tsutaya Jūzaburō, these volumes are the most
beautifully printed books of eighteenth-century Japan and are unique
in the field of ukiyo-e. Showing Utamaro's close observation of nature
and his remarkable ability to reproduce what he saw, they are among
the most exquisite nature studies in world art (Color Plate 7).

Compared with some of the other masters of ukiyo-e, Utamaro
was relatively old when he reached his maturity as an artist, for it was
really not until the late eighties and early nineties that he achieved his
fully developed artistic style. Significantly, one of the first major works
to show this style was *The Poem-Pillow Picture Book,* a *shunga* album that
revealed his interest and ability in the realm of erotic prints. In fact a
large part of his work is devoted to this type of subject matter, and it
has often been said, with some justice, that he is probably the greatest
master of this genre in the entire history of the Japanese print (Plate
36). But even more outstanding are his half-length portraits of beautiful
women, which date from the early nineties. Sets such as *Ten Learned
Studies of Women* and *Types of Women's Physiognomies* have always been

considered among his supreme achievements. In these prints Utamaro's unique vision of woman as the eternally alluring femme fatale whose beauty, elegance, and veiled eroticism have enchanted lovers of his art for almost two centuries is for the first time fully realized. Combining a strong but sensitive line, brilliant but subtle color harmonies, which often include mica in the background, and a wonderful sense of pattern and composition, they are true masterpieces equaled by few others and never surpassed even by Utamaro himself. In their original edition they were printed and engraved by the very best craftsmen Edo had to offer and emerged under the loving and critical supervision of the finest publisher of the day. It is probably no exaggeration to say that these Japanese woodblock prints of the 1790s are the most perfect works executed in this medium in any age or during any civilization in the entire history of art (Plate 37).

Although the portraits are often said to depict specific women such as the celebrated teahouse waitress Okita of the Naniwaya or Ohisa of the Takashimaya or famous courtesans of the day, they all look very much alike, for they embody the ideal of feminine beauty envisioned by the artist rather than the actual women themselves. Unlike the typical Japanese girl of the times, who tended to be rather short and squat, Utamaro's women are always tall and slender, with well articulated features, narrow slanted eyes with high painted eyebrows, pale oval faces, and heavy black hair. Their expression is rather aloof, even haughty, indicating that they are well aware of their erotic appeal and elegant beauty, which exercised such fascination for men. Although others have imitated Utamaro's style, no one has ever equaled him in portraying this type of woman: a type quite different from the graceful, petite girls of Harunobu or the tall, stately women of Kiyonaga.

The other type of print for which Utamaro is famous is the ōkubi-e, in which he presents close-up views of the heads of beauties of the Yoshiwara district. Series like his *Selected Poems on Love* or *A Selection of Six Famous Beauties* are true masterpieces of their genre, and while many others have produced such large heads, none have surpassed Utamaro in this field. Not only is every print beautifully executed, with marvelous drawing, color, design, and printing, but also, in spite of the limited subject matter and huge output, no two prints are exactly alike. They all display the vivid imagination and inventiveness of Utamaro at the height of his creative power (Plate 38).

While Utamaro's main subject was no doubt the green houses and

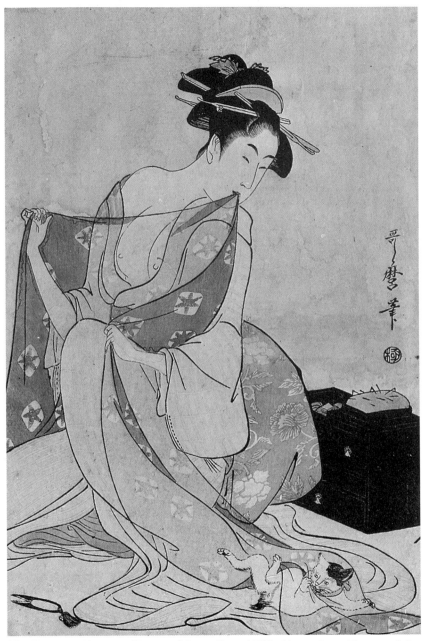

37. Kitagawa Utamaro: Dressmaking. *About 1793. Metropolitan Museum of Art, H. O. Havemeyer Collection, bequest of Mrs. H. O. Havemeyer, 1929.*

90　UTAMARO AND CONTEMPORARIES

38. Kitagawa Utamaro: Courtesan. About 1795. Metropolitan Museum of Art, H. O. Havemeyer Collection, bequest of Mrs. H. O. Havemeyer, 1929.

their inhabitants, he also made many prints showing ordinary women in their characteristic pursuits. Among them are the series showing mothers taking care of their children or nursing them, women engaged in domestic work, and, probably best known, girl shell divers. Particularly fine are his great triptychs like the one showing women who are staying at an inn getting ready to retire behind their mosquito netting (Plate 39) and the double set of triptychs showing a group of elegant ladies crossing Ryōgoku Bridge and looking down upon the women in the boats below. In works like these Utamaro's marvelous sense of composition is brilliantly displayed as he combines three or, in the case of the ladies on the bridge, six sheets into one large composition and at the same time makes it possible to enjoy each individual unit as a separate artistic entity.

Working continually for several different publishers and producing some five thousand prints in all, Utamaro became the dominant figure in ukiyo-e, eclipsing all others and exerting a strong influence on his

39. *Kitagawa Utamaro:* Women Guests at an Inn. *Triptych. About 1795. New York Public Library; Astor, Lenox, and Tilden Foundations.*

contemporaries. By 1800 all his major rivals had either died or retired from printmaking. Yet the golden age of the figure print was coming to an end, and even Utamaro's own artistic output had begun to decline. To be sure, there were still some great series in these final years of his career, notably the marvelous set called *The Twelve Hours in the Yoshiwara,* dating from the late nineties and depicting the life of the courtesans in intimate detail. But during the last years of his life, notably after his brief imprisonment for violating the censorship laws in 1804, he lost some of his creative power. His last major work, a series called *Warnings to Watchful Parents,* shows a distinct decline both aesthetically and technically and lacks the delicate beauty and artistic taste for which Utamaro had become famous. Be it the death of his great friend and publisher Tsutaya in 1797 or the shock and disgrace of being handcuffed and thrown into jail, Utamaro's creative abilities seem to have flagged, and by the time he died in 1806 at the age of fifty-three his best period was definitely over.

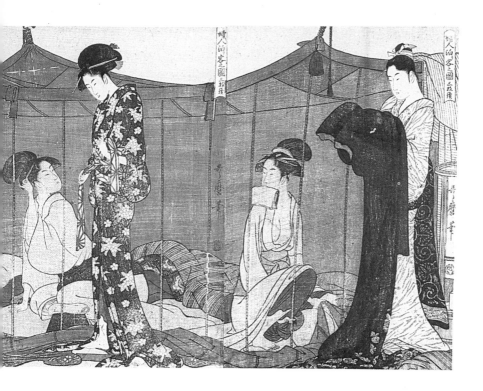

There were of course those who attempted to follow in his footsteps—men such as Koikawa Harumachi II, who after marrying Utamaro's widow called himself Utamaro II and tried to imitate his style with little success. And there were others who claimed to be his successors—printmakers who can be readily recognized by their names, into which they had incorporated the second character of Utamaro's own name. These included Shikimaro, Kikumaro, Yukimaro, and several more, but none of them approached the master's genius, and within a few years after his death Utamaro's distinctive artistic style and heritage had come to an end. The leaders of the new age of printmaking devoted themselves largely to the depiction of landscapes rather than of courtesans.

Among Utamaro's contemporaries who worked in the same artistic genre, the two most gifted were Chōbunsai Eishi and Eishōsai Chōki. Eishi, who was only three years younger than Utamaro, was born of a samurai family in 1756 and lived until 1829. His grandfather, Hosoda

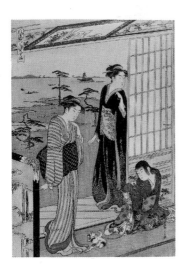

40. Hosoda Eishi (Chōbunsai Eishi): Women and Child at Seashore. *Left-hand print of a triptych. About 1795. Metropolitan Mùseum of Art, H. O. Havemeyer Collection, bequest of Mrs. H. O. Havemeyer, 1929.*

Tokitoshi, had been a famous statesman and served as a minister of finance under the Tokugawa shoguns, but in spite of his aristocratic background and elevated position in society Eishi decided upon an artistic career and studied painting under a master of the Kanō school. He then served for three years as an official artist under the shoguns Ieharu and his successor Ienari but at the age of thirty renounced his title and became an artist of the plebeian ukiyo-e school. His early work reflected the influence of Kiyonaga, but later he came under the sway of Utamaro. After that he developed his own distinctive style, which reflected his noble background in its elegance and refinement.

His most creative period as a printmaker was the 1790s, during which he produced a large body of excellent work. After the turn of the century he gave up prints for the more prestigious art of painting and became one of the most successful and sought-after painters of the ukiyo-e school. Among his many fine sets of prints one of the best is *Six Poems on Yoshiwara Beauties as Flowers.* In spite of his background he was particularly fond of portraying the courtesans of the amusement district, but he also pictured the girls and women of the upper classes engaging in such characteristic diversions as catching fireflies or viewing the cherry blossoms. At other times he is inspired by classical subjects taken from Japanese literary works like the eleventh-century *Tale of Genji,* but, as was customary among the artists of this school, he shows scenes from these taking place in a contemporary setting. In all of these

works Eishi exhibits his typical style with an emphasis on the graceful, slender figures of the elegant women seen against idyllic settings rendered in a poetic manner (Plate 40).

He was not only one of the most successful and popular artists of his day, whose prints and paintings were much admired, but was also a very influential teacher who had many pupils and followers. Most of them used the first character of his name Eishi in their own names, calling themselves Eishō, Eisui, Eiri, Eiga, and Eiju. The most out-standing of them was Chōkōsai Eishō, whose best work dates from the 1790s. He is particularly noted for his close-up portraits of women, mostly courtesans of the Yoshiwara district (Plate 41). Influenced by Utamaro and Kiyonaga as well as by Eishi, he brings to this subject a certain earthiness and robustness that makes his work rather different from that of his teacher. His finest set is his *Beauties of the Pleasure Quarters,* in which he equals the high artistic standards set by his best contemporaries, but most of his output is far inferior to that of the great masters of this age.

The other follower of Eishi who is of interest is Eiri, who was active during the 1790s and early 1800s. Little is recorded about his life, and it is not known with certainty if Chōkyōsai Eiri and Rekisentai Eiri are the same artist or two different printmakers, as Richard Lane contends. What is distinctive about Eiri's depiction of women is that he does not portray the leading courtesans of the day, the proud *tayu* or *oiran* who were the aristocrats of their profession, but common prostitutes who were readily available to all comers. Characteristic of his work is the set *Fair Streetwalkers of the Three Capitals,* which shows three lower-class women roaming the streets looking for customers. Yet even they are depicted as charming and attractive girls with slender, graceful bodies resembling the kind of woman Chōki and, in more recent times, the Taishō (1912–26) printmaker Yumeji were fond of portraying.

While the life and the artistic career of Eishi, probably because of his noble lineage, are well documented, little is known about Chōki. In fact even the period of his artistic activity is uncertain. All we know is that he studied under Sekien along with Utamaro and published his best prints with Tsutaya during the 1790s, at the very time the great publisher was also printing the work of Utamaro and Sharaku. A book of his own time relates that he was not very successful and had to turn to brushmaking for a living, but, as Seiichiro Takahashi says, this infor-

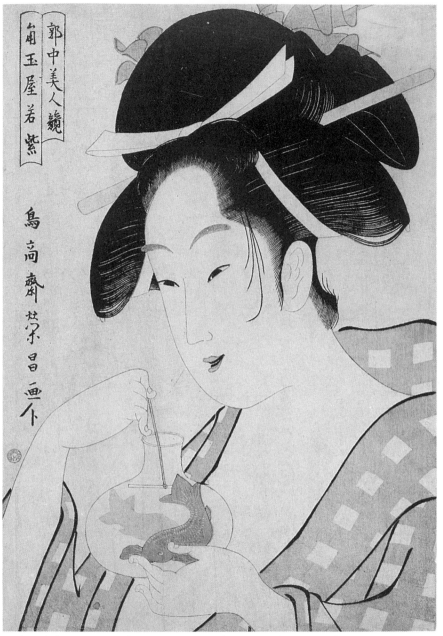

41. *Chōkōsai Eishō:* The Courtesan Waka Murasaki. *About 1800. Metropolitan Museum of Art, Fletcher Fund, 1925.*

96 UTAMARO AND CONTEMPORARIES

mation comes from a not too reliable source.[2] Modern critics have assessed his work very differently. The famous German ukiyo-e scholar Julius Kurth saw him as a giant among Japanese woodblock atrists, and Richard Lane calls him a great artist and says, "The wonder of it is that though Chōki may not be ranked equally with any of the men he studied, in a small number of his finest prints he somehow surpassed them all in the evocation of poetic atmosphere and in the creation of an ideal of feminine beauty that is second to none in ukiyo-e."[3] Yet other critics consider him but a minor master, one of the many gifted artists working in the woodblock medium (Color Plate 8).

The truth of the matter is that much of Chōki's work is very derivative and not of the first order, reflecting the influence of Utamaro and Eishi but not equaling their artistic attainment. There are nevertheless a few prints of the middle nineties that are without question among the great masterpieces of ukiyo-e and are today among the rarest and most sought after of all Japanese prints. Two prints that are particularly famous and show Chōki's unique artistic style at its best are the one of a girl under an umbrella in the snow, with a servant bending down in front of her to clean her sandal, and the one of a young woman and a boy catching fireflies on a summer night. The latter, especially, is among the loveliest of Japanese woodblock prints. In this work all the qualities that lovers of Chōki admire so much are seen at their best—for example, the graceful attenuated figure of the young woman with her high shoulders and narrow face; long, slender nose; tiny mouth; and slanted eyes under high, vaulted eyebrows. The delicate gesture of her hands, holding a fan and a cage for the fireflies; the poetic mood, with the night sky illuminated by the insects depicted with mica; and the beauty of the setting, with the blooming irises and gentle flow of the river, are particularly fine. Printed by the leading publisher of the day with the help of the most skilled and exacting craftsmen available, prints like this one not only show Chōki at his very best but also are true gems of Japanese art comparable to the best paintings produced by the artists of the time.

2. Seiichiro Takahashi: *Traditional Woodblock Prints of Japan.* Tokyo, 1972; page 95.
3. Richard Lane: *Masters of the Japanese Print.* London, 1962; page 213.

12 Sharaku, Toyokuni, and Their Followers

THE MOST MYSTERIOUS and one of the most remarkable figures in the history of ukiyo-e and, for that matter, the entire history of world art is Sharaku. In spite of years of diligent research on the part of Japanese and Western scholars into his work and life, almost nothing is known about him, and even his true identity remains a subject of controversy and speculation. All we really know for certain is that in the spring of 1794 an artist who signed himself Tōshūsai Sharaku began producing actor prints of extraordinary boldness and expressive power and that ten months later, after having produced some one hundred and forty prints, he stopped his production. Just who he was, where he was born, under whom he was trained, and what became of him when he ceased making actor prints is not known.

Contemporary Japanese sources have little to say about him besides that his career was short and that his work met with little success. In his *Reflections on Ukiyo-e,* an indispensable handbook for ukiyo-e scholars, Ōta Nampo says: "Sharaku designed portraits of Kabuki actors, but in attempting to achieve extreme realism he drew people as they are not and was thus not long in demand, ceasing to work within a year or two."[1] Another account just reports that "he lived at Hatchōbori, in Edo, and worked for only about half a year."[2]

The only other piece of information about the artist comes from Tatsuta Shashūkin, an author who was writing seventy-five years after

1. Ichitaro Kondo: *Toshusai Sharaku.* Rutland, Vermont and Tokyo, 1955; page 4.
2. Richard Lane: *Images from the Floating World: The Japanese Print.* New York, 1978; page 22.

Sharaku was active. Tatsuta reports that Sharaku's true name was Saitō Jūrobei, that he lived at Hatchobōri in Edo, and that he was a Noh actor in the suite of the lord of Awa. But how reliable this is can no longer be determined.

Since it seems unlikely that an artist of such striking skill should appear so suddenly without any record of earlier works, all kinds of ingenious explanations linking his work with that of other artists have been offered. Artists as diverse as Maruyama Ōkyo, Shiba Kōkan, Sakai Hōitsu, Hokusai, Kunimasa, Enkyō, and Chōki have been suggested as being identical with Sharaku, but none of these hypotheses have proved very convincing.

The truth, as far as we know today, seems to be that like a meteor in the sky the enigmatic figure of Sharaku appeared quite suddenly and just as suddenly disappeared again. Since the production of prints in Edo-period Japan was a purely commercial venture, it is not surprising that an artist whose prints met with little success would give up making them. But that someone who had no training in designing wood-block prints should have, without any previous experience in this intricate and demanding art form, been able to produce works of such beauty and sophistication does not seem likely. It must therefore be assumed that even if we are ignorant in this matter, somewhere there are probably records showing who Sharaku was and giving a full account of his life.

A great deal has also been made of his originality, and some critics have even suggested that his lack of success was the result of his being very un-Japanese. While there is certainly something to the thesis that his actor prints are more realistic than those of other ukiyo-e artists and sometimes border on caricature, they nevertheless are within the tradition of Japanese printmaking of his period. His full-length figures are derived from the tradition established by Shunshō and Bunchō a decade or two earlier, and even his celebrated close-up portraits of actors' faces owe a great deal to the work of Shunkō, who made similar ōkubi-e several years before Sharaku. That he had little success with the Edo public is apparent, yet at the same time it cannot be denied that his work was published by the greatest and most highly esteemed publisher of the time, Tsutaya Jūzaburō, who had also brought out the work of Utamaro and Chōki. It is a fact, as well, that Sharaku's work exerted a profound effect on the printmakers who followed him, notably Enkyō and Toyokuni.

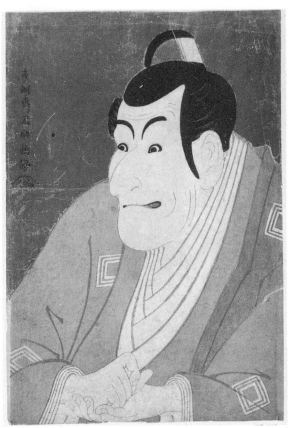

42. Tōshūsai Sharaku: The Actor Ichikawa
Ebizō as Takemura Sadanoshin. *Dated 1794.*
Tokyo National Museum.

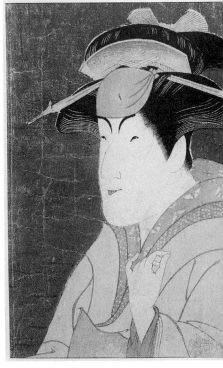

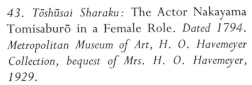

43. Tōshūsai Sharaku: The Actor Nakayama
Tomisaburō in a Female Role. *Dated 1794.*
Metropolitan Museum of Art, H. O. Havemeyer
Collection, bequest of Mrs. H. O. Havemeyer,
1929.

The rediscovery of Sharaku's unique oeuvre, which today is es-
teemed so highly by both Japanese and Western critics and collectors,
was the contribution of the German scholar Julius Kurth, who as early
as 1910 wrote a book about Sharaku in which he compared his stature
with that of Rembrandt and Velázquez. The authoritative study of his
artistic output was the work of two Americans, Harold Henderson and
Louis Ledoux, who in 1939 published *The Surviving Works of Sharaku*.
While the best Japanese books on Sharaku date from later years, this
is no doubt not pure chance. Even today Sharaku's prints seem to hold
a peculiar fascination for the Western observer beyond the appeal
they have for the Japanese artistic sensibility, which finds them
exaggerated and lacking in artistic taste.

In spite of Sharaku's very brief artistic career, which, from all we
can gather, lasted less than one year, several distinct phases can be
distinguished, the first one being by far the most outstanding. It was
during this phase that he produced twenty-eight close-up views of
actors' faces taken from the plays that were running at the three major
Kabuki theaters of Edo during the fifth month of 1794. Printed with
extreme care in brilliant color against a silvery mica background,
these prints are without question among the masterpieces of ukiyo-e
and are today among the rarest and most expensive of all Japanese prints
(Plate 42). What makes them so remarkable is not only the beauty of
their colors and designs but, above all, their expressive power, which
surpasses that of any other depiction of this subject. Showing the actor
as he actually looked rather than being an idealized portrait of him,
they have a truthfulness and psychological depth not usually found in
Japanese art, which for the most part tends toward the generalized
and the decorative rather than the in-depth portrayal of human
emotion.

Not only does Sharaku depict the various actors of the day as they
really were, but he also shows them in their specific roles, portraying
them as they could be seen on stage, with the actors of male roles in
their heroic poses and dramatic climaxes and the female impersonators
as they actually appeared, without their usual idealized glamour
(Plate 43). Striking also are the prints of two faces or figures in which
he usually shows two contrasting types (Plate 44), thus making for
additional drama and enabling him to bring out the different types of
actors and their very different roles in the Kabuki plays. In these
works Sharaku reveals himself as one of the great masters of the

Japanese print, with only Utamaro equaling him in the production of these large heads, known as *ōkubi-e* in Japanese.

The second group of prints by the artist consisted of thirty-eight actor prints made in July and August of the same year. Although they too are magnificent works of art, they are less original, since they present full-length figures more closely related to those seen in the work of Shunshō and Bunchō. Showing either one or two figures in a dramatic scene against a plain background, they are often very expressive and give a marvelous evocation of what the Kabuki theater is like. Again they reflect Sharaku's vivid realism, depicting the actors not as their public imagined them but as they actually looked, and this may have been the reason why these prints did not enjoy the same popularity as did the very idealized portrayals of courtesans that Utamaro was producing at the same time.

Sharaku's late period brought the production of sixty actor portraits and some sumo-wrestling scenes in November of 1794 and fourteen additional actor prints early in 1795. However, be it that his inspiration flagged, that he was trying to be more conventional in his approach and thereby lost his uniqueness, or that an illness affected him, there can be no doubt that the later works are quite inferior to the earlier ones. In fact if Sharaku had produced only these prints, he would today be known, if at all, as merely one of the minor figures who contributed little that was original and did not achieve any great artistic skill. His career ended as rapidly and surprisingly as it began, for by February 1795 he seems to have stopped making prints, and what became of him after this time we do not know.

Although Sharaku's artistic career was a very short one, it did not remain without influence on his contemporaries and the artists specializing in actor prints of the next generation. The two contemporaries who stood most under his sway were gifted but not very prolific artists about whom little is known. The one who reflects Sharaku's style most closely is Enkyō, who lived from 1749 to 1803. By profession he was a writer of Kabuki plays and probably an amateur when it came to the production of woodblock prints. Only seven of his works are known, all of them actor portraits dating from the middle of the 1790s. While not equal to the work of Sharaku in depth of psychological penetration or beauty of design, they nevertheless have real power and are rightly referred to by Richard Lane as minor masterpieces.

Another more important artist was Kunimasa, who lived from 1773

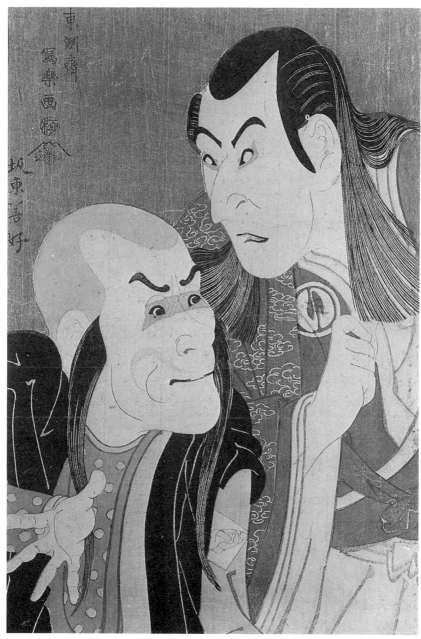

44. *Tōshūsai Sharaku:* The Actors Bandō Zenji and Sawamura Yodogorō.
*Dated 1794. Metropolitan Museum of Art, Elisha Whittelsey Collection, Elisha
Whittelsey Fund, 1949.*

SHARAKU AND TOYOKUNI **103**

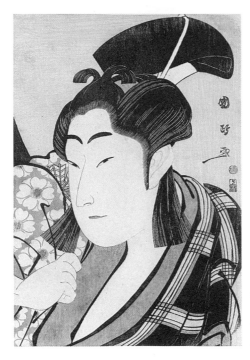

45. *Utagawa Kunimasa:* The Actor Nakamura Noshio II as Sakuramaru. *Dated 1796. Museum of Fine Arts, Boston.*

to 1810 but whose artistic output dates largely from the late 1790s. A native of Aizu (in the present Fukushima Prefecture), he was first trained as a dyer but became a pupil of Toyokuni and is therefore considered a member of the Utagawa school. The most important prints for which he is primarily remembered today are a group of thirty to forty large close-up faces of actors. These prints, published between 1795 and 1798, clearly reflect the inspiration of Sharaku's portraits of 1794. At his best, Kunimasa is a very accomplished artist, although he never achieved the expressive power of Sharaku. In fact in some ways he is really closer to Shun'ei and to his own teacher, Toyokuni (Plate 45). Far rarer than his actor prints are those depicting genre subjects, and it is among these that his most original designs can be found. Particularly charming are his portrayals of women in a domestic setting—for example, a print showing a girl seated with a samisen in her lap and another showing a girl seated by a foot warmer and playing with a cat. His output was limited, and it is believed that he stopped making prints somewhere around 1800.

Another printmaker who was greatly influenced by Sharaku and was

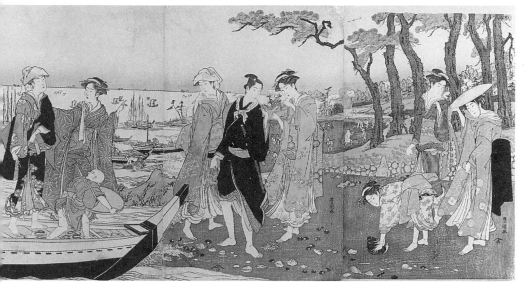

46. Utagawa Toyokuni: Ebb Tide at Shinagawa. Triptych. About 1795. Metropolitan Museum of Art, Rogers Fund, 1914.

a far more important and influential artist than either of these minor masters was Toyokuni. Born in Edo in 1769, he was somewhat younger than his great contemporaries Utamaro and Eishi, whose work had a profound effect on his. At sixteen he became a pupil of Utagawa Toyoharu and in 1784 was permitted to take the Utagawa name. His earliest work consisted largely of book illustrations, but by the mid-nineties he had turned to the depiction of beautiful women in the style of Utamaro. While never equaling the greatest work of Utamaro or Eishi, the other contemporary artists of this genre, the best of these early prints are very fine indeed, combining strong design with excellent printing. Particularly good are the prints showing scenes from the Shinagawa district—for example, the delightful triptych depicting the ebb tide at the beach of this popular seaside place, with the lovely young women enjoying the pleasure of a boating trip and shell gathering (Plate 46). The fishing boats and activities of the fishermen in the distance, treated in a somewhat Western style using perspective, clearly reflect the influence of his early master, Toyoharu, who had specialized in this type of print.

SHARAKU AND TOYOKUNI *105*

Toyokuni's most outstanding series of *bijinga* prints is the *Seven Elegant Paragons of Beauty,* which dates from the very end of the century. In this work he develops his own style, which, although owing a great deal to Utamaro, nevertheless shows an emotional detachment and an originality in devising interesting compositions that are wholly his own. He also produced a close-up portrait of the celebrated beauty Ohisa, whom Utamaro had depicted so frequently, but he seems to have preferred the full-length figures to the bust portraits.

Although the best of Toyokuni's early female representations are much admired and eagerly collected, his importance in the history of ukiyo-e rests mainly upon his actor prints, of which he made a large number. The earliest of these date from the 1790s, when he produced a series called *Views of Actors on Stage.* Published between 1794 and 1796, it at once established him as a leading artist of the Kabuki stage (Plate 47). In this genre, as in *bijinga,* he was very eclectic, reflecting the style of Shunkō, Shun'ei, and especially Sharaku, and after these three ceased working he became the undisputed master in this field. In fact he enjoyed a much greater reputation than Sharaku in his own lifetime and was considered one of the masters of the Japanese print. The modern estimate of his work has varied. Some critics regard him as a truly great artist whose work ranks with that of the best of his contemporaries, while others have dismissed him as an eclectic who copies all his contemporaries but adds little to their contribution. The truth, as the truth so often does, probably lies somewhere in between, for on the one hand there are several real masterpieces among his early prints—both his *bijinga* and his actor portraits (Plate 48)— but as the years went by he produced ever more prints to satisfy the tremendous demand for his work, and the result was a marked deterioration of quality in terms of both design and printing. In consequence the typical Toyokuni print after the early decades of the nineteenth century lacks all of the artistic refinement of even his own early work and sets the stage for the shoddy mass production of the late Edo period. Just who was to blame for this development has been debated for decades. No doubt Toyokuni contributed to it by producing too many prints too rapidly, but the times had changed, and the public for the prints, as well as the publishers themselves, had become less demanding and no longer showed the discriminating artistic taste that had prevailed during the golden age of ukiyo-e.

Toyokuni's fellow pupil under Toyoharu was Utagawa Toyohiro,

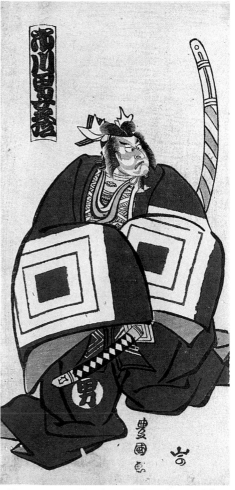

47. *Utagawa Toyokuni:* The Actor Ichikawa Yaozō. *About 1795. Brooklyn Museum.*

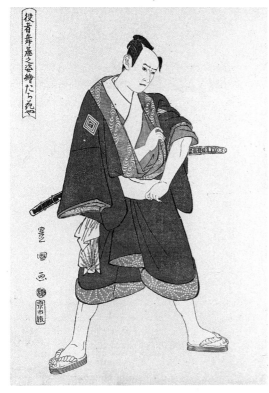

48. *Utagawa Toyokuni:* The Actor Ichikawa Omezō as Kamakura no Gongorō Kagemasa. *About 1800. Brooklyn Museum.*

SHARAKU AND TOYOKUNI *107*

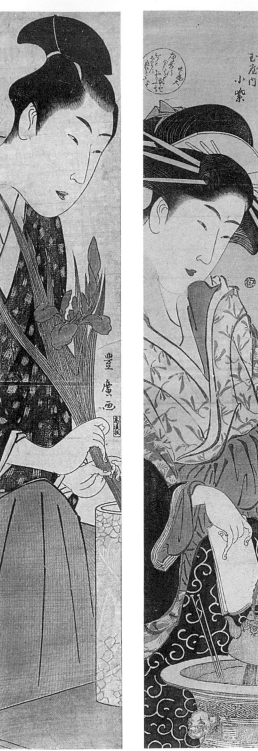

49. Utagawa Toyohiro: Young Man Arranging
Irises *(left) and* Courtesan *(right). About 1800.*
Museum of Fine Arts, Boston.

who lived from 1773 to 1828. Neither as prolific nor as influential as Toyokuni, he nevertheless was an artist of real merit whose work has a quiet charm. Reflecting the influence of Eishi, he produced numerous courtesan prints of beauty and refinement. He was also important in the development of the landscape print, his two best series in this genre being his *Six Tama Rivers* and his *Eight Views of Edo*. Other fields in which he excelled were the pillar print (Plate 49) and *surimono*, in which he did some of his most original work. By no means a major figure, he nevertheless is an artist of real ability whom such a discriminating critic as Jack Hillier praises very highly in his essay on him.[3]

Both Toyokuni and Toyohiro were extremely effective as teachers, and it was due to them that the Utagawa school became the most influential one in ukiyo-e of the first half of the nineteenth century. Among Toyokuni's innumerable pupils were his son-in-law, who after his master's death took the name Toyokuni II; Kuniyoshi; and, above all, Kunisada, who also called himself Toyokuni III. But they were merely the best known of numerous minor artists who studied under Toyokuni, most of them using the second character of his name in their own. Of Toyohiro's pupils by far the most important was Hiroshige, who along with Hokusai was to dominate the field of landscape prints and who surpassed his teacher in originality and greatness.

3. Jack Hillier: *The Japanese Print: A New Approach.* London, 1960; pages 121–30.

13 Hokusai, the Old Man Mad with Painting

WITH THE DEATH OF UTAMARO in 1806 the great period of the figure prints was over, and the woodblock artists began to look to new themes for inspiration. The most important of these was the landscape, which was to become the most popular subject among the printmakers of the late Edo period. The dominating artist in this development was Katsushika Hokusai, who lived from 1760 to 1849. Although Hokusai is a towering figure in the history of ukiyo-e, his reputation and his place in the artistic tradition of Japan have been subjects of some debate. Western writers like the Goncourt brothers, who published a book on him as early as 1896, and the German scholar Brinckmann praised him to the skies and saw him as one of the culminating figures in Japanese art, if not the most dominant, but Japanese opinion tended to be more restrained in its enthusiasm. In fact there have been those who considered him to be somehow alien to the Japanese tradition and felt that the Western liking for his works indicated that he was really closer to the Western than to the truly Japanese artistic tradition. Along with this view went a reevaluation of his true position in the evolution of Japanese art, in which he represents without doubt a late flowering rather than a grand climax, as had at one time been thought by some European critics.

Contemporary opinion seems to have settled on a position between these two extremes. Such an eminent Japanese authority on ukiyo-e as Muneshige Narazaki, in his book on Japanese prints, says, "Hokusai stands alone among the artists of ukiyo-e. No other artist can be compared with him. He called himself Sōri from age thirty-six to thirty-nine, and around this time he succeeded in blending three styles—

Japanese, Chinese, and Western—into one unified, individual, and highly personal style. From that time on, he became the most famous ukiyo-e artist of the time.''[1] Today Hokusai is universally regarded as one of the six great masters of the Japanese woodcut and, together with Hiroshige, one of the two outstanding artists of the landscape print. His output, which is estimated at no less than thirty to thirty-five thousand different designs, is staggering, and the period of artistic activity spanning some seventy of his ninety years is extraordinary. Certainly the name he gave himself in his old age, the Old Man Mad with Painting, was richly deserved, for no other artist of his school devoted himself so completely and obsessively to the creation of woodblock prints, illustrated books, drawings, and paintings.

Born in Edo in 1760, he was actually only eight years younger than Kiyonaga and seven years younger than Utamaro, but in terms of the evolution of ukiyo-e he was a man of a very different age. While Kiyonaga and Utamaro had belonged to the Kansei era, which lasted from 1789 to 1801, Hokusai was the outstanding artist of the subsequent Bunka and Bunsei eras, doing his most important work between 1810 and the 1830s. His prints reflect the spirit of the new age when Japanese prints, although more popular than ever, no longer adhered to such high standards of artistic and technical excellence and when their public was not restricted to a relatively small, aesthetically sensitive class of cultured art lovers but included vast masses of common people whose enthusiasm for this art form was not matched by their artistic discrimination.

Born in 1760 in the Honjo district of Edo, Hokusai came from an artisan background. He was first apprenticed to a woodblock engraver with whom he worked from 1774 to 1777. In 1778, when he was eighteen, he entered the studio of Katsukawa Shunshō, who was at that time the leading designer of actor prints. Shortly after he made his first actor prints, he adopted the artist's name Shunrō, meaning Spring Brightness, and became a member of the Katsukawa school. The prints of this period of his career already show his considerable talent but are little more than school pieces, resembling those of Shunshō's other gifted pupils. During the 1780s he also ventured into the field of *bijinga,* in which his work clearly reflects the influence of

1. Muneshige Narazaki: *The Japanese Print: Its Evolution and Essence.* Tokyo and New York, 1966; page 182.

Kiyonaga, who was the dominant figure in this field of printmaking at the time. Some of these courtesan prints, produced when the artist was in his twenties, have considerable merit, but they are still very derivative and show none of the originality that was to characterize his mature work.

It was only during the 1790s that Hokusai emerged as an artist in his own right. This development was furthered by the death of his master, Shunshō, in 1793, which freed him from the confines of the Katsukawa school. In fact tradition has it that before that date he was expelled from the studio of his teacher for having studied Kanō-school painting under Yūsen. In 1797 he assumed the name Hokusai, under which he is best known today, although this is but one of the thirty-one different noms d'artiste he employed during his long artistic career. Now in his thirties, Hokusai produced a large number of excellent designs in the form of individual prints and illustrated books as well as very fine long *surimono* greeting cards, a medium in which he was particularly outstanding. In these works he began to shift away from the traditional themes of the Katsukawa school, namely actors and courtesans, to genre scenes, which were to be one of his chief interests throughout his long life.

Always experimenting and filled with endless curiosity and boundless energy, Hokusai also studied several Japanese painting styles. From the Kanō masters he learned the art of brush painting, which was to stand him in such good stead in his sketchbooks, and from the Kōrin and Tosa schools he derived his wonderful sense of pattern and decorative design. But he by no means restricted himself to the art of his native country, for he also studied Chinese painting, especially bird-and-flower and figure painting of the Ming and Ch'ing periods, and, in the late nineties, Western-style painting under Shiba Kōkan, the great pioneer in this type of art. Under Kōkan's influence Hokusai produced a series of very interesting landscape prints in the Western manner employing chiaroscuro and European-style perspective: works that, although awkward and not fully realized, foreshadow his great landscape prints of the following decades.

During the early years of the nineteenth century, although continuing to produce both prints and greeting cards, he tended to concentrate on illustrated books, of which he produced a prodigious number. Among them by far the most famous are the fifteen volumes of sketchbooks called *Manga,* which began to appear in 1814, although the last

volumes were only printed after his death. These random sketches, as he called them, were intended for the instruction of young artists and have been used in this capacity by both Oriental and Western art students ever since. In these volumes Hokusai mirrors the entire world of contemporary Japan drawn in a very spirited, informal manner with a wonderful use of line. The emphasis is on the people shown in all kinds of occupations and positions: working and sleeping, wrestling, fighting and making love, elegant ladies and poor beggars, ordinary laborers and farmers, as well as ghosts and grotesque monsters. In addition there are landscapes and buildings, birds and animals, flowers and trees, as well as scenes from history and legend—a whole encyclopedia of Japan of the Edo period.

Unlike many of the outstanding ukiyo-e artists who died early or who after a decade or two of creative printmaking turned to painting or literary pursuits, Hokusai continued to pour out a large volume of work to the very end of his life. In fact his very best work was produced after his seventieth year, and it was during the eighth decade of his life that he designed the prints that are today regarded as his masterpieces. The most famous of these sets is the one entitled *Fugaku Sanjūrokkei,* or *Thirty-six Views of Mount Fuji,* which is believed to have been published between 1829 and 1833, although innumerable later editions exist. Since this series proved to be very popular with the Edo public from the very beginning, Hokusai added ten more prints, the so-called *Ura Fuji,* or *Fuji from the Other Side,* to the first group, making forty-six in the complete set. No other series of Japanese landscape prints, with the possible exception of Hiroshige's *Fifty-three Stations on the Tōkaidō,* has ever enjoyed such popularity, and well-printed early copies are among the most sought after and expensive of all Japanese prints.

In this series all the qualities found in Hokusai's previous prints are combined into a new style representing a synthesis of the influences that had gone into his earlier work. The decorative quality of the Kōrin school, the narrative emphasis of *yamato-e* (native-style Japanese painting), the brush drawing of the Kanō school, the interest in genre scenes reflected in his ukiyo-e background, as well as the greater realism and emphasis on spatial depth derived from Western sources and the influence of Chinese art, are all found in these magnificent prints. These elements are used imaginatively by the artist to form a completely realized artistic creation that is all his own and represents an

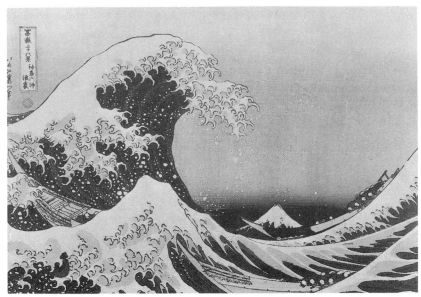

50. *Katsushika Hokusai*: The Great Wave off Kanagawa *from* Thirty-six Views of Mount Fuji. *About 1825. Metropolitan Museum of Art, Howard Mansfield Collection, Rogers Fund, 1936.*

altogether novel and highly original vision of the Japanese landscape and the common people of Japan.

The three most famous prints of this set, and those most beloved by Western painters and collectors, are the so-called *Great Wave,* more correctly *The Great Wave off Kanagawa; Southerly Wind and Fine Weather,* better known as *The Red Fuji;* and *Rainstorm Below the Mountain,* also known as *Fuji Above the Lightning.* In these works the boldness of Hokusai's forms and the wonderful sense of decorative pattern are seen at their best. Paintings like Gauguin's scenes from Tahiti and van Gogh's landscapes were clearly influenced by these famous depictions of Mount Fuji, and the ornamental design used in representing the foam in *The Great Wave off Kanagawa* exerted a powerful influence on the artists of the art-nouveau movement (Plate 50).

These, however, are but a few of the marvelous prints in this series and not necessarily the best ones. In fact many of the others are more characteristic of Hokusai's art and the spirit of the ukiyo-e

school. In these prints the artist shows all the aspects of Japanese life of the Edo period: the fishermen casting their nets or sailing their boats, the peasants planting rice or picking tea leaves, the carpenter making a large tub or the wood dealers in the timberyard, and, above all, the travelers in various locations and activities. And in all of the prints, somewhere in the background, often hardly noticeable, is the majestic form of Fuji. A typical example is the print showing people on the balcony of the Temple of the Five Hundred Rakan looking out over the water into the distance where the snow-covered mountain is visible. Combining, as it does, the interest in space and landscape with a vivid depiction of the Japanese people admiring the beauty of their native land, this print is typical of Hokusai's best work (Color Plate 9).

The 1830s not only brought this famous set but also proved to be the most productive stage of Hokusai's entire career. Literally thousands of designs, among which are many of his most famous ones, were made during this period. The early years of the decade were especially fertile ones, with the production of the series *Famous Bridges in All the Provinces of Japan* and the one called *A Journey to the Waterfalls of the Provinces,* both of which date from 1831 to 1832. They again combine in a very effective way the portrayal of the picturesque scenery of Japan with the rendering of small human figures traveling to see the famous landmarks of the countryside. The incomplete series *One Hundred Poems by One Hundred Poets* is similarly effective in its landscapes with figures (Plate 51).

Landscape, however, was by no means the only field of printmaking in which Hokusai excelled. Another subject in which he was a master was bird-and-flower prints, of which he made two famous series that some critics regard as among his best work. They are called the *Large Flower Series* and the *Small Flower Series,* because of the difference in their size, and both date from the early 1830s. Although some of these prints are clearly based on Chinese bird-and-flower painting of the Ming period, others, like the lovely print depicting irises, are typically Japanese in their emphasis on pattern and color, reflecting the kind of designs loved by the artists of the Kōrin school (Plate 52). Another notable series made during this period contains the strangely haunting prints depicting ghostly tales, with dramatic skeletons and skulls appearing mysteriously during the nighttime hours. Less spooky but equally admired by ukiyo-e connoisseurs is the set of ten prints

51. *Katsushika Hokusai:* Travelers in a Landscape *from the incomplete series* One Hundred Poems by One Hundred Poets. *About 1840. Museum of Fine Arts, Boston; Bigelow Collection.*

showing the celebrated poets of China and Japan and entitled *A True Mirror of Chinese and Japanese Poems.* These show such famous literary figures as Li Po and Po Chü-i among the Chinese and Abè no Nakamaro and Sei Shōnagon among Japanese writers against picturesque landscape settings.

Somewhat later in date are two other celebrated works, namely the *One Hundred Poems Explained by the Nurse,* dating from the end of the decade, of which twenty-seven are known, and the *Fugaku Hyakkei,* or *One Hundred Views of Mount Fuji,* the first volume of which appeared in 1834. The latter work, which was printed entirely in black and white in book form, contains some of Hokusai's most original designs and has enjoyed, along with his *Manga* series, particular fame in the West, where it was reprinted in 1881. But even the works discussed here represent only a small selection of Hokusai's vast output. In addition to his multitude of prints he produced hundreds of illustrated books, *surimono* (Plate 53), and many *shunga* albums. In fact connoisseurs of *shunga* regard Hokusai as one of the outstanding artists of the erotic

52. *Katsushika Hokusai:* Irises. *About 1825. Metropolitan Museum of Art, Frederick Charles Hewitt Fund, 1912.*

print, and his *Models of Loving Couples* is regarded as a masterpiece of this genre. This is of course aside from considering his paintings and drawings, of which large quantities have been preserved. No other Japanese artist has ever had a richer and longer artistic career. Spanning some seven decades and encompassing all the important artistic tendencies of Hokusai's day, it gives the most vivid and complete picture of what Japan was like during the first half of the nineteenth century. When Hokusai died in his ninetieth year, his only regret was that he had not been given ten or even five years longer so that he might have become a truly great painter.

Hokusai had many pupils and followers but none of them even began to reach his stature. The most important of them were Hokuju, Hokuei, and Gakutei, as well as his daughters Oei and Otatsu. The most outstanding in the field of landscape prints was Shōtei Hokuju, whose exact dates are not known. His most remarkable works, coming from the twenties of the nineteenth century, are his Western-style landscapes, which have a strangely modern look, with their cubist forms

53. *Katsushika Hokusai:* New Year's Gifts. Surimono. *About 1825. Munsterberg Collection, New Paltz, New York.*

and high degree of stylization. In these he attempts to render space in depth and to present forms in the European manner by using a perspective and modeling in light and shade in a very awkward way, thereby achieving a new and original treatment of the forms of mountains and tiny figures that stands halfway between Western and Japanese conventions and has an appeal quite its own (Plate 54).

Totoya Hokuei, who lived from 1780 to 1850, had started his life as a fishmonger but had then turned to art. He first studied under a Kanō master and later became a pupil of Hokusai. He too made some landscape prints, notably a series called *Shokoku Meisho,* or *Famous Views of the Provinces,* that were published during the 1830s. But he is primarily known for his *surimono,* which are printed with great care and often have very interesting subject matter taken from Japanese history and legend as well as lovely little still lifes. He in turn was the teacher of another outstanding *surimono* artist, Yashima Gakutei, who lived from around 1786 to 1868. Although Gakutei was a native of Edo, his most famous landscape prints depict Osaka. He was also a

54. *Shōtei Hokuju:* View of Ryōgoku in Edo. *About 1810. Tokyo National Museum.*

prominent writer who in his lifetime was better known for his *kyōka* poems and his Japanese adaptation of the Chinese novel *Hsi-yu-chi,* or *Journey to the West,* than for his prints.

Of particular interest not only because of their relationship to their father but also as women artists are Hokusai's daughters Nakajima Oei and Katsushika Otatsu. The former made some prints in her father's style, while the latter was primarily a painter of *bijinga.* While they showed a certain talent that they were able to exercise by way of their membership in the artist's family, their careers demonstrated how nearly impossible it was for a woman to receive the type of professional training and find the artistic opportunity needed to develop into an outstanding artist.

14 Hiroshige and the
Landscape Print

THE LAST OF THE GREAT creative artists of the traditional Japanese print was Andō Hiroshige. Born in Edo as the son of a fire warden in 1797, he was an entire generation younger than Hokusai, but much of his most important work is contemporary with that of the older master. As a youth of fourteen he became a pupil of Utagawa Toyohiro and gave up the hereditary profession of his family. Tradition has it that he originally wished to join the studio of Toyokuni but that he was turned down because the master already had too many pupils. Be this story true or not, it was no doubt better for the young artist to come under the influence of Toyohiro, whose gentler and more lyrical style suited his own temperament, rather than under that of Toyokuni, who at this point had declined greatly and was producing very melodramatic and conventional actor prints.

Hiroshige proved a very able student, for in 1812, only one year after he joined Toyohiro's workshop, he was permitted to use the artist's name Utagawa Hiroshige, thereby becoming a member of the most prominent and influential ukiyo-e artist's family of that day. He published his first work in 1818, when he was twenty-one years old. While officially belonging to the ukiyo-e school, Hiroshige also studied Chinese-style Kanō painting and that of the realistic Shijō school, the tendencies of both of which are reflected in his own work. The following decade was a period of slow artistic growth and maturing that produced courtesan, actor, and warrior prints of no great aesthetic merit or originality.

It was really not until 1830, when he was already a man in his early thirties, that Hiroshige emerged as a major artist in his own right.

The main reason for this seems to have been that, after the death of his teacher Toyohiro in 1828 and under the influence of Hokusai, he had turned from the figure print to the portrayal of the Japanese landscape, a field in which he was to prove preeminent. In fact the Japanese themselves regard him as the supreme master in this artistic genre, and some critics go as far as to call him the greatest of all Japanese printmakers. Whatever his position may be, when he is ranked with Hokusai and the other great masters of the Japanese woodblock print, there can be no doubt that he caught the feeling and atmosphere of Japan as no one before him or after him ever did. Even today, when Westernization and industrialism have changed the face of Japan so much, many a traveler arriving in Japan has commented upon how frequently the countryside and seashore look the way Hiroshige portrayed them more than a century ago.

In contrast with Hokusai, who had emphasized the formal design pattern and had really been more interested in the human activity taking place in his pictures than in the aspects of nature, Hiroshige was primarily concerned with the impressions he got from the landscape at the various times of year. The misty atmosphere of the rainy season, the summer showers, the forms emerging out of the fog, the freshly fallen snow on the ground and the buildings, the bright, clear fall day with its red maples and green pines—these were the subjects he never tired of depicting in ever new variations. It is also not pure chance that while Hokusai was the favorite of the post-impressionists, Hiroshige, while also appealing to them, was particularly influential for the impressionists, notably Monet, Pissarro, and Whistler.

The set of Hiroshige prints that brings out these characteristics most clearly and is usually regarded as his finest work is the *Tōkaidō Gojūsan Tsugi,* or *The Fifty-three Stations on the Tōkaidō.* Published during 1833 and 1834, when the artist was in his middle thirties, it proved to be a sensation and established Hiroshige's reputation as the foremost landscape artist of the day, surpassing even Hokusai in this field. It comprised a total of fifty-five prints, for to the prints depicting the fifty-three stations on the great highway between Edo, the seat of the Tokugawa shoguns, and the ancient capital of Kyoto the artist had added one print showing the departure of travelers from Nihombashi in the center of Edo and another showing the arrival of travelers in Kyoto. The theme was a very popular one in Japanese art. Already the founder of the school, Moronobu, had produced

55. *Andō Hiroshige:* Mitsuke *from* The Fifty-three Stations on the Tōkaidō. *About 1833. Private collection, New York.*

a long illustrated map of the Tōkaidō in the late seventeenth century, and Hiroshige's own teacher Toyohiro had designed a small *kyōka* series of the Tōkaidō in the early 1800s. Hokusai, too, had addressed himself to this theme in the early decades of the century.

It was Hiroshige's depiction of this subject, however, that not only established the artist's reputation but also made the Tōkaidō the most popular subject of the landscape printmakers. In fact Hiroshige himself made no fewer than twenty sets of Tōkaidō prints, and many others followed in his footsteps. He made his first trip along the Tōkaidō during the summer of 1832, when he was permitted to join a convoy escorting the shogun's gift of horses to the emperor in Kyoto. Experiencing the life of this busy highway and absorbing the picturesque scenery along the coast, in the mountains, and along the rivers, Hiroshige found in this subject the inspiration for his most notable artistic achievement. No one up to that time had ever brought to the scenery of Japan the sensitivity and poetic temperament of this artist. While the single most famous print and one of the most popular and sought after of all Japanese prints is that showing travelers caught in a sudden summer shower at Shōno, with its marvelous depiction

of mist and rain, there are many other masterpieces among the prints of this series that are equally accomplished. Certainly his print showing freshly fallen snow on a winter's night at Kambara, with three lonely travelers stomping through the deserted white landscape; the one with the beautiful design of pines, cliffs, fishing boats, and Mount Fuji at the Satta Pass in Yui; the one of Mitsuke, with its bold patterns portraying the Tenryū River (Plate 55); and the picture of travelers in the morning mist at Mishima are among the greatest works of Hiroshige's brush.

Enjoying a tremendous popularity almost at once and reprinted innumerable times, these prints are frequently encountered in galleries and auction houses, and no major museum or private collection is without them. Editions of as many as ten thousand copies of these and other popular Hiroshige prints were already issued in his lifetime, and reprints continued to be made during the Meiji era and are even being made at present. The result is that there are many editions, which vary tremendously in quality and value. Although it is not necessarily true that the very first edition, supervised by the artist, is the best, and although connoisseurs may often have serious differences concerning the merits of specific editions, there is nevertheless a consensus that, on the whole, the early editions are better printed and have more sensitive use of color, while the later editions are often carelessly executed and were produced merely for immediate profit rather than with thought of making the best possible work of art.

Among the other sets devoted to the journey from Edo to Kyoto the most famous is the one called *Kiso Kaidō Rokujūkyū Tsugi*, or *The Sixty-nine Stations on the Kiso Highway*. This series had been started by Eisen, but most of the prints were made by Hiroshige. It was published during the late 1830s and has been reprinted innumerable times since. Again travelers depart from Nihombashi as depicted by Eisen and then journey along the back road over the mountains instead of along the seashore, reaching the Kyoto region at the village of Ōtsu, famed for its folk paintings. While no individual print is perhaps as famous as the Shōno and Kambara ones in the Tōkaidō series, there are many excellent prints in this set as well, notably the one picturing Seba, with its poetic interpretation of the moonlit landscape and its melancholy willows, rushes, and boatmen traveling on the river, or the family crossing the bridge in a misty atmosphere at Miyanokoshi. But it is

56. *Andō Hiroshige:* Kinryūzan Temple in Asakusa *from* One Hundred Views
of Famous Places in Edo. *Dated 1856. Private collection, New York.*

really not so much the single masterpieces as the large outpouring of fine prints depicting all aspects of the scenery and life along the highway that makes the woodcuts so memorable and gives such a vivid picture of the Japan of the time.

Next to the Tōkaidō Road, Hiroshige's favorite subject was his native city of Edo, which he never tired of representing over and over again. In fact his very last work, part of which was published after his death, was the *Meisho Edo Hyakkei,* or *One Hundred Views of Famous Places in Edo,* consisting of 119 prints produced between 1856 and 1858, when he died. Although some critics, like Professor Narazaki, talk of Hiroshige's decline in his later period, some of the artist's very finest designs are found among these prints. Certainly *Sudden Shower at Ōhashi,* with its marvelous depiction of the intense rain, the curving bridge across the Sumida, and the people protecting themselves against the downpour, is one of Hiroshige's supreme achievements (Color Plate 11), and his *Moon-shaped Pine at Ueno Temple* is one of his most original and bold designs. A particular favorite of many print collectors is *Kinryūzan Temple in Asakusa,* with its large lantern and its snow-covered temple buildings (Plate 56). It is also interesting to note that no less a person than Vincent van Gogh made close copies of two prints of this set, the *Plum Garden at Kameido* and *Sudden Shower at Ōhashi,* in oil in 1888, even signing them in Japanese characters to show his admiration for Hiroshige and Japanese prints.

Yet even these works are merely a small part of Hiroshige's vast and many-sided production. His total oeuvre comprises some five thousand prints, not all of which are by any means devoted to landscape, although it is agreed that he was best in this field. There are many smaller series that are truly excellent—for example, *Ōmi Hakkei,* or *Eight Views of Lake Biwa,* with its *Night Rain on the Karasaki Pine Tree,* by common consent one of his most sensitive works, and *Autumn Moon at Ishiyama* (Plate 57) There is also his *Kyōto Meisho,* or *Famous Places in Kyoto,* consisting of ten prints that were produced in the middle 1830s, of which *Cherry Blossoms at Arashiyama* is the loveliest. Over and over again Hiroshige returns to the scenery of his native country and portrays it in all seasons, weathers, and moods. Although of course in such a large output not all prints are equally good, a surprisingly large number are of very fine quality if they are encountered in their original editions rather than in the numerous later reprints that flood the market.

While most of Hiroshige's prints are individual prints in the *ōban*

57. Andō Hiroshige: Autumn Moon at Ishiyama *from* Eight Views of Lake Biwa. *About 1835. Metropolitan Museum of Art, Rogers Fund, 1914.*

format, he also produced some triptychs and pillar prints and many illustrated books. Among the triptychs the three great landscape designs of 1857, the year before his death, are the most impressive. One of these is *The Strait of Naruto in Awa Province,* picturing animated waves and pine-clad islands. The other two are the romantic *Night View of Kanazawa,* showing the town under a full moon, and the *Mountains and Rivers of Kiso,* with its majestic mountain scenery. His pillar prints often depict birds and flowers, a genre known as *kachōga* in Japanese. In these works, above all, the influence of Chinese painting on the work of Hiroshige is clearly evident, for both the subject itself and the looser and freer style in which he renders the forms reflect Chinese prototypes. The same is also true of his fish prints, which are closely related to the fish paintings of the Shijō and Kanō schools (Plate 58). His figure prints, an important part of his total output, are for the most part early works. They do not as yet show his mature style and are certainly inferior to his landscapes. He died in 1858, in his sixty-second year, still at the height of his creativity.

Like most of the great artists of ukiyo-e, Hiroshige had many students and followers, but none could equal him either in inventiveness or in quality of output. The most immediate successor was

58. *Andō Hiroshige:* Crayfish and Shrimp. *About 1840. Brooklyn Museum.*

Shigenobu, who, after the master's death, married his daughter and called himself Hiroshige II. He lived from 1829 to 1869. He had been Hiroshige's pupil and adopted son but was not an artist of any great distinction. His best prints come from the years immediately following Hiroshige's death, and he may even have had a hand in completing some of the work left incomplete in the master's studio when he died. His most notable series are *One Hundred Famous Views of the Provinces,* published between 1859 and 1864, and *Thirty-six Views of Edo,* dating from 1859 to 1862. In 1865 his marriage to Hiroshige's daughter was dissolved, and he went to Yokohama and resumed his original name Shigenobu. It was at that time that another of Hiroshige's pupils took on the artist's name Hiroshige III. Somewhat younger than Hiroshige II, he was born in 1843, so that he had had little opportunity to study with the first Hiroshige, since he was only fifteen at the master's death. He lived until 1894, outliving Hiroshige I by thirty-six years and in fact experiencing the end of the Tokugawa regime and the beginning of the Meiji era. By far his most interesting prints are those depicting the new port city of Yokohama with its Western buildings, steam locomotives, and exotic foreigners.

15 Kunisada, Kuniyoshi, and Their Contemporaries

THE MOST INFLUENTIAL SCHOOL of the figure print during the late Edo period was the Utagawa school, which produced two important artists, Kunisada and Kuniyoshi, both of whom enjoyed tremendous popularity during their age. While later critics tended to downgrade their work and refer to them as the decadents of ukiyo-e, they have had a revival in recent years, and some connoisseurs now regard Utagawa Kuniyoshi as one of the great figures in the history of the Japanese woodblock print. Both of them were pupils of Toyokuni and based their work on that of their teacher, although Kuniyoshi in his maturity went his own way and developed a highly original style that differed completely from that of his predecessors.

Kunisada, who was the older of the two, was born in 1786, eleven years before Hiroshige, and died in 1864 just a few years before the Meiji Restoration. A tremendously prolific artist, he is estimated to have produced more prints than any other artist in the entire history of this medium, and to this day his prints are the most common and consequently the least expensive of all those made by major artists of ukiyo-e. With the public for prints expanding steadily during this period and including many working-class people with little artistic sophistication, the output was huge but did not live up to the high standards set by the print lovers of the eighteenth century. The result was that most of Kunisada's work was very poor, but at his best he is certainly one of the outstanding print artists of the nineteenth century.

Little is known about Kunisada's early life, but like most of the major figures of ukiyo-e he was a son of Edo and grew up in the Honjo district of that city. It is reported that he early showed a keen interest

59. *Utagawa Kunisada (Toyokuni III)*: Kabuki Scene. *About 1850. Loebl Collection, New York.*

in painting and had the good fortune to observe artists like Utamaro, Sharaku, and Toyokuni at the very height of their power when he was a young boy. In 1801, at the age of fifteen, he became a pupil of Toyokuni and assumed the artist's name Kunisada. In 1807 he produced his first independent work as a book illustrator, and in 1808 he published his first actor print, entering a field in which he was to become a leading master (Plate 59). The bulk of his work was devoted to the depiction of scenes taken from the theater and the world of beautiful women (Plate 60), although he also designed some *surimono* and landscapes. In addition he was well known for his numerous book illustrations, notably of ghost stories, tales of revenge, and domestic dramas, all of which had reached a high level of popularity during his time.

It is generally thought that his best work is that of his youth and that because of overproduction and lowering of artistic standards on the part of the craftsmen producing those prints, his later prints show a marked decline. Compared with the idealism seen in the prints of the

KUNISADA AND KUNIYOSHI 129

60. *Utagawa Kunisada:* Courtesan Writing. *About 1820. Private collection, New York.*

eighteenth-century masters, Kunisada's depiction of the female figure is more realistic, although always within the highly formal tradition of Japanese art. Picturing a lower class of courtesans and common women taken from ordinary life, he often shows rather plain types with hunched shoulders and heavy chins, flaunting their sexuality in a very obvious way. His actor prints are often highly exaggerated, emphasizing the enlarged eyes and distorted facial expressions. While modern critics have tended to downgrade these prints as representing a marked decline in comparison with the work of his teacher and the great masters of the previous generation, his contemporaries much admired his work and made him one of the most successful of all ukiyo-e artists. In 1844 he took the name of his teacher and became Toyokuni III, since the title of Toyokuni II had been preempted by the pupil and son-in-law of his master, who is also known as Toyoshige. Under this new name he produced a large number of actor prints and *bijinga,* but unfortunately the quantitative increase was accompanied by a decrease in quality. He continued working until his death at the age of seventy-eight. He

and his numerous pupils, among them Kunisada II, who lived from 1823 to 1880, dominated the field of actor prints during the middle of the nineteenth century, making the Utagawa school the most important of the day.

Kunisada's chief rival and, in the eyes of posterity, a far more interesting artist was Kuniyoshi. Like Kunisada he was a member of the Utagawa school and a pupil of Toyokuni. Born in 1797, he was eleven years younger than Kunisada and an almost exact contemporary of Hiroshige. A very versatile artist, he studied not only ukiyo-e but also traditional Japanese painting of the Tosa school, Chinese-style ink painting of the Kanō school, and the realistic Maruyama-school art, as well as Western prints. His output was large, including paintings and book illustrations in addition to prints, and comprised all artistic genres. While the early Western scholars of ukiyo-e tended to ignore him, he is today rightly regarded as the last of the truly creative figures in the development of traditional Japanese woodblock prints. Several modern Western collectors, notably Raymond Bidwell of Springfield, Massachusetts, and B. M. Robinson of the Victoria and Albert Museum in London, have specialized in his work.

His early prints are without much distinction and consist largely of actor and courtesan pictures in the manner of Toyokuni. This period lasted from about 1815, when he made his first prints, to the middle twenties, when he turned to warrior and battle scenes, probably in order not to have to compete with Kunisada, who dominated the other fields. There can be no doubt that it was in this artistic genre that his talent lay, and he almost at once emerged as a great master in the depiction of battle scenes, heroic warriors, and ghosts: prints that brought him great success (Plate 61). Especially his dramatic triptychs representing scenes from Japanese history and legend are among the most impressive woodcuts of the nineteenth century and in their own way quite the equal of the best of Kunisada's Kabuki prints and Hiroshige's landscapes. The chief reason they have not enjoyed as much favor with modern collectors as they did in Kuniyoshi's lifetime is that the contemporary public is less given to militarism and finds the subjects portrayed less appealing. To the Japanese of the Edo period, portrayals of ancient warriors fighting enemies and demons and of the ghostly figures of myth and legend had a reality they no longer possess even for the Japanese public of today. This subject matter is combined with a wealth of detail and a very melodramatic treatment best seen in

61. Utagawa Kuniyoshi: Unuma *from* The Sixty-nine Stations on the Kiso Highway, *depicting a battle scene from Bakin's* Hakkenden. *About 1850. Private collection, New York.*

132 KUNISADA AND KUNIYOSHI

Kuniyoshi's celebrated *Suikoden* series of 1827–30, which comprises one hundred and eight prints illustrating episodes from the *Shui Hu Chuan,* the great Chinese classic that in Bakin's Japanese version, *Suikoden,* enjoyed tremendous popularity at the time.

Rather more in keeping with modern taste are Kuniyoshi's landscapes, which clearly reflect his interest in European art. Particularly fine are those in the set of 1833 called *Tōto Meisho,* which depicts famous spots in Edo. In the prints of this series the employment of shading and perspective clearly reflects his interest in the conventions of Western art (Color Plate 12). The finest of all his many landscapes, however, are the ones depicting episodes from the life of the great Kamakura-period priest Nichiren. In this set, which dates from the mid-1830s, all of the qualities that mark Kuniyoshi's style are seen at their best, the sensitive and effective depiction of the landscape being combined with a dramatic representation of such climactic scenes from the life of the priest as his calming a storm or going into exile.

The printmaker whom Kuniyoshi resembles most in his tremendous creative energy and varied output is Hokusai. For in addition to being a producer of warrior prints and landscapes, in which he achieved his greatest success, he was an outstanding illustrator, a splendid maker of *kachō* and fish prints (the latter particularly notable), a fine fan painter, a prolific *shunga* artist, a master of the comic *kyōka* print, and an accomplished *surimono* designer. The range of his output is truly astounding, extending all the way from purely Western-style prints, which resemble nothing as much as European baroque works, as in *Confucius' Disciple Binshiken* from his *Twenty-four Chinese Paragons of Filial Piety* (1847) to his purely Tosa-school prints in the *One Hundred Poets* (1840) and the ukiyo-style of his depiction of the Tōkaidō road (1834–35). But his most memorable works next to his warrior and battle scenes were his magnificent skeletons and ghosts, which have a reality and an expressive power not equaled by any other ukiyo-e master. While his output was vast and varied, it was uneven, but at his best he was an outstanding artist of great power. It can therefore be truly said that with his death at the age of sixty-four in 1861 the creative phase of ukiyo-e had come to an end.

While the Utagawa school completely monopolized the field of actor prints, in *bijinga* there was yet another group of artists active during this age. The leaders among them were Eizan and his pupil Eisen. Kikukawa Eizan was born in 1787 and died at the age of eighty

in 1867. He had studied Kanō-style painting under his father Eiji, ukiyo-e under Hokusai's pupil Hokkei, and the Shijō style under Nanrei. The greatest influence on his own work, however, was that of Utamaro, and it has often been said that it was Eizan who, after Utamaro's death in 1806, most faithfully carried on his tradition. He specialized in depicting beautiful women in a very elegant style, using subtle colors and carefully worked-out compositions (Plate 62). Although his output was far more restricted than that of his contemporary Kunisada, who was born only one year before him, the quality of his prints was better, showing some of the refinement that was characteristic of the eighteenth-century artists. Most of his prints date from the first three decades of the nineteenth century, for in his later years he devoted himself largely to book illustration, a field in which he also excelled.

His pupil Keisai Eisen, who lived from 1790 to 1848, was a less sensitive and refined artist but was far more prolific and played a prominent role in the art of his time. He too had studied Kanō-style painting as well as ukiyo-e and was the author of one reedited version of the main sourcebook for our knowledge of the history of Japanese woodblock prints, the *Mumei Ō Zuihitsu,* or *Essays of a Nameless Old Man.* He is perhaps best known for his collaboration with Hiroshige in the set of prints called *The Sixty-nine Stations on the Kiso Highway,* to which he contributed some very fine designs. Other landscapes of his are rather more original in style, reflecting both the influence of Hokusai and that of Western art. Particularly fine is a set of vertical prints from the 1830s called *Famous Spots in Edo* in which he combines a fine sense of Japanese decorative pattern with the use of extension in space suggesting Western perspective.

The bulk of his artistic output, however, was devoted to the depiction of beautiful women and to *shunga.* It is the work in these genres that most perfectly reflects the decadence at the end of the Tokugawa regime. His women tend to be vulgar and coquettish, lacking the elegance and perfection that had marked the women of the great masters of the 1790s and even to a certain extent the *bijinga* of his own teacher, Eizan. He was probably at his best in his half-length portraits, of which he made several notable sets. Again, his greater realism in depicting the female personality is clearly evident in the far more detailed and lifelike rendering of the facial expression and mood of the girl shown (Plate 63). But the great bulk of Eisen's output is very

62. *Kikukawa Eizan: Courtesan. About 1810. Ronin Gallery, New York.*

63. Ikeda Eisen (Keisai Eisen): Woman and Morning
Glories. *About 1830. Museum of Fine Arts, Boston.*

coarse and uninspired, and it reflects the decay that the ukiyo-e print
was experiencing at this time. From a technical point of view as well,
the prints no longer adhered to the high standards of an earlier age,
although Eisen did introduce one innovation that at the time enjoyed
great popularity, namely, printing in one color, a synthetic indigo
blue imported from abroad, with different gradations of this color and
the white paper replacing the varied colors of the traditional *nishiki-e*
print. As the years went by, Eisen's work tended more and more
toward stereotypes and repetitions, showing overcrowded composi-
tion and careless drawing, and by the time of his death at fifty-eight his
creative gift had spent itself.

16 Prints of the Meiji Era

WITH THE MEIJI RESTORATION of 1868 and the opening of Japan to the West, a completely new chapter in the history of Japanese culture and art began. Traditional ukiyo-e as it had flourished for almost three centuries came to an end, and new artistic trends influenced by European art became more prominent. A wave of enthusiasm for everything foreign and Western swept the country, and Japanese prints, like all other aspects of the visual art, could not help but be affected. Yet very soon a counterreaction toward more traditional values set in, and Meiji art shows a deep division that in many ways still characterizes the Japanese people and their culture.

The art of this time, which had been much neglected for many years, has recently, especially since the Meiji centennial of 1968, experienced a revival that has brought the fascinating transitional culture of this period to our attention. Printmakers like Kunichika, Yoshitoshi, and Kiyochika, who had been almost forgotten and, if mentioned at all in books on Japanese prints, were dismissed as late, minor figures of little consequence, are today much admired and once more, as they were in their own day, looked upon as significant and interesting artists who vividly reflect the spirit of their age. Their work is eagerly collected and exhibited in both private and public galleries.

Among the many different schools and artistic personalities that existed side by side during the Meiji era (1868–1912) there were, as Professor Narazaki has pointed out, four main tendencies. The first group of artists consists of those who continue to use a traditional style and subject matter, adding little new but employing the chemical pigments imported from the West. The second group, which is

MEIJI-ERA PRINTS *137*

probably the most representative of the spirit of the age, is the one that attempts to fuse East and West by combining Japanese traditional themes with artistic devices derived from Western art. The third group does just the reverse, employing the traditional Japanese woodblock-print style to depict Western subject matter, notably the exotic foreigners, their appearance, customs, and buildings as they could be seen in the new port city of Yokohama. And finally there were the artists who abandoned the old techniques and styles of representation and worked in a realistic European manner, exhibiting a completely new aesthetic sensibility. Although all four of these artistic currents flourished simultaneously, there can be little doubt that the first trend represented the last gasp of a dying tradition, while the rejection of all Japanese values was an extreme trend that saw its high point in the early years of the Meiji era, notably during the 1870s, and that the attempt to somehow fuse the best of the old with the best of the new was the dominant cultural force of this epoch.

The artist who exemplifies the first of these tendencies most clearly, and on the highest artistic level, is without doubt Toyohara Kunichika. Born in 1835 and dying in 1900, he was a man of thirty-three when the Meiji Restoration took place and lived almost to the end of this era. A native of Edo, he had first been a pupil of Toyohara Chikanobu, whose name he took, but then studied with Kunisada, who was the most prominent maker of actor prints in Kunichika's youth. In consequence he specialized in actor prints but produced landscapes, historical subjects, and illustrations as well. His output was vast but uneven. Earlier critics usually dismissed him as having little merit, reflecting in his work the cluttered design, cheap aniline dyes, and poor printing that characterized many of the prints of the second half of the nineteenth century. This may indeed be the case, but there is at least one group of prints by Kunichika that cannot be dismissed so easily. These are his close-up views, or *ōkubi-e,* of actors, which are among the most powerful prints produced during this age. Bold in design, printed in brilliant colors, and picturing faces contorted in vivid expressions, these prints stand in the tradition of Sharaku and represent the last flowering of actor prints, a genre that began in the seventeenth century with Kiyonobu. They are today rightly much admired and eagerly sought after by collectors (Color Plate 13).

The most original and characteristic woodblock artist of the Meiji era was without doubt Yoshitoshi, who lived from 1839 to 1892.

His original family name was Yoshioka (later Tsukioka), but after 1873 he changed it to Taiso. As a youth of twelve he became a pupil of Kuniyoshi, but he also studied with the well-known painter Kikuchi Yōsai, who worked in an eclectic style derived from the *yamato-e,* and with artists of the Kanō and Ōkyo schools. Yoshitoshi's mature work was greatly influenced by European art, which he probably saw reproduced in Western periodicals and illustrated books. An example of Western influence on his designs is to be seen in his curious print depicting the *yamauba* (mountain woman) and her child, from his series *Ikkai Zuihitsu* of 1873, a print that seems to be derived from a European engraving showing the Madonna and Child. But this type of print is exceptional for him, for most of his work displays a mixture of typically Japanese subject matter and sensibility with certain Western stylistic devices, especially in regard to shading and the depiction of space.

Yoshitoshi's early work stands clearly under the impact of Kuniyoshi. His first major print, dating from 1853, when he was only fourteen years old, depicted the victory of the Minamoto over the Taira clan, an event that had taken place in 1185 and had often been treated in Japanese art. In 1860, at the age of twenty-one, he produced a series of twelve prints portraying scenes from the most popular of all Kabuki plays, *Chūshingura,* or *The Story of the Forty-seven Rōnin,* as Hiroshige, Kunisada, and Kuniyoshi had done before. Most of his subjects during the 1860s are taken from Japanese history, such as battle scenes and depictions of Japanese heroes. While this work from his early years is often powerful and certainly shows him to be a very talented artist, he had yet not developed his highly individual style but was still only the best of Kuniyoshi's many pupils.

The turning point in his artistic career came during the 1870s. In 1872 he experienced a nervous breakdown that interrupted his work for a time, but in the following year he recovered, and the years between 1873 and his death in 1892 were the most creative and important in his entire life. Although he initially suffered from lack of commercial success and had to live in dire poverty, by the late seventies he was enjoying great popular acclaim and during the eighties was regarded as the foremost printmaker in all of Japan. When the American art expert Ernest Fenollosa organized a national exhibition of Japanese painting in 1882, Yoshitoshi's work, along with that of Chikanobu and Kyōsai, was included in the show.

64. *Tsukioka Yoshitoshi:* Midnight Moon at Mount Yoshino *from* One Hundred Views of the Moon. *Dated 1886. Ronin Gallery, New York.*

140 MEIJI-ERA PRINTS

Of his large and varied output the three series usually regarded as his outstanding ones are *One Hundred Views of the Moon,* which he began in 1885 (Plate 64); *Thirty-two Aspects of Social Customs of Women,* of 1888; and the set of thirty-six prints called *Ghosts in New Form,* published between 1889 and 1892. In these works we see not only the full evolution of his style but also his ability to create a new type of print quite outside of the ukiyo-e tradition. He was the first artist to amalgamate successfully Eastern and Western artistic traditions and create a different type of art expressing the spirit of the new age. At the same time he exhibits an emotional range that is truly astonishing, showing the lyrical, poetic side of Japan in his moon series, with subjects derived from Japanese and Chinese history, legend, poetry, and drama, while in depicting the women of various periods and classes he presents elegant Meiji ladies dressed in the latest Western fashions as well as traditional courtesans who recall the women portrayed by such great predecessors of his as Utamaro, Eizan, and Kunisada. In his last major series he created his most unique and amazing works: prints in which his wild fantasy comes to the fore and has prompted Richard Lane to comment that a love for his work "requires a special taste either for the bizarre and diabolical or the quaint customs of Meiji Japan." Be that as it may, there is no doubt that Yoshitoshi in his maturity exemplified the taste of the Edo public during the middle of the Meiji era, and it is reported that sometimes entire editions of his prints were sold out on the day of publication. It is also significant that after almost a hundred years of neglect, when his work was hardly ever exhibited, a great revival of interest in this artist has occurred in recent years, with major shows held in Cologne and at the Philadelphia Museum, as well as several smaller exhibitions in his native country.

The printmaker who best exemplifies the purely Western trend in Japanese art of the Meiji era is Kobayashi Kiyochika. Born in 1847, he was roughly a decade younger than Kunichika and Yoshitoshi and consequently less set in his ways at the time of the Meiji Restoration. In fact, since he was only six when Commodore Perry's "black ships" landed in Japan and twenty-one when Japan was opened to the West, he grew up much more under the impact of European culture, a fact that is clearly reflected in his work. He came from samurai stock, and his father was a minor retainer of the Tokugawa regime who lost his position when the government collapsed. As a young man he went to

Yokohama, where he studied Western art under the Englishman Charles Wirgman and photography under Shinooka Renjō, a Japanese pioneer of this new art form. He was also trained in Japanese-style painting under Kawanabe Kyōsai and Shibata Zeshin.

Impressed by imported lithographs and engravings, he turned to the graphic arts for his means of artistic expression and, beginning in 1876, produced a large number of woodblock prints. His main subjects were views of Edo, especially the area along the Sumida River where he had grown up. While basically derived from the landscape tradition of Hiroshige and Kuniyoshi, Kiyochika's work is completely new and different in using Western artistic conventions, notably in his interest in realistically depicting light and its effect on scenes and objects (Plate 65). In this way he is really far closer to Western art than to ukiyo-e. Some critics have referred to him as the last great master of ukiyo-e, but it would really be more correct to think of him as the first great master of the modern Western-style Japanese print, anticipating the work of such Taishō-era artists as Hasui and Yoshida.

While his prints are probably not of the first rank as works of art, they have a great appeal for the contemporary viewer in evoking in a nostalgic way the Tokyo of the early Meiji era, when the influence of the West was rapidly changing the ambience of the city. Unfortunately this period of his artistic career was a relatively brief one, lasting for only five years from 1876 to 1881, when a great fire devastated the section of Tokyo that he loved most. His popularity, which had been great during this phase of his career, declined as a counterreaction against the extreme Westernization set in. His later life was largely devoted to purely commercial art for magazines and newspapers. He also did a series of triptychs depicting scenes from the Sino-Japanese War of 1894–95 and the Russo-Japanese War of 1904–5. These, however, are quite undistinguished as works of art and conservative in style. He died in 1915 at the age of sixty-eight. He had two gifted followers who also produced landscapes in a Western style, Inoue Tankei and Ogura Ryūson, both of them fine artists but not his equals.

A distinct genre of Japanese woodblock prints that is perhaps the most characteristic of the Meiji era and best reflects the changes taking place at the time is found in the Yokohama prints. While artistically on a lower level than the best work of the artists just discussed, these prints are nevertheless of some appeal and, above all, of great historical interest. Although they employ traditional ukiyo-e techniques and a

65. *Kobayashi Kiyochika:* Snow at Koume Hikibune-dōri. *Dated 1879. Ronin Gallery, New York.*

style derived from older Japanese sources, they are modern in their choice of subject matter, for they concentrate entirely upon the depiction of the new port city of Yokohama, which was established in 1859 in what had been a tiny fishing village in Edo Bay. The narrow strip of land, which was bounded by the sea on one side and a river, creek, and swamp on the other sides, was located near Kanagawa, one of the stations on the Tōkaidō. Since together with Nagasaki it was the focal point of Western trade with Japan, it became a boom town within no time at all. There the Japanese were able to observe the exotic foreigners—largely Americans, English, French, Russians, and Dutch—for the first time from close up. All aspects of the life of these strange people—their dress, customs, amusements, houses, and ships— served as an endless source of curiosity for the Japanese, who had been isolated for two and a half centuries.

The term Yokohama prints, strictly speaking, applies only to the woodcuts made between 1860 and 1863, when the finest of these works depicting the Westerners and their strange ways were produced. They were actually not printed in Yokohama but in Edo (soon to be Tokyo) by the very same artists who produced the ukiyo-e prints.

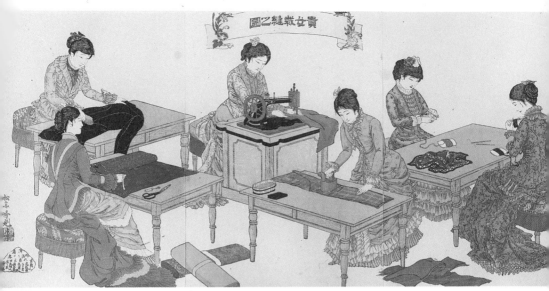

66. *Adachi Ginkō:* Women of Fashion. *Triptych. Dated 1887. Museum of Fine Arts, Boston.*

More loosely, however, this term is often used for the numerous prints depicting the new capital city of Tokyo, with its Western-style buildings, the railway running from Shimbashi Station, the gaslit streets, the opening of parliament, and, above all, the fashionable ladies and gentlemen attired in the latest European styles performing concerts with European instruments and sewing on newly imported sewing machines (Plate 66). No aspect of contemporary life remained unrecorded, so that these prints are our most complete and immediate pictorial record of Japan during the Meiji era (Plate 67). The artists who made these prints did not restrict themselves to Tokyo and Yokohama but went on to portray cities like Paris, London, and Amsterdam, or at least what they believed they looked like, and even gave a glimpse of California. Particularly delightful are their depictions of the Western circuses that began to visit Japan and of the large balloons, which created a sensation.

Among the many artists who were active in this field, the most distinguished was probably Gountei Sadahide, who lived from 1807 to 1873 (Plate 68). A member of the Utagawa school and a pupil of Kunisada, he had also produced figure prints and landscapes, but it is

67. *Anonymous Yokohama artist:* The Latest in Western Fashions. *About 1890. Munsterberg Collection, New Paltz, New York.*

his Yokohama prints, especially his triptychs, that show him at his most original and best. His work was shown at the Paris Exhibition of 1866, and the French government presented him with the Legion of Honor for his contribution. Two other prominent artists working in this field were the second and the third Hiroshige, who lived from 1826 to 1869 and 1841 to 1894 respectively. Their work represents in a very accurate way the new buildings and street scenes of Meiji times and offers a vivid reminder of Tokyo and Yokohama as they existed prior to the great earthquake of 1923, when so much of that part of Meiji-era Japan was destroyed.

The making of prints depicting Westerners and their ways was by no means restricted to a few well-known artists. Many minor print-makers, most of whom belonged to the Kuniyoshi or Kunisada tradition, turned to the new subject matter, since such prints enjoyed great popularity. A number of them, to indicate their descent from Kuni-yoshi, used the second character of his name in their own names, as did Yoshikazu, who flourished between 1850 and 1870 and was well known for his prints portraying the foreigners in their splendid establishments and pursuing their pleasure in the gay quarter of

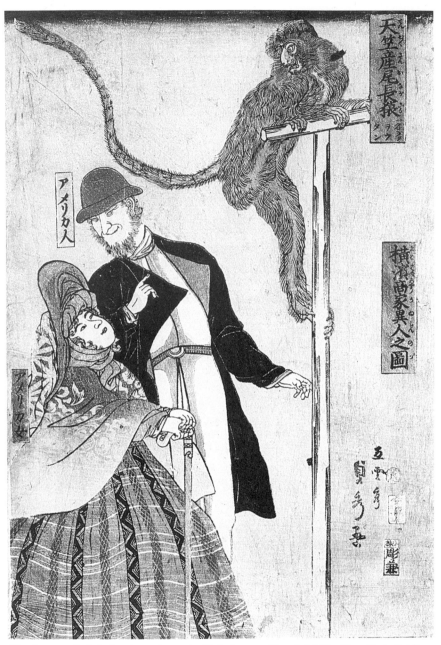

68. *Gountei Sadahide:* Americans in Yokohama. *Dated 1861. New York Public Library; Astor, Lenox, and Tilden Foundations.*

146 MEIJI-ERA PRINTS

Yokohama, where a special so-called teahouse named Gankiro was established for their use. Others were Ichimōsai Yoshitora, whose depictions of foreign scenes are particularly charming, and Ikkeisai Yoshiiku, whose depiction of a prosperous English merchant's display room is one of the most famous of the Yokohama prints.

These works, long neglected and hardly mentioned in most books on Japanese art, have experienced a great vogue in recent years, and at least one prominent Japanese collector, Mr. T. Tamba, a businessman from Yokohama, has specialized in them and published a book devoted to this subject in 1962. More recently, in 1972, the Philadelphia Museum of Art, which had for some time collected prints of this type, staged a very interesting exhibition of Yokohama prints entitled Foreigners in Japan. In keeping with this the prices of such prints, which up to very recently were absurdly low, have risen sharply. Fine examples in good condition are now greatly sought after and have come to be as expensive as the prints of the more traditional masters of the nineteenth-century ukiyo-e.

17 Woodblock Prints Outside of Edo

ALTHOUGH EDO WAS the great center of print production in Tokugawa Japan and practically all of the ukiyo-e artists, even those who were natives of other places, lived in this great metropolis, there were several cities in which other schools of printmaking arose. Notable among them were Nagasaki, Osaka, and Kyoto, where artistic traditions far older than those of the new capital had existed. Traditionally, especially in the Western world, these local schools have tended to be neglected, for it was ukiyo-e that aroused the enthusiasm of European and American collectors, but in recent years there has been a growing interest among both Japanese and Western scholars and collectors in the prints made outside of Edo.

The rarest, and in terms of Japanese cultural history the most interesting, of these graphic works are the copperplate engravings produced by Western missionaries and their Japanese converts during the Momoyama period. Their subject matter is usually religious and follows European models very closely. A good example of such a print is the one showing the Virgin and Child, based on a similar picture made in Seville by Hieronimus Wierx. It is dated 1597, and the Latin inscription definitely states that it was produced at a Japanese seminary. It is today preserved in the Catholic church Ōura Tenshu-dō in Nagasaki and may well have been printed there, since this city was a center of missionary activity. No doubt many such prints were made at the time, but only a very few of them survived the persecution of Christianity in later times.

The type of print now associated with Nagasaki and consequently referred to as Nagasaki-e dates from a somewhat later period and is

printed in the woodblock technique. It is executed in a rather provincial style and depicts the foreigners, largely Dutchmen, who were referred to as redheaded barbarians and who were permitted to maintain a trading mission on the island of Deshima in Nagasaki harbor. These prints were usually printed in color, although some of them are black and white with color added by hand. It is thought that the growth of this school of woodblock printing may have been stimulated by ukiyo-e, but it developed along very different and independent lines. While ukiyo-e depicted the life of the Japanese, the Nagasaki-e was almost wholly concerned with what to the Japanese was the exotic life of the Europeans and, to a lesser extent, the Chinese, who were also permitted to trade in Nagasaki. It was their ships that were shown in these prints along with the colorful garments and strange habits of the foreigners and their African and Japanese servants and, most fascinating of all, the wives and families of the *Orandajin,* as the Hollanders were called. The wives and families had never before been seen in Japan, since the Japanese authorities had not permitted the European men to bring their wives but supplied them with Japanese female companionship (Color Plate 12).

These prints, which date from the second half of the eighteenth and the first half of the nineteenth century, are today eagerly collected, not only for their aesthetic appeal but also as historical documents depicting the early contacts between Japan and the West. Technically they are very inferior to the woodblock prints made in Edo during the same period, but, like American primitive paintings of the same period, they have a kind of naive charm that appeals to the modern sensibility. Originally they were sold as souvenirs, which travelers to Nagasaki could acquire in order to have a pictorial record of the strange foreigners who were at this time restricted entirely to Deshima. In a way Nagasaki-e can therefore be looked upon as forerunners of the Yokohama-e prints of the Meiji era. In fact the opening up of Japan by Commodore Perry sounded the death knell for the Nagasaki-e prints. Several Nagasaki publishers were active in this field, the most prominent being Hariya of Sakuramachi, which flourished as early as the 1750s. Hariya was followed by Toshimaya, Tomishimaya, and Bukindō, all located in Katsuyama-machi. Many artists contributed to the output, but their names usually are not known, and even if the artists can be identified, little is known about them.

Most of the literature on Nagasaki-e is in Japanese. Recently,

however, one of these studies, Professor M. Hosono's book on the subject, has been translated into English. Among Westerners who have written on Nagasaki-e are Professor C. P. Boxer, whose scholarly study of the history of the Jan Compagnie in Japan deals with Nagasaki-e, and N. H. N. Mody, who in 1939 published a two-volume catalogue of his extensive collection of art works in this field—a collection that unfortunately was later destroyed by fire. It is called *A Collection of Nagasaki Colour Prints and Paintings Showing the Influence of Chinese and European Art on That of Japan.*

The other great center of print production was Osaka, where a school of woodblock printing flourished from the 1790s to the 1860s. Technically these prints are of a much better quality than those from Nagasaki. In fact they are equal to those of Edo artists in terms of design, engraving, and printing, but they are far more limited in style and subject matter. Virtually all of them deal with the Kabuki theater, which enjoyed tremendous popularity in Osaka. Especially the numerous clerks working in this great trading center were enthusiastic followers of Kabuki and therefore were natural patrons of an art form that was dedicated to depicting the favorite actors of the day in their most popular roles. While a few prints of courtesans and landscapes were also produced, it was to actor prints that the Osaka school was almost entirely devoted.

It is estimated that about two hundred Osaka artists worked in this field and that their total output was between ten thousand and fifteen thousand prints. This, by Edo standards, was a small number, since not only the tremendously productive Hokusai but also others, like Kuniyoshi and Kunisada, are said to have made in excess of ten thousand designs each. The Osaka prints were also very limited in their subject matter, for virtually all of them were devoted to the Kabuki, and they were very similar in style, with little difference between the various printmakers. There is indeed a lack of inspiration and vitality in most of this output, which makes the prints decidedly inferior to those of Edo from an aesthetic point of view.

The golden age of this school was the 1820s and 1830s, when the best of the Osaka artists were at work. Outstanding among them was Shunkōsai Hokushū, who was active between 1808 and 1832. Little is recorded about his life, but it is known that he met Hokusai in Osaka in 1817 and worked for him as a copyist on an illustrated book. He is well known for his actor prints, which are outstanding for their

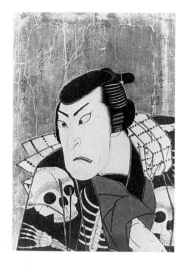

69. *Shunkōsai Hokuei:* Kabuki Actor. *About 1830. Private collection, New York.*

design and execution. Especially fine are his close-up views of actors' faces and his dramatic highlights from favorite plays. His main pupil was Shunkōsai Hokuei, who flourished between 1829 and 1837 (Plate 69). Hokuei was particularly outstanding as a *surimono* designer, using embossing, metallic pigments, and color without outline for his work in this genre. His production ended in 1837, when political and economic troubles in Osaka and then repressive laws passed by the government virtually brought an end to the publication of prints. There was, however, a revival of printmaking from the late 1840s to the 1860s. The outstanding artist of this late phase of the Osaka print was Gosōtei Hirosada, who was active between about 1819 and 1865. He was a poet as well as a print designer. With his death in 1865 the Osaka tradition of printmaking came to an end.

There has been great difference of opinion in judging the prints of the Osaka school. The traditional opinion has been to downgrade them, and older books on the history of Japanese prints have tended to ignore the production of this school altogether. In more recent years, however, there has been a new interest in the Osaka prints and the well-known American ukiyo-e scholar Roger Keyes, together with his wife Keiko Mizushima, organized a major show of this type of print at the Philadelphia Museum in 1973 and issued an elaborate catalogue that has become the standard work in this field.

The third city known for its graphic work was Kyoto, the ancient

capital, where a great artistic tradition had existed for over a thousand years. Unlike the plebeian culture of Edo, the new capital city, this so-called Kamigata tradition was an aristocratic one, appealing to the cultured men of letters, the so-called *bunjin,* or literati. Based largely on Chinese sources, the prints produced here were derived from Kanō, Shijō, and *nanga* painting depicting Chinese-style landscapes, birds and flowers, and scenes from literature, history, and legend. Virtually none of them were printed as single sheets but consisted of book illustrations or appeared in albums. The printing technique is also very different from that of ukiyo-e, far closer to Chinese woodcuts like those of the famous *Mustard-Seed Garden* series, which had been reprinted in Japan and enjoyed great popularity among Japanese connoisseurs of Chinese art. Instead of emphasizing line and pattern, as the Edo printmakers had done, the artists of this school, in keeping with the usage of *sumi-e* painters, stressed the tonal effects at the expense of sharp outlines.

The best of these albums were produced during the first half of the nineteenth century, or the late Edo period, but the beginning of the tradition can be traced back to the second half of the eighteenth century. Some of the artists working in this field were famous *bunjinga* painters like Yosa Buson and Ikeno Taiga, but most of them were lesser known artists like Ki Baitei, Kawamura Bumpō, and Kan'yō-sai, many of whom were painters and haiku poets and, above all, men of refinement and culture rather than mere artisans.

The judgment on the artistic merit of these prints has differed greatly. Like the Osaka prints, they have tended to be neglected by the ukiyo-e enthusiasts and are hardly mentioned in the literature except for publications on illustrated books such as Louise Norton Brown's and, more recently, Chibbett's studies. In 1957, however, the English author Owen E. Holloway published an entire volume on the subject, *Graphic Art of Japan: The Classical School,* in which he makes extravagant claims for the prints of this school. While his praise of the Kyoto-school prints at the expense of the works of the ukiyo-e school is ill founded, since Hokusai and Hiroshige were certainly greater and far more original graphic artists than any of their contemporaries in the Kamigata area, the efforts of the Kyoto printmakers certainly deserved more attention, and it is to be welcomed that their works, like the Nagasaki and Osaka prints, are now also being studied and collected.

18 Prints of the Taishō Era

WITH THE DEATH of the Meiji emperor in 1912, a new era in Japanese history, known as Taishō, began. Although officially it lasted for only fourteen years to 1926, when the present emperor, Hirohito, acceded to the throne, from a cultural point of view it extended to the end of the twenties. It was a period of great change, with growing Westernization and modernization completely transforming the country. The most dramatic event of this age, as far as Japan was concerned, was the great earthquake of 1923, which destroyed all of Yokohama and much of downtown Tokyo and, as we shall see, affected the production of woodblock prints as well.

Until quite recently the artistic output of this period was much neglected, especially by Western writers and collectors, but during the last decade there has been a marked revival of interest. The output of prints of all kinds was a particularly rich and varied one but had been virtually ignored in America, except by Dorothy Blair, curator of Oriental art at the Toledo Museum, who staged two important exhibitions of one major aspect of the print production of this era in 1930 and 1936. For these she issued fine catalogues that are still the main references in English for prints by Hasui and Yoshida. Dr. Shizuya Fujikake's book *Japanese Wood-Block Prints,* in the Japan Tourist Library, first published in 1938 and reprinted many times since, also takes up the work of some leading artists of this age.

The type of woodblock print that came into being at this time is usually referred to as the new print in contrast with the traditional ukiyo-e print, which had entirely ceased by this time, and the modern creative print of the Shōwa era. The person most immediately

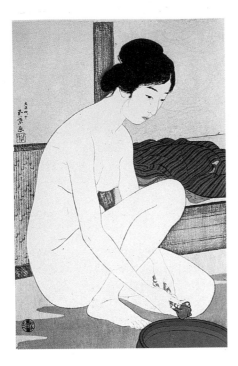

70. *Hashiguchi Goyō:* Woman in the Bath. *Dated 1915. Ronin Gallery, New York.*

responsible for the birth of this art form was the print publisher Watanabe, who ran an art gallery in Tokyo in which he handled both modern prints and reproductions of traditional ukiyo-e. This enabled contemporary graphic artists to develop new types of prints that, while employing the traditional techniques, created fresh styles and themes more in keeping with the modern age. It had of course always been true that publishers and booksellers had played a prominent role in the commissioning and distribution of woodblock prints in Japan, but no one before Watanabe, with the possible exception of Utamaro's and Sharaku's publisher Tsutaya, played as significant a role in the history of Japanese prints. His first venture in this field was his publication of Goyō's *Woman in the Bath* in 1915 (Plate 70), the fourth year of Taishō, followed soon after by Shinsui's *Looking into the Mirror* of 1916 and, in 1918, the first landscape print of this school, by Hasui. Employing highly skilled craftsmen, who engraved and printed the designs of these artists, Watanabe was able to produce technically excellent prints that were very popular with the public. Although the great earthquake of 1923 destroyed all of the blocks and most of the

154 TAISHŌ-ERA PRINTS

prints, the artists and craftsmen survived, and in a few years the new print flourished even more than before.

The most gifted of the young print artists published by Watanabe was Hashiguchi Goyō, who lived from 1880 to 1921. A native of Kagoshima, the southernmost city in Kyushu, he went to Tokyo, where he attended the Tokyo School of Fine Arts and studied Japanese-style painting under the last of the Kanō-school masters, Hashimoto Gahō, and Western-style painting under the great pioneer of this genre, Kuroda Seiki. He turned to printmaking at the age of thirty-five in 1915 and in the few remaining years of his life, for he died prematurely at the age of forty-one, produced a small number of exquisite prints that are today the most expensive and sought after of the Taishō era. Basing his art on Utamaro and Chōki, whom he admired greatly, Goyō largely depicted beautiful young girls either disrobed for the bath or dressed in elegant kimonos. A superb draftsman who made meticulous pencil sketches for his prints, he produced designs of great beauty and sensibility. A student of ukiyo-e, on which he had written a book, he tried to recapture the spirit of this art form. Although some critics have referred to his work as being dry and lifeless, the general consensus is that he succeeded remarkably well in this endeavor. Yet at the same time he is definitely not an ukiyo-e artist but uses the traditional sensibility and sense of design to create a completely new art form. His detailed realistic manner and emphasis on the nude human body especially reflects his training in Western art. This is even more clearly seen in his landscape prints, which employ European perspective and modeling in terms of light and shade.

Somewhat younger than Goyō but turning to printmaking under Watanabe's auspices at the same time was Itō Shinsui, who was born in 1898 and died in 1972. A Japanese-style painter who had studied under the leading *bijinga* artist of modern times, Kaburagi Kiyokata, Shinsui achieved fame primarily with his traditional scroll paintings depicting beautiful women and young girls, but he was an important printmaker as well. Starting in 1916, he designed landscape prints for Watanabe's establishment. His most famous series is his *Eight Views of Lake Biwa,* or *Ōmi Hakkei,* which was published in 1917, when he was only nineteen years old. Other sets dating from the 1930s are *Twelve Views of Ōshima, Eight Views of Izu,* and *Three Views of Mount Fuji.* In these, Shinsui, a typical product of his age, uses an artistic style that combines traditional Japanese with Western elements.

Yet his most popular woodblock prints were his series of modern beauties, in which he treated the time-honored themes of charming young women taking a bath, washing their hair, making up, catching fireflies, hooking a mosquito net, or just looking lovely dressed in their kimonos and displaying their beauty (Plate 71). The best of these are today great favorites among contemporary print collectors and bring prices comparable to those brought by Goyō and even the works of the great *bijinga* ukiyo-e masters of the Edo period. Executed with great care by highly skilled craftsmen, these sheets are excellent woodblock prints in the traditional vein even if they often, like so much of modern Japanese-style painting, suffer from being overly sweet.

The other two woodblock artists sponsored by Watanabe were the landscapists Kawase Hasui and Yoshida Hiroshi. Hasui was born in Shiba, Tokyo, in 1883 and died in 1957. Like Shinsui, while essentially an artist of the Taishō era, he continued to work right into the postwar period and was honored by the Japanese government in 1956 at the age of seventy-three. Again like Shinsui, as a young man he had studied Japanese-style painting under Kiyokata but later also studied Western art, so that he was well versed in both artistic traditions, as is clearly reflected in his own work. His first woodblock prints were inspired by seeing Shinsui's Lake Biwa series. They were also made for Watanabe and were taken from a series of sketches made at Shiobara in 1918. In the following year he turned full time to printmaking and in the subsequent decades produced several hundred landscape prints.

Among his early series are *Twelve Views of Tokyo, Souvenirs of Travel, The Twelve Months in Tokyo,* and *A Collection of Scenes in Japan,* all of them produced prior to the great earthquake of 1923 and therefore very rare and difficult to find today. But even the destruction of so much of his life's work did not discourage him for long, since by the fall of the year he was traveling through Japan making sketches and designing new prints. Concentrating on picturesque sites all over Japan and even in Korea, he produced a large number of prints that, as souvenirs and faithful depictions of beauty spots and historical places, have enjoyed great popularity with the Japanese and Western public (Color Plate 14). Combining, as they do, the realism of Western art and a strong decorative appeal in keeping with the Japanese tradition, they are charactersitic expressions of the spirit of the Taishō era (Plate 72).

Hasui's contemporary, Yoshida, although he portrayed similar sub-

71. *Itō Shinsui:* Woman with Umbrella. *Dated 1931. Museum of Fine Arts, Boston.* ▶

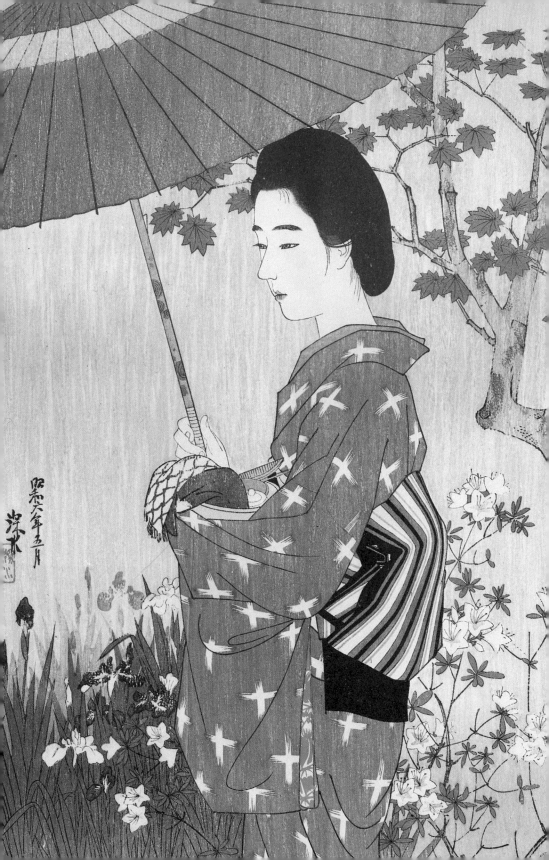

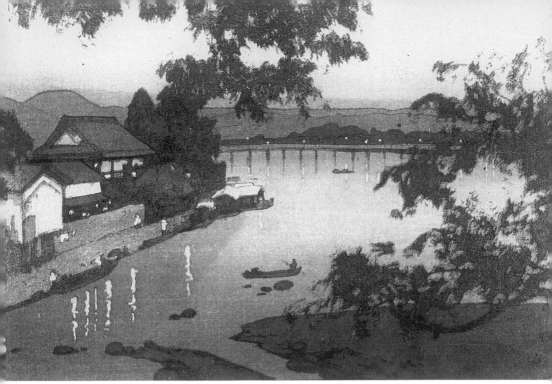

72. Kawase Hasui: Evening at Hida. *Dated 1933. Museum of Fine Arts, Boston.*

jects, is rather different in background and style. The very fact that he is known by his family name instead of his artist's name is indicative of his close relationship to Western art. Born in 1876 in Kurume, he went as a youth of nineteen to study oil painting in Kyoto under Tamura Sōritsu and later, in Tokyo, under the well-known Western-style painter Koyama Shōtarō. This period of learning was followed by travel and study in Europe and America during 1899 and 1900. He received prizes in Paris and Detroit, where he befriended Charles Freer, and became well known as a realistic landscape painter in the European tradition. His subject matter was largely taken from Europe, America, and the Middle East, the Alhambra and Egypt being among his favorite motifs.

It was not until 1919 that he became interested in the woodblock technique, and it was only in 1921, when he was forty-five, that he made his first print. His early prints, produced for Watanabe before the 1923 earthquake, were largely destroyed in that disaster and are almost unobtainable. After the earthquake he resumed printmaking,

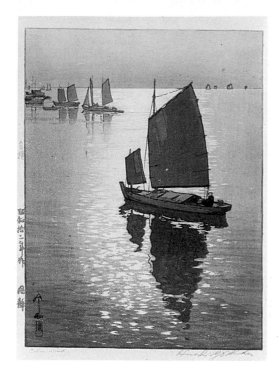

73. *Yoshida Hiroshi:* Calm
Wind. *Dated 1937. Private
collection, New York.*

acting as his own publisher. Between 1921 and 1941, when he stopped
making any new designs, he produced almost three hundred prints
depicting the landscapes and people not only of Japan but also of
Europe, America, Africa, India, Korea, China, Southeast Asia, and
Manchuria. He died in 1950 in his seventy-fifth year.

While Yoshida's prints were made in the typically Japanese manner,
with engravers and printers working from his watercolor sketches,
both the spirit and the style are completely Western, and this probably
accounts for his great popularity among Western travelers and collec-
tors. Basically, although they are woodblock prints made in Japan
after paintings by a Japanese artist, they are little but Western-style
watercolors translated into a different medium by professional artisans
(Plate 73).

Another type of print sponsored by Watanabe was that devoted to
birds and flowers (*kachō*). Numerous artists were active in this field,
and the most prominent was Ohara Shōson, or Koson, who lived from
1877 to 1945. A Japanese-style painter who was patronized by the

famous American scholar and connoisseur of Japanese art Ernest Fenollosa, he became a professor at the newly established Tokyo School of Fine Arts and served as an adviser to the Tokyo National Museum. His teacher had been Suzuki Kason, and he consequently at first called himself Koson, but in 1912 he changed this to Shōson, under which name most of his work appeared. Early in his career, at Fenollosa's suggestion, he made a few landscape and bird-and-flower prints, but the bulk of his output in the woodblock medium dates from the twenties and thirties and was published in conjunction with the Watanabe print shop (Plate 74).

A very conservative artist, Shōson continues the tradition of bird-and-flower painting as it had first originated in Sung China and then been practiced by many Japanese artists of the Edo period. While the bulk of his output literally depicts all kinds of birds and flowers, either together or separately, the term is applied loosely and may include dragonflies and fish as well. Typical of his prints are *Heron in Rain, Swans and Reeds, Peach Blossoms and Skylark, Wisteria and Swallow, Hawk on a Snow-covered Tree,* and *Crows on a Moonlight Night.* His work, which is very decorative and at the same time quite realistic in depicting actual natural forms, enjoyed great popularity, especially among foreign collectors, and is often found in Western museums and illustrated in Western books devoted to Japanese prints.

The printmaker who best exemplifies the feeling of the Taishō era is an artist who stands outside this new-print movement: Takehisa Yumeji. A native of Okayama, where he was born in 1884, he came to Tokyo in 1901 and briefly attended Waseda University. He then dropped out of school to become an illustrator and studied commercial art in the United States and in Europe. He worked in oils, watercolors, and book and magazine illustration, but he is today most admired for his prints, which enjoy a great vogue with present-day Japanese collectors who have a nostalgia for the Taishō era. Unlike Goyō and Shinsui, who were looking to ukiyo-e as their model and employed professional artisans to cut and print their work, Yumeji based his work on Gauguin and art nouveau, did his own engraving, and printed the designs himself. His style, highly original and quite unlike anything else found in the work of Japanese printmakers, combines expressionistic distortion of form with bright colors. Especially striking are his close-up portraits, with their pale faces and elongated forms, and scenes from contemporary life in which the tension and anxiety of this time

74. *Ohara Shōson:* Heron in Rain. *About 1935. Japan Gallery*, New York.

of rapid change are vividly reflected (Plate 75). He died in 1934 at the age of fifty and thus did not live much beyond the end of the Taishō age. Today he is looked upon by Japanese critics and art collectors as the very essence of Taishō sensibility.

While all these artists were continuing the older Japanese tradition, there was another group of artists during this period who were the pioneers of a very different school of printmaking, a school that was to prove the dominant one in the subsequent Shōwa era. These were the artists who established the creative-print, or *sōsaku-hanga*, movement. Influenced by European ideals and practice, they looked to

75. *Takehisa Yumeji:* Green Liquor. *Dated 1940. Munsterberg Collection, New Paltz, New York.*

modern Western artists for inspiration and admired men such as Edvard Munch, Toulouse-Lautrec, Bonnard, Vuillard, Kandinsky, and the German expressionists rather than the printmakers of the ukiyo-e school. They also insisted on cutting their own blocks and doing their own printing. Furthermore, they experimented with Western techniques like lithography and etching in addition to woodblock printing. In 1918, the seventh year of Taishō, they formed the Japan Creative Print Association, or Nippon Sōsaku Hanga Kyōkai, and in 1919 staged its first woodblock-print show at the Mitsukoshi Department Store in Tokyo.

Among the founders of this movement the most prominent were Yamamoto Kanae, Tobari Kogan, and, above all, the somewhat younger Onchi Kōshirō. Yamamoto, who was born in 1882, had lived in Paris from 1912 to 1916 and had made his first creative print as early as 1904. After a very promising beginning, during which he made prints under the influence of European artists like Gauguin, he turned to other pursuits. Kogan, who was born in the same year and died in 1927, had spent some time in New York during the opening years of the twentieth century. On returning to Japan in 1906 he had taken up sculpture under the influence of the well-known Western-style artist Ogiwara Morie, who worked in the style of Rodin. He was also active as an illustrator and woodcut artist and had twelve of his works in the Mitsukoshi show. His prints, in their realism, reflect the influence of Western art but also have a strong sense of pattern and decorative design. In 1922 he published a book on creative prints and the technique of making them.

By far the most original and influential of these early creative-print artists was Onchi Kōshirō, who for many years until the time of his death in 1955 was the head of the movement. Born in Tokyo in 1891, he came from an aristocratic family and received his early art training under the auspices of the Imperial Household. In 1911 he entered the Tokyo School of Fine Arts, where he studied oil painting. It was not long, however, before he turned to woodblock printing and became a fervent advocate of the new creative-print movement, rejecting the traditional ukiyo-e print entirely. He was also a pioneer in introducing abstract art into Japan. As early as 1914 he wrote: "Abstract art is now as it should be, the main way of art, and I hope that our civilization soon comes to realize this." As a printmaker, book designer, and writer, he played a prominent role in the modern-print movement and

in 1914 founded the art magazine *Tsukubae,* in which abstract prints were reproduced for the first time.

A very original and poetic artist, he worked in both a representational and an abstract style. Among his masterpieces in the former manner are the portrait cf his friend the poet Hagiwara Sakutarō and the sensitive portrayal of his daughter Mioko, which recalls Bonnard at his best. More significant, however, in terms of the development of modern Japanese art are his abstract prints with titles like *Lyric Number 1* or *Impression of Musical Works,* which recall Kandinsky's pioneering works in a similar vein. Yet Onchi brings to these prints a delicacy and a sensibility that are truly Japanese. At his best he is probably the greatest modern print artist Japan has produced, and his position as the leader of the creative-print school is undisputed.

19 The Contemporary Japanese Print

THE DEATH of the Taishō emperor in 1926 marked the beginning of the Shōwa era, during which the creative print became the dominant type of graphic art. This artistic form, which had been pioneered by such men as Yamamoto, Kogan, and Onchi and by the Sōsaku Hanga Kyōkai, now became firmly established as the leading school of woodblock printing, replacing ukiyo-e and the new print of the Taishō era. The struggle for recognition of the print as a major independent type of artistic expression equal to painting and sculpture now bore fruit when the Imperial Government Exhibition of 1927 accepted prints for inclusion in its show along with painting. In 1931 a new organization of over one hundred members, including all types of graphic artists, was formed, calling itself the Nihon Hanga Kyōkai, or Japan Print Association. Although woodblock prints continued to be the preferred medium, all the graphic arts, including lithography, etching, engraving, and stencils, were now to be seen in the print shows, and in 1935 the Tokyo Academy of Fine Arts for the first time established a department of printing. As a result of all this the work of the creative printmakers gradually became better known, and exhibitions of prints were held at museums, galleries, and department stores throughout Japan. Art magazines and art critics began to discuss modern prints, and scholars of Japanese prints began to take cognizance of the new art form. The first to do so was Dr. Shizuya Fujikake, a noted ukiyo-e scholar, who befriended and patronized the leading members of the Sōsaku Hanga Kyōkai and discussed their work in his writings.

It was not until the postwar period, however, that this school of

76. Hiratsuka Un'ichi: Garden at Isui-en. *About 1940. Museum of Fine Arts, Boston.*

printmaking achieved broad recognition in Japan itself and in the outside world. As Maekawa Sempan, one of the outstanding artists of this group, put it: "It wasn't until the Americans came that creative prints really caught on." Two Americans who had come to Japan as soldiers but stayed on as civilians played a prominent role in this development. They were William Hartnett, who was the first to form an extensive collection of modern prints, and Oliver Statler, who not only bought the works of contemporary Japanese printmakers but also was the author of what was to become the standard book in this field, *Modern Japanese Prints: An Art Reborn,* which was first published in 1956 and has gone through many printings since that time.

Since there were no fewer than three hundred woodcut artists associated with the modern creative-print movement by 1955, it would obviously be impossible to list all of them or to make an attempt to discuss more than a fraction of their work. In contrast with the ukiyo-e

printmakers, who had been based almost entirely in Edo, the new printmakers came from all over Japan. Of the major figures only Onchi was a native of Tokyo, while Hiratsuka came from Shimane, Maekawa from Kyoto, Kawanishi from Kobe, Kawakami from Yokohama, Yoshida Masaji from Wakayama, Saitō from Fukushima, and Munakata from Aomori. Representing a great diversity of backgrounds and artistic styles, they were nevertheless united in their belief in the print as a major form of artistic expression that did not just serve to duplicate painted design but was a new and vital art form. They also admired modern Western printmakers like Gauguin, Munch, and Kandinsky rather than traditional Japanese prints.

Two woodblock artists who along with Onchi had been among the pioneers of the modern-print movement were Hiratsuka Un'ichi and Maekawa Sempan. The former was born in 1895 in Matsue, the town made famous by Lafcadio Hearn. As a very young man he had come under the influence of the oil painter Ishii Hakutei, with whom he had studied first in his native town and then in Tokyo. But he soon turned to woodblock printing and as early as 1916 showed two prints depicting scenes from his home prefecture, Shimane, at the annual exhibition of the Nikakai, one of the avant-garde art associations of Japan. From this time on, he has been active as a printmaker. Since 1931 he has served as head of the print section of Kokugakai Art Association and since 1935 as professor of woodblock engraving at the Tokyo Academy of Fine Arts. He was also active as spokesman for the new-print movement, writing a book on the technique of woodblock printing and another on the appreciation of prints.

Unlike Onchi, whose inspiration came largely from Western art, Hiratsuka was inspired by traditional Japanese prints, not so much by the sophisticated and highly refined works of the ukiyo-e school as by the Buddhist prints of the medieval period. Drawn in a simple, bold style and printed in black and white, his prints have an honesty and a strength that are striking (Plate 76). His subjects are usually landscapes and artistic or historic monuments such as the Hōryū-ji temple, a picturesque pagoda (Plate 77), an old Shinto shrine, or the stone Buddha images at Usuki. His output is large and of a very even quality. It is characteristic of him that he vowed to make as many as ten thousand copies of a print of the famous Buddhist priest Nichiren as a religious act.

Slightly older than his friends Hiratsuka and Onchi was Maekawa,

77. *Hiratsuka Un'ichi :* Three-Story Pagoda. *About 1950. Munsterberg Collection, New Paltz, New York.*

who was born in Kyoto in 1888 and died in Tokyo in 1960. Trained at the Kansai Bijutsu-in, he first studied oil painting. In his early years he worked primarily as a caricaturist and graphic artist but also made prints and was an active member of the Nippon Sōsaku Hanga Kyōkai. Unlike those of Hiratsuka, his prints are largely in color and reflect his background as an illustrator. He was particularly interested in depicting scenes from traditional Japanese life—folk festivals, popular dances, country inns, and hot springs—and he rendered these with nostalgia and affection. While he was neither such a great innovator as Onchi nor as powerful an artist as Hiratsuka, his prints have a quiet charm and subtle beauty reflecting his Kyoto upbringing.

Another early modern-print artist from the Kansai area was Kawanishi Hide, who was born in Kobe in 1894 and died there in 1965. Originally trained in commercial art, he turned to printmaking after seeing a woodcut by Yamamoto in an Osaka shop. His work is marked by its gay, vibrant colors and decorative appeal (Plate 78). He was particularly fond of using brilliant reds, yellows, and blues, thereby creating beautiful combinations of the primary colors. Growing up

78. *Kawanishi Hide:* Kobe Harbor. *About 1940. Museum of Fine Arts, Boston.*

79. *Kawakami Sumio:* Arrival of Portuguese in Japan. *About 1950. Munsterberg Collection, New Paltz, New York.*

in the port city of Kobe, he was greatly interested in foreign people and things, especially the German Hagenbeck circus, with its exotic animals and acrobats. Of particular interest is his series *One Hundred Views of Kobe,* in which he pictures well-known landmarks of the city, among them many that were destroyed in World War II. His output was large, comprising close to one thousand prints, and is of a very high quality. He, too, throughout his long career, was an active member of the Japan Creative Print Association.

Sharing Kawanishi's interest in the ships and customs of the Westerners was Kawakami Sumio, who was born in Yokohama in 1895, the same year as Hiratsuka. Most of his life was spent in Utsunomiya, north of Tokyo, and he died there in 1972. As a young man he went to America, where he decided to become an artist. Upon his return he became an English teacher at the local high school in Utsunomiya. An early member of the Nihon Hanga Kyōkai (Japan Print Association) and a friend of Hiratsuka, he produced a large number of

woodcut prints and illustrated books in both black and white and color. His favorite themes were the exotic *nambanjin,* or "southern barbarians," as sixteenth-century Westerners in Japan were called, and especially foreign merchants and Westernized Japanese of the early Meiji era as they were encountered in the port city of Yokohama during the late nineteenth century. The emphasis in his work is always on representation and the narrative rather than abstract design (Plate 79).

Very different in style and emphasis are the two leading artists of a somewhat younger generation, Munakata Shikō and Saitō Kiyoshi, who were born in 1903 and 1907 respectively. In contrast with the print artists of the older generation, both of them were more oriented toward traditional Japanese values but combined these with a definite modern influence. Unlike most contemporary Japanese artists, who either work in a completely Western style or preserve a purely Japanese sensibility, Munakata and Saitō tried to fuse East and West and to create an art both modern and traditional at the same time. In the case of Munakata we find a joining of Buddhist icoongraphy with the manner of van Gogh and Renoir, while Saitō combines the spirit of Zen with Gauguin's and Mondrian's aesthetics.

Munakata, coming from a simple working-class background (his father was a blacksmith) and growing up in Aomori, the northernmost city in Honshu, reflected these humble beginnings in his life. He was a member of the folk-art movement and a great admirer of the traditional Buddhist prints of Japan, and, unlike the more sophisticated urban print artists, he remained close to the Japanese tradition. Having grown up during the Taishō era, he went to Tokyo as a young man and studied oil painting, even winning a prize for his work in this field. But working in what he perceived as a foreign medium left him dissatisfied, and when he encountered the work of Hiratsuka and Kawakami, he realized that woodblock printing was the best means of artistic expression for him. By 1935, at the age of thirty-two, he had become a junior member of the print section of the art association Kokugakai, and in the following year he exhibited a series of twenty prints mounted as a traditional horizontal Japanese scroll in the association's spring exhibition. This work, called *Yamatoshi Uruwashi,* or *Japan the Beautiful,* created great interest and established Munakata's reputation as a print artist. Yanagi Sōetsu, founder of the folk-art museum Mingeikan and guiding spirit of the *mingei,* or folk-art, move-

ment, saw it and bought it for the museum's collection. As a result of this patronage, Munakata became the first modern printmaker to be able to make a living on prints alone and also became a friend of the famous *mingei* potters Hamada and Kawai.

Having reached his artistic maturity and having developed a highly personal style, Munakata now embarked on one of the most brilliant and creative careers in modern Japanese art. His output was vast, comprising not only a huge number of woodblock prints but also many illustrated books, paintings, and highly personal calligraphy. Working rapidly and with tremendous fury, he produced woodcuts of a vigor and expressive power unlike those of any other contemporary Japanese artist (Plates 80, 81). Outstanding among his many masterpieces was the set of large vertical prints entitled *The Ten Disciples of the Buddha,* which he completed in 1939, just before the beginning of the war. Fortunately, in spite of the fact that his studio was completely destroyed in an air raid on Tokyo in 1945, the blocks for these prints survived, so that they could be reprinted after the war. Combining a bold pattern of black and white and iconography derived from Japanese folk prints and Central Asian wall paintings with a technique recalling the woodcuts of the German expressionists, the prints are altogether unique in their expressive power and emotional intensity (Plate 82).

With the end of the war and the discovery of modern prints by American collectors and critics, Munakata became both famous and successful. Interestingly enough, this recognition came first from abroad and only later in Japan itself. In 1951 he won the first prize at the Lugano, Switzerland, International Print Exhibition and in 1955 the Grand Prix at the Venice Biennale. It was only during the sixties that his achievement was properly appreciated in his native country, for it was not until 1963 that he was given the Medal of Honor and in 1970 the Order of Culture. In 1959 he was invited to visit the United States and spent some time in New York, where his work was shown with a considerable amount of success at the Willard Gallery and the Museum of Modern Art. He died at seventy-two in Tokyo in 1975.

Saitō Kiyoshi, like Munakata, was born in northern Japan and came to Tokyo as a young man of twenty-five. He, too, originally set out to be an oil painter and had his work included in several prominent modern-art shows, but he soon turned to woodblock printing, which

80. *Munakata Shikō:* Women. *About 1950. Munsterberg Collection, New Paltz,*
New York.

81. *Munakata Shikō:* The Willow Is Green, and the Plum Blos-
som Is Red. *Dated 1955. Private collection, New York.*

82. Munakata Shikō: Disciple of the Buddha. *Dated 1937. Private collection, New York.*

83. *Saitō Kiyoshi:* The Temple Engaku-ji in Kamakura. *Dated 1971. Private collection, New York.*

he found a more congenial form of artistic expression. It is not any of the traditional Japanese printmakers, however, but Redon, Munch, and Gauguin whom he lists as the artists who influenced his own work most and, it could be added, Mondrian and modern abstraction during his later period. He, like Munakata, attempts to combine this modern Western aesthetic influence with the Japanese tradition and succeeds in fusing these two strains into a new kind of artistic expression that is modern in form but traditional in subject matter and sensibility (Plate 83).

Among his early prints the most outstanding are those depicting scenes from his childhood in bold patterns of black and white and simple, strong forms. An example is his *Winter in Aizu,* dating from 1941. His most unique work, however, is seen in the prints of his maturity, made during the 1950s and 1960s and portraying such typically Japanese subjects as old temples, rock gardens, stone lanterns, *shōji* screens, *haniwa* figurines, and Buddhist statues. Reducing these subjects to simple and semiabstract designs and rendering them in flat color patterns, he achieved extremely beautiful decorative

THE CONTEMPORARY PRINT 175

effects. Like Munakata, he has won several international prizes, notably in São Paulo and Yugoslavia, and has had numerous shows both in Japan and abroad. His output has been large and has had an enthusiastic reception especially among American collectors.

Very different from these two artists, who tried to create an art that was distinctly Japanese in form and subject matter, were the makers of abstract prints, who saw themselves as part of the international modern-art movement. The towering figure among the artists working in this vein was Onchi Kōshirō. His artistic career began in the Taishō era, but his true importance for Japanese art was only realized during the postwar period. At that time a man in his fifties, Onchi became the leading spokesman for the creative-print movement and was widely hailed as a pioneer of abstract art. Working not only in the woodblock medium but also employing any material that struck his fancy, he used bits of string, glass, paper, feathers, leaves, and even at times rubber heels in creating highly original prints of great sensitivity and poetic beauty. While much of his earlier work had been representational in character, the prints of his later years were almost all abstract.

Outstanding among these prints are his lyrical evocations of various emotional states—for example, *Lyric Number 13: Melancholy of Japan, Loneliness, Poem Number 19: The Sea,* and *Poem Number 8: The Butterfly.* His most powerful works, however, are the prints made at the very end of his life, when death was already imminent. These include the beautiful abstraction *My Own Dead Face,* of 1954 (Plate 84). Printed in subdued blacks, grays, and whites, with free-flowing abstract shapes, these works have a suggestive power that is aesthetically and emotionally very moving, and, in spite of the fact that Onchi himself always emphasized his affinity with modern Western art, also have a profoundly Japanese sensibility. Onchi died at sixty-four in 1955. His prints are today very rare and much sought after, since he printed very small editions, often not numbering more than a few copies.

Among the many younger artists who came under the influence of Onchi and worked in the abstract idiom, by far the most sensitive was Yoshida Masaji, who was born in 1917, a full generation after Onchi, and died in 1971 at the age of fifty-four. A graduate of the Tokyo Academy of Fine Arts, he studied oil painting under the well-known Western-style painter Fujishima and woodblock printing under Hiratsuka. But he was most influenced by Onchi, under whose

84. Onchi Kōshirō: My Own Dead Face. *Dated 1954.*
Onchi Collection, Tokyo.

inspiration he turned to abstract art. His best work was done during
the fifties, when he developed a highly original style. Using blacks and
grays and closely spaced parallel lines, he achieved subtle and muted
effects. The very titles of his prints, such as *Silence* and *A Day of Pathos,*
suggest the feeling of melancholy he wished to express. His shapes are
abstract but have a vague suggestion of natural forms, and they show
depth of feeling unlike the purely decorative quality found in so many
other abstract prints.

While Yoshida Masaji is probably the most powerful of the younger
generation of abstract woodblock artists, he is merely one of a large
number of printmakers who work in this area. Since there are literally
hundreds of such artists at work, and new ones are constantly making
their appearance, it is not easy to select among them. Selection is also
difficult because many of them have produced only a few fine works

85. Oda Kazumaro: Matsue Bridge. Dated 1924. Museum of Fine Arts, Boston.

among many less distinguished ones. Their general tendency is toward the decorative and formally pleasing, but they lack the inventiveness and poetic quality of Onchi and the depth of feeling of Yoshida. If among the hundreds of artists now active, certain individuals of outstanding stature will emerge, only time will tell.

The graphic media other than woodcuts have never played a very important role in Japan. Although artists such as Shiba Kōkan had experimented with copperplate engraving as early as the late eighteenth century, lithography and etching were introduced only in ·modern times. The outstanding lithographer was Oda Kazumaro, who lived from 1882 to 1956. A contemporary of Onchi and Maekawa, Oda was also active in the creative-print movement and was one of the founders of the Nippon Sōsaku Hanga Kyōkai. A native of Tokyo, he studied Western-style oil painting under Kawamura Kiyo-o, but his

most important work was done in the form of color lithographs depicting picturesque Japanese scenes in a completely Western style not unlike that of Yoshida Hiroshi (Plate 85). In addition to his lithographs he made woodcuts and published two books on ukiyo-e prints. While several other artists attempted working in this medium, it never caught on in Japan and has not played a significant role in the artistic life of the country.

Etching, on the other hand, is beginning to assume a more prominent place, for two leading Japanese printmakers of the younger generation are working in this medium. They are Tanaka Ryōhei and Ikeda Mutsuo. The former was born in Kyoto in 1933 and works in a detailed realistic style, picturing scenes from the rural life of contemporary Japan. A consummate and meticulous draftsman, he uses a very fine line to render the visual reality with precision. His work has enjoyed great popularity with the public, especially foreign collectors.

A very different artist, born two years later, in 1935, is Ikeda, who also employs etching and, in his more recent work, dry point. A native of Nagano, he studied in Tokyo and has worked both there and in the United States. Having grown up in the postwar period, he is very much a citizen of the world, more at home with the international modern-art movement than with the Japanese tradition. The great influence on his art was surrealism and the work of such painters as Klee, Miró, and Dubuffet. A sensitive and highly imaginative artist, he has created strikingly original images springing out of a fantasy world quite different from the accurately depicted real world found in the work of Tanaka. At a youthful age he achieved international recognition at the Venice Biennale in 1966 and with a one-man show at the Museum of Modern Art in New York, an honor bestowed on very few Japanese artists.

An artistic medium that has been used in Japan since ancient times and has recently experienced a revival in printmaking is that of the stencil. Traditionally the technique has served for textile design, but present-day printmakers, especially those associated with the folk-art movement, have also employed it for graphic works on paper. Outstanding among them is Mori Yoshitoshi, who was born in Tokyo in 1898. A member of the older generation of modern artists, he studied at the Kawabata Art School and began his career as a painter in Japanese style. In 1955, however, he turned to making stencil prints in a folk-art style and, along with such artists as Munakata,

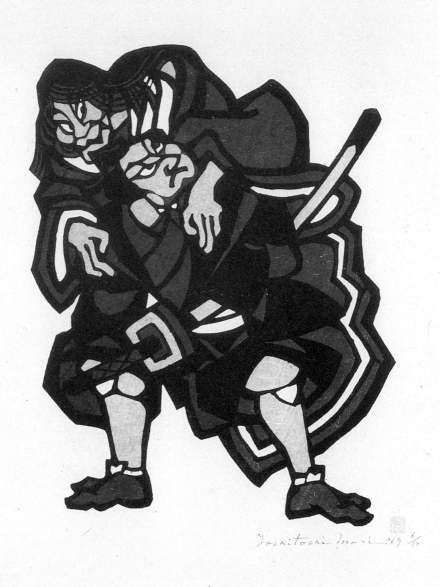

86. *Mori Yoshitoshi:* Ōmori Hikoshichi and Female Demon. *Dated 1969. Ronin Gallery, New York.*

became a leading member of the Nippon Hanga-in. His prints are simple and strong, with black, brown, and gray predominating. The subjects are usually taken from rural Japan, showing craftsmen at work or traditional dancers and actors. At his best, Mori is a powerful artist whose work reflects the older, simpler tradition of his youth (Plate 86).

20 The Collecting and Care of Japanese Prints

EVER SINCE Japanese woodblock prints first reached the Western world, they have been eagerly collected by both Europeans and Americans. During the nineteenth century, when high-quality prints were readily available and could be had in Japan for a pittance, great collections were formed, especially in France, Germany, England, and the United States. Instrumental in bringing these prints to the West were the two Japanese dealers Hayashi and Wakai, who bought up all the available ones in their country, where they were not appreciated, and brought them to Paris, where they were much in demand. Prints bearing the seals of these two dealers are still highly regarded and much sought after.

Among the many collectors who were active in the late nineteenth and early twentieth centuries were the Goncourt brothers, Gonse, Haviland, Bing, Vignier, Koechlin, and, above all, Vever in France; Straus-Negbaur, Jäckel, and Mosle in Germany; and Morrison in England. There were also numerous fine collections in the United States, among which those of Fenollosa, Frank Lloyd Wright, Ficke, Chandler, Spaulding, Gookin, Happer, Ainsworth, Mansfield, and especially Ledoux, whose collection was probably the choicest ever assembled, were outstanding. It has often been said that it is impossible to form such remarkable collections today, and it is no doubt true that good prints are far rarer and more expensive than they were a hundred years ago. Still, James Michener in America and Theodor Scheiwe in Münster, West Germany, have demonstrated that really fine groups of ukiyo-e can still be purchased. And others such as Tamba in Yokohama and Statler in Chicago indicate that in special fields—for example,

Yokohama prints and modern prints—worthwhile collections can be formed.

The appeal of Japanese prints is manifold, and they lend themselves particularly well to study and collecting. A tremendous number of prints were produced during a period close enough to our own that many of them survive and come on the market. Dealers, auction houses, and bookstores handle them, and the collector is never at a loss to find new material. It comes in all price ranges, offering something for every type of collector. Those who can afford it may spend tens of thousands of dollars for particularly choice or rare prints, and the impecunious lover of ukiyo-e can find more common prints and pages from illustrated books for as little as fifty or a hundred dollars. Furthermore, the interest of a collection and the pleasure it gives its owner stand in no relationship to its monetary value, and many a modest collector has formed a worthwhile collection without a great expenditure of money.

Traditional ukiyo-e prints also offer a great deal of variety in spite of the fact that virtually all of them were made in Edo between 1680 and 1880. For those interested in the life of the Yoshiwara there is plenty of material available, as it is for those whose primary interest is the Kabuki theater. For others there are the landscape prints depicting the beauty of Japan, and there are the genre scenes recording the life of the times. Yet others may be fascinated by the erotica of the *shunga* type or specialize in *surimono,* printed albums, or illustrated books. Some collectors concentrate on the work of one particular artist or school that appeals to their fancy. Among them are those who have brought together a large number of Hiroshiges or Kunisadas or of wrestler or Kabuki prints. There is truly something for everyone, be the chief fascination with ukiyo-e purely aesthetic, historical, ethnographic, or literary.

What is to be avoided at all costs is simply to accumulate a large number of inferior prints because they are cheap. No collection worth possessing is ever formed that way. As Arthur Ficke said years ago, "Poor copies are worth nothing, but choice ones are never really dear at any price." The best policy is always to get the very best prints available at a price you can afford. A collection is only as good as the quality of the prints it contains, and quality is always preferable to mere quantity. Louis Ledoux limited his collection to two hundred and fifty prints, forcing himself to dispose of an inferior example every

time he added yet another choice print to his collection. In fact a collection is often improved both in aesthetic appeal and in value merely by getting rid of second-rate works that lower the artistic level of the entire collection.

Just what to buy and how to go about acquiring it is very much a question of the temperament, knowledge, opportunities, and financial resources of the collector. If the potential buyer knows little about the field, it might be best to start with buying from one reputable dealer whom he trusts and who guarantees the work sold. Even the most established auction house may not always prove reliable, and there are many small dealers who sell copies, reprints, and fakes either out of ignorance or to make an unfair profit. Many collectors try to acquire a representative collection including one or two works of all the major periods, schools, and artists, but others may prefer to concentrate on some particular field of prints and become knowledgeable in dealing with prints from the particular genre they are interested in. In either case it is important to know what you are doing. It is advisable to visit museums and exhibitions in order to become acquainted with the best work of the artists you are specializing in and to compare prints you are interested in or have acquired with other copies in public collections. There is also a vast literature on ukiyo-e consisting of general surveys, publications on specific collections, exhibition catalogues, and studies of individual artists, all of which are invaluable to the serious collector.

Prices of Japanese prints have varied depending on the economy, the supply of prints, and the fashions. While it is generally true that the value of really fine prints has increased over the years, Japanese prints, like all other objects of art, have known periods when they were much in demand and fetched very high prices and others when they seemed less fashionable. A marked increase in prices paid and in the number of collectors has occurred in the last decade or two, while during the thirties, probably because of the political conditions, Japanese prints were less popular. There has also been a noticeable fluctuation in the interest in the work of individual artists or types of prints. For example, Kuniyoshi, who in the past was not very highly regarded and whose work brought only modest prices, has been accepted as a major figure and is much more expensive today, and Yoshitoshi, who even ten years ago was hardly known to most collectors and not in demand, is today one of the most sought after of

printmakers. The same is true of whole categories of prints such as Yokohama-e, Taishō prints, and *sōsaku hanga,* which were not widely collected until recent years and now fetch prices comparable to those of all but the greatest masters of the traditional ukiyo-e prints of the Edo period.

In spite of the fact that there is an active international print market, the value of an individual print and the fair price for it are difficult to judge. It is not at all uncommon to find that the several versions of the very same print appearing at an auction may bring very different prices. Nor is it at all inconceivable that two genuine Hiroshige prints of the same subject may bring such disparate prices as five hundred dollars for one and fifty thousand dollars for the other, if one is a late printing in a poor state and the other is an early printing in mint condition. There are many factors that enter into what price a given print brings or what it should cost. The aesthetic appeal, of course, enters in, for prints that have beautiful designs and appealing subjects are always more in demand than those of merely historical interest. But this is by no means the only consideration. The fact that a print was in a famous collection may have an appeal for some collectors, the fact that it carries the signature of a famous artist rather than merely being attributed to him, the rarity of the print—all these things are of importance in determining how much a collector might have to pay.

The novice is likely to be unduly influenced by the name of the artist, but this is wrong. Artists like Hiroshige and Kunisada had huge editions, and poor late prints by them are worth very little, while an anonymous print by an early artist might be far more desirable. In every case the condition of the print is of uppermost importance. Even works by the very greatest masters, such as Harunobu, Kiyonaga, and Utamaro, are of little value if they are darkened and faded, as often happened when they were mounted on screens in Japanese homes or handled carelessly by Western collectors who exposed them to brilliant light and did not protect them from dust and soot. While some connoisseurs may prefer slightly faded colors to more vibrant ones, by and large the most relevant considerations in determining the desirability and value of the print are its condition, the sharpness of impression, and the beauty of the colors. These are the most important criteria in judging the quality and value of a specific print. Often considerations that might not be apparent to the uninformed person, such as the print's belonging to a famous series, being of an early or

later edition, or being extremely rare, may well influence the price.

Another question that is very difficult to find agreement on is how much the desirability and value of a print should be influenced by the condition of the work. Japanese and American collectors tend to place great emphasis on the print's being perfect, while Europeans are more willing to buy a print even if it has been torn and repaired, the border has been trimmed, the color has faded, or some other imperfection is found. Often at auctions two almost identical prints may bring very different prices because one has some fairly innocuous damage to it. The same may occur if it is known that a given print belongs to a diptych or a triptych of which the other parts have been lost. The opposite may be the case in which a print belonging to a set that a collector wishes to complete or to a triptych of which he has the other two may suddenly jump to a price high above what the auction house had estimated. In short, many considerations not readily apparent to the novice may influence the price of a specific work.

All of this is of course assuming that the print is genuine, and genuineness presents a problem in itself. Usually, reputable auction houses and established dealers sell only originals, but there can be no doubt that even they may make mistakes and that the number of copies is legion. By and large, Japanese prints may be divided into four fairly distinct categories: originals made under the artist's supervision or at least in his lifetime; late impressions, often made very carelessly from worn-out blocks, sometimes even after the death of the artist who produced the original design; reprints; and modern replicas. Outright fakes are relatively rare in ukiyo-e prints and would be made primarily of very valuable, rare early prints that bring very high prices. The difference between the first and second categories is fairly clear and can be determined by comparing various states and versions of a single print. While it is generally felt that the first impression of a print is the most desirable, actually, since the quality of a print depends very much on the skill of the engraver and the printer, it is quite conceivable that the second or third impression is better than the first. In any case our knowledge of Japanese prints has not reached the stage where these distinctions can be determined with certainty. It is also true, of course, that the difference between categories one and two is not clearly defined. In any case even the late versions of a print are originals rather than copies.

A far more complicated problem, both in terms of their standing

and their value, is that of the reprints. During the Meiji era, especially between 1865 and 1880, when Japanese prints were in great demand in Europe, reprints of works by the famous masters were made in Japan by the very same methods employed by the original publishers. Some of them are of very good quality, and all of them have a certain commercial value on today's market, but they are not considered originals and are never the equal of prints made during the Edo period. What gives them away is first and foremost the paper and the color, both of which are quite inferior to those used by the old printers. It is of course at least theoretically possible that some skillful modern forger has used the old paper and good natural pigments made from mineral and vegetable colors and, by a photographic process, has copied the design so accurately that the replica is almost indistinguishable from the original. There are, in fact, a few celebrated examples on which experts have not been able to agree, but all of this would be very difficult and expensive to do, and highly skilled craftsmen are rare today. It is therefore unlikely that many such works exist. Furthermore, since the outstanding prints are usually well known, it would be difficult to introduce suddenly a whole group of previously unknown masterpieces without arousing suspicion.

In determining the authenticity of a print, the first thing to look at is the quality of the paper. Genuine old paper is softer and more mellow. It absorbed the colors, so that when you turn the print around and hold it against the light, the color should not only be on the surface but also have penetrated the paper itself, with the result that the entire design can be seen. If the color appears from the back to consist merely of blotches, this is a poor sign. The reason is that modern machine-made paper is stiffer, smoother, and less absorbent. The colors, too, are very different. The old natural pigments have a subtle and clear quality and a soft glow that modern aniline dyes do not have. The latter are often gaudy or have a flat, dead quality never found in the older prints. Of course all of this would apply primarily to the prints made prior to the introduction of European pigments, which occurred in Hiroshige's lifetime and led to their common use during the Meiji era. But since the later prints have not been copied or faked, the whole problem is less vexing to collectors in this field.

Finally there is one other type of print that falls into an entirely different category—namely, the modern facsimile. It is not a reproduction meant to deceive but a frankly made copy of a famous masterpiece

of which originals are extremely rare. Prints like these are often made with great care through the use of processes employed by the original publishers, but they have inscriptions clearly indicating that they are present-day replicas. (Publishers like Adachi and Watanabe have excelled in this type of work.) While such prints are not acceptable to serious collectors, someone who buys a print merely as a wall decoration for a place where it will be exposed to sunlight, or perhaps a lecturer who wishes to show his audience what ukiyo-e prints look like, will find them desirable.

In caring for Japanese prints several principles should always be kept in mind in order to ensure that the works you own will survive under optimum conditions. Only too often rare and beautiful prints have been damaged by careless handling and neglect. Folded, trimmed, and mutilated prints are not at all uncommon, and it is said that prints in mint condition were sometimes aged with tea to make them look older. Even more common is fading by exposure to bright sunlight and damage by gluing a print to cardboard or cheap paper. Other common sources of decay are exposure of the prints to dampness or washing them in acid baths without proper professional supervision. Thousands of otherwise splendid impressions have been needlessly ruined by such practices, and the collector is warned to be aware of this in order to protect his own possessions and preserve these masterpieces of Japanese art for future generations.

When handling Japanese prints, the following precautions must always be taken. Never hold a print so that your finger tips grip the surface, and never let moisture of any kind touch it. Do not fold any print even if it is so large that it does not fit into your portfolio or storage cabinet. Never glue a print to a cardboard backing but use a bit of paste or filmoplast. Prints should be placed in a mat or folder made of acid-free paper and must always be stored in a cool, dry place. If you frame them for display, be sure that they are not exposed to direct sunlight, for this will cause the colors to fade. If possible, instead of ordinary glass use UF3 plexiglass, since it filters out the ultraviolet light.

The restoration and repair of prints requires the utmost caution. Older books sometimes advise the collector to bleach darkened prints, restore faded colors, and repair holes and tears. While all this can be done and, in the case of rare, valuable prints, may indeed be advisable, it should never be attempted without the advice and

help of a person who specializes in treating works on paper. In case of doubt, the best thing is to do nothing, for even the most skillful treatment will almost invariably change the look and feel of a print, and even subtle alterations in the color pattern or texture may seriously damage the picture. In the case of a print that is particularly beautiful and valuable, be sure to have the work done entirely by an expert. Unfortunately, there are only a few such people available outside Japan, most of them attached to major museums. Above all, remember that the prints you own have been passed on to you by earlier generations of collectors and art lovers. You, in turn, should hand them on to future generations in good condition, and you must do for later owners what your predecessors have done for you.

For the American collector of ukiyo-e, the following information might be of interest. The Ukiyo-e Society of America, with its headquarters located at 1692 Second Avenue, New York, New York 10028, offers monthly lectures on various subjects related to ukiyo-e. Sotheby's and Christie's, both in New York and in London, have several auctions of Japanese prints each year. For those who prefer to deal with private galleries, there are three in New York that specialize in ukiyo-e. The largest is the Ronin Gallery, at 605 Madison Avenue. It stages major shows and issues very scholarly catalogues. The others are the Japan Gallery, at 1210 Lexington Avenue, and the Tsuru Gallery, at 29 East Sixty-first Street. There are also several galleries of Japanese prints in England, France, and Germany. Of Japanese dealers, Matsushita, Watanabe, and Yōseidō are to be recommended. The first of these maintains a branch in New York. Watanabe is outstanding for having published and sold the works of leading printmakers of the Taishō and early Shōwa eras, and Yōseidō is a leading dealer for contemporary Japanese prints.

For collectors who wish to have their prints authenticated, both museum curators of Oriental art and dealers in the field would usually be willing to do so. If repair and cleaning of a print are called for, the best and most reliable places to go are the Museum of Fine Arts, in Boston; the Metropolitan Museum of Art, in New York; and the Freer Gallery of Art, in Washington, D.C., all of which employ highly skilled Japanese restorers who do an excellent job. But since this type of service is rather expensive, it is worthwhile only for very fine prints.

Glossary

benizuri-e: early prints in which *beni,* or pink, is the dominant color, often in combination with green

bijinga: prints depicting beautiful women

chūban: medium-sized prints averaging 26 by 19 centimeters

Chūshingura: famous Kabuki play relating the story of the forty-seven *rōnin,* often pictured in ukiyo-e prints

courtesan: term usually employed in English ukiyo-e literature when referring to prostitutes of the Edo period

e: suffix meaning picture or painting, as in the terms ukiyo-e and *yamato-e*

Edo: old name for Tokyo and for the period between 1603 and 1868

egoyomi: calendar prints, usually in *surimono* format

ehon: picture books, often illustrated with prints

geisha: literally, "accomplished person"; entertainers who dance, play music, sing, and converse with guests at a formal party

Genroku: the Edo-period era between 1688 and 1704, noted for grandeur and sumptuous display

gō: art name of a painter or a print designer

green houses: Edo-period term for houses of prostitution

hanga: woodblock print; also a term employed for modern creative prints of the Shōwa era

hashira-e: literally, "pillar print"; a narrow vertical print averaging 67 by 13 centimeters

hosoban: a print of narrow format averaging 30 by 15 centimeters

Kabuki: the traditional popular theater of Japan

kachō-e: see *kachōga*

kachōga: prints depicting birds and flowers

kakemono-e: print similar in format and size to a hanging scroll

Kamigata: district in which Kyoto and Osaka are located

kamuro: young apprentice courtesan often shown in ukiyo-e

Kanō school: traditional school of Japanese painting specializing in Chinese-style ink painting

kentō: guide marks used in printmaking to assure accurate register

Kōrin school: Edo-period school of Japanese painting emphasizing decorative effects

Meiji: era of modern Japanese history between 1868 and 1912, during which Japan was opened to the West

Nagasaki: port city in Kyushu through which European civilization reached Japan during the Edo period

nishiki-e: literally, "brocade picture"; polychrome print

ōban: literally, "large print"; standard-size print averaging 58 by 32 centimeters

oiran: high-class courtesan of the Edo period

ōkubi-e: literally, "large-head pictures"; close-up portraits emphasizing the head

onnagata: male actor specializing in female roles in Kabuki

pillar print: see *hashira-e*

pillow print: print depicting intimate sex life

Shijō school: school of realistic painting popular in Kyoto during the later Edo period

Shōwa: present era of Japanese history, which began in 1926 when Emperor Hirohito ascended the throne

shunga: literally, "spring pictures"; erotic prints

sumizuri-e: prints done entirely in black and white without addition of color

sumo: Japanese wrestling (in Japanese, *sumō*)

surimono: small-sized prints intended for use as greeting cards, calendars, and mementos of special occasions

Taishō: era of modern Japanese history between 1912 and 1926, during which the modern Japanese print came into being

tan-e: print in which bright red is dominant

Tōkaidō: highway between Edo, the seat of the Tokugawa shoguns, and Kyoto, the imperial capital

Torii school: school of printmakers specializing in prints of Kabuki actors and scenes

Tosa school: school of traditional Japanese painting seen as forerunner of ukiyo-e

uki-e: perspective print

ukiyo-e: literally, "pictures of the floating world"; paintings and prints dealing largely with the world of pleasure

urushi-e: lacquer prints decorated with metallic dust

yamato-e: traditional narrative-scroll painting

Yokohama: port city near Tokyo through which Western commerce and culture reached Japan during the Meiji era (1868–1912)

Yoshiwara: Edo amusement and brothel district and scene of many of the subjects depicted in ukiyo-e

Selected Bibliography

NOTE: This bibliography is intended primarily for the English-speaking reader, although titles in several other languages are included. For more complete listings see M. Narazaki: *The Japanese Print* and R. Lane: *Images of the Floating World*.

GENERAL HISTORIES

Binyon, L., and Sexton, J. J. O'Brien: *Japanese Colour Prints*, London, 1923; second edition, revised by B. Gray, London, 1960.

An excellent and very scholarly book with a wealth of information on the history of ukiyo-e. Although somewhat outdated, invaluable for its chronological tables and its charts of artists' signatures, actors' crests, and publishers' and censors' seals.

Ficke, A. D.: *Chats on Japanese Prints*, London and New York, 1915; enlarged Japanese edition, Tokyo, 1919.

A charming and poetic book by one of the early collectors and connoisseurs of Japanese prints. No longer useful for factual information but enjoyable as an appreciation of ukiyo-e.

Fujikake, S.: *Japanese Wood-Block Prints*, Tokyo, 1938; revised edition, 1957.

A concise survey of Japanese prints by a leading Japanese scholar. Brief treatment of ukiyo-e but good for Taishō and Shōwa eras.

————: *Ukiyo-e no Kenkyū* (The Study of Ukiyo-e), 3 vols., Tokyo, 1943.

A standard scholarly work by the dean of Japanese ukiyo-e scholars, with 516 plates and text in Japanese.

Kurth, J.: *Die Geschichte des japanischen Holzschnittes,* 3 vols., Leipzig, 1925–29.

The most extensive and ambitious attempt at giving a complete history of ukiyo-e in a Western language, by the leading German scholar of Japanese prints. Outdated in much of its factual material but still an impressive monument to German scholarship.

Lane, R.: *Images from the Floating World: The Japanese Print,* New York, 1978; also in French and German editions.

This magnificent volume is by far the best book on ukiyo-e published by any Western scholar. It combines a historical account of the Japanese print with a dictionary of ukiyo-e and has many excellent reproductions both in color and in black and white. Dr. Lane's scholarship is always accurate and highly informative. If the student of Japanese prints wants to acquire just one book on the subject, this would be the one to buy.

————: *Masters of the Japanese Print,* London, 1962; also in Dutch, French, German, Italian, and Spanish editions.

By far the best brief history of ukiyo-e, with special emphasis on the painting of the ukiyo-e school in addition to prints.

Michener, J. A.: *The Floating World,* New York, 1954.

A delightful but somewhat chatty book by the well-known novelist, who is also a scholar and an avid collector of Japanese prints. Text is excellent, but quality of plates is disappointing.

Narazaki, M.: *The Japanese Print: Its Evolution and Essence* (English adaptation by C. H. Mitchell), Tokyo and New York, 1966.

A beautiful volume with large and excellent color reproductions of outstanding prints. The informative text is by one of Japan's leading ukiyo-e scholars.

Seidlitz, W. von: *Geschichte des japanischen Holzschnittes,* Dresden, 1897; reprinted several times, most recently in 1928; also in English and French editions.

An early general history of Japanese prints by a German pioneer in ukiyo-e studies. Although outdated, still interesting and useful.

Takahashi, S.: *Traditional Woodblock Prints of Japan,* Tokyo and New York, 1972.

This book, translated from the Japanese by Richard Stanley-Baker, is one volume in the Heibonsha Survey of Japanese Art. Written by one of the grand old men of ukiyo-e studies, it covers the subject well and is illustrated with a large number of black-and-white and color plates.

SPECIALIZED STUDIES OF CERTAIN TYPES OF PRINTS

Chibbett, D.: *The History of Japanese Printing and Book Illustration,* Tokyo and New York, 1977.

A scholarly and up-to-date work on Japanese illustrated books that replaces the old standard volume on this subject by L. N. Brown.

Evans, T. and M.: *Shunga: The Art of Love in Japan,* London, 1975.

The best and most complete work on this subject.

Hillier, J.: *The Japanese Print: A New Approach,* London, 1960.

A series of excellent essays dealing with some of the minor masters of ukiyo-e.

Hosono, M.: *Nagasaki Prints and Early Copperplates,* Tokyo and New York, 1978.

This is an English translation and adaptation (by Lloyd R. Craighill) of a volume in the Japanese Arts Library series by the leading expert in the field.

Ishida, M.: *Japanese Buddhist Prints,* New York, 1964.

The only book in English on this subject, it has many excellent plates and a scholarly text translated from the Japanese.

Kawakita, M.: *Contemporary Japanese Prints,* Tokyo, 1967.

A good survey of modern Japanese prints with numerous illustrations.

Keyes, R., and Mizushima, K.: *The Theatrical World of Osaka Prints,* Philadelphia, 1973.

Originally a catalogue for a show at the Philadelphia Museum of Art, this is the standard book on Osaka prints.

Meissner, K.: *Japanese Woodblock Prints in Miniature: The Genre of Surimono*, Rutland, Vermont and Tokyo, 1970.

A brief and not very complete study of this art form, although it supplies the basic information on *surimono*.

Robinson, B. W.: *Japanese Landscape Prints of the Nineteenth Century*, London, 1957.

An excellent and scholarly study of Japanese landscape prints by the noted curator at the Victoria and Albert Museum.

Schraubstadter, C.: *Care and Repair of Japanese Prints*, Cornwall on Hudson, New York, 1948; reprinted, New York, 1978.

This little book, especially in the new form, updated and revised by D. Randall, is the best guide for taking care of Japanese prints.

Statler, O.: *Modern Japanese Prints: An Art Reborn*, Rutland, Vermont and Tokyo, 1959.

This volume, which has an introduction by James A. Michener, was a pioneer study of contemporary Japanese prints and is still the standard book on this subject in English.

Stewart, B.: *Subejcts Portrayed in Japanese Prints: A Guide to All The Subjects Illustrated*, London and New York, 1922.

In spite of its ambitious subtitle, this work is very disappointing in limiting itself largely to very late prints of little merit, with heavy emphasis on *Chūshingura*.

Suzuki, J., and Oka, I.: *The Decadents*, Tokyo and New York, 1969.

This book in the Masterworks of Ukiyo-e series is a study of the work of the leading artists of the late Edo period—Kunisada, Kuniyoshi, and Eisen—by two of Japan's leading ukiyo-e scholars.

Tamba, T.: *Yokohama Ukiyo-e*, Tokyo, 1962.

The most complete book on this subject, it is based largely on Mr. Tamba's private collection. Text mainly in Japanese but with English summary and captions for the numerous plates.

Turk, F. A.: *The Prints of Japan*, London and New York, 1966.

A series of essays on various aspects of Japanese prints such as production, subjects treated, prints outside Edo, *surimono,* and printed books, with much fascinating and useful information.

MONOGRAPHS ON INDIVIDUAL ARTISTS

Brandt, K. J.: *Hosoda Eishi, 1756–1829: Der japanische Maler und Holzschnitt-meister und seine Schüler,* Stuttgart, 1977.

A very complete and scholarly study, but it suffers from having very poor black-and-white illustrations.

Henderson, H., and Ledoux, L.: *The Surviving Works of Sharaku,* New York, 1939.

While not completely up to date, it is still the best study in English of this mysterious artist.

Hillier, J.: *Hokusai,* London, 1955.

An excellent treatment of the work of this artist, with numerous illustrations in color and in black and white.

————: *Utamaro,* London, 1961.

By far the best of many books on this great artist, it is a well-illustrated work by England's leading ukiyo-e scholar.

Hirano, C.: *Kiyonaga: A Study of His Life and Works,* Cambridge, Massachusetts, 1939.

This very complete and scholarly work in two volumes is a model of what an oeuvre catalogue should be, but unfortunately the reproductions are largely in black and white.

Robinson, B. W.: *Kuniyoshi,* London, 1961.

An excellent book on the work of this much-neglected artist.

Shibui, K.: *Utamaro,* Tokyo, 1964.

This book, in Japanese, is volume 13 in a projected series of twenty-four volumes on ukiyo-e called Ukiyo-e Zuten. Although the illustrations are all in black and white and not very well produced, the book is the work

of one of Japan's leading ukiyo-e scholars and is the most complete study of Utamaro ever written.

Strange, E. F.: *The Colour Prints of Hiroshige,* London, 1925.

While there are several more recent and complete books on this artist in Japanese, such as those by Tamba and Uchida, this is still the best and most complete work on Hiroshige in English.

Succo, F.: *Katsukawa Shunshō,* Plauen im Vogtland, 1922.
_____: *Utagawa Toyokuni und seine Zeit,* Munich, 1913; reprinted, 1924.

Although outdated and not well illustrated, these works by an early German ukiyo-e scholar are still the only ones on the two artists in a Western language.

CATALOGUES OF COLLECTIONS OF PRINTS

Art Institute of Chicago: *The Clarence Buckingham Collection of Japanese Prints,* 2 vols., 1955, 1965.

The first volume of this splendid catalogue of one of the great collections of ukiyo-e is devoted to the primitives and was edited by H. C. Gunsaulus. The second volume, covering Harunobu, Koryūsai, Shigemasa, and contemporaries, was edited by M. O. Gentles, R. Lane, and K. Toda.

Hillier, J.: *Japanese Prints and Drawings from the Vever Collection,* 3 vols., London, 1976.

This excellent catalogue of one of the greatest private collections of Japanese prints ever assembled was prepared by the eminent British expert on ukiyo-e.

Ledoux, L. V.: *Japanese Prints in the Collection of Louis V. Ledoux,* 5 vols., New York and Princeton, 1942–51.

This sumptuous and beautifully produced catalogue of what was probably the finest collection of ukiyo-e ever assembled in the United States is a model for what such a publication should be.

Michener, J. A.: *Japanese Prints: From the Early Masters to the Modern,* Rutland, Vermont and Tokyo, 1959.

This book is essentially a catalogue of Mr. Michener's own collection (now

at the Honolulu Academy of Arts), with a lively and enthusiastic text by him and notes by Richard Lane.

National Museum of Ethnology, Leiden: *Philipp Franz von Siebold's Ukiyo-e Collection,* 3 vols., 1978.

A magnificent publication with all items reproduced in superb color plates, it contains a brief text in Japanese by various Japanese and Dutch authorities. The collection itself, however, while historically very significant, has few really first-rate examples except for some Utamaro prints.

Schmidt, S.: *Katalog der chinesichen und japanischen Holzschnitte im Museum für Ostasiatische Kunst,* Berlin, 1971.

A scholarly and well-illustrated catalogue of one of the great public collections of Japanese prints in Europe.

Tokyo National Museum: *Ukiyo-e Hanga-hen: Tōkyō Kokuritsu Hakubutsukan Zuhan Mokuroku* (Ukiyo-e Prints: Illustrated Catalogue of the Tokyo National Museum), 3 vols., Tokyo, 1960–63.

A very complete catalogue of the finest collection of Japanese prints in the country of their origin, reproducing 3,926 prints, many of them originally in the famous Matsukata Collection.

Toledo Museum of Art: *Exhibition of Modern Japanese Prints at the Toledo Museum of Art,* 2 vols., 1930, 1936.

These catalogues, edited by Dorothy Blair, are the most complete and scholarly publications in English on Taishō and Shōwa prints.

EXHIBITION CATALOGUES OF JAPANESE PRINTS

Bowie, T., Kenney, J., and Togasaki, T.: *The Art of Surimono,* Bloomington, Indiana, 1979.

Catalogue of an exhibition of *surimono* at the Indiana University Gallery. Good text and many plates, some in color.

Hillier, J.: *Suzuki Harunobu,* Philadelphia, 1970.

Excellent and beautifully produced catalogue of an exhibition at the Philadelphia Museum of Art marking the bicentenary of the artist's death.

Jenkins, D.: *Ukiyo-e Prints and Paintings: The Primitive Period,* Chicago, 1971.

An excellent and scholarly catalogue of a show held at the Art Institute of Chicago in 1971 in memory of Margaret O. Gentles.

Link, H.: *The Theatrical Prints of the Torii Masters,* Honolulu, 1977.

A scholarly catalogue of an exhibition of actor prints of the Torii school held at the Honolulu Academy of Arts and at the Riccar Art Museum in Tokyo.

Riccar Art Museum: *Exhibition of Ukiyo-e by Ippitsusai Bunchō,* Tokyo, 1978.

Catalogue of an exhibition of this artist's work with brief text in Japanese and a large number of plates, some in color.

Schamoni, W., and others: *Taiso Yoshitoshi: Ein Holzschnittmeister an der Schwelle der Neuzeit,* Cologne, 1971.

A very interesting catalogue with essays by various German scholars on the life, work, and times of Yoshitoshi. Many plates, some in color.

Ukiyo-e Society of Japan (Nihon Ukiyo-e Kyōkai): *An Exhibition of the Prints of the Taishō Era by the Ukiyo-e Society of Japan,* Tokyo, 1963. Text by I. Oka in *Ukiyo-e Geijutsu* (Ukiyo-e Art), no. 4, 1963.

Catalogue of the most ambitious show of Taishō prints ever held.

Vignier, C., and Inada, H.: *Estampes japonaises exposées au Musée des Arts Décoratifs,* 6 vols., Paris, 1909–14.

A magnificent catalogue of what was probably the finest exhibition of Japanese prints ever held. Essays by R. Koechlin.

Waterhouse, D. B.: *Harunobu and His Age,* London, 1964.

Scholarly catalogue of an exhibition held at the British Museum to commemorate the bicentenary of the invention of polychrome printing in Japan.

COMPENDIUMS OF JAPANESE PRINTS

Hillier, J.: *Japanese Masters of the Colour Print,* London, 1954.

A well-chosen selection in a picture book of the popular kind, with a brief discussion of the nature of the print by the well-known British authority.

Kikuchi, S.: *A Treasury of Japanese Wood Block Prints: Ukiyo-e,* New York, 1968.

The work of one of Japan's leading ukiyo-e authorities, it was originally published in Japanese and was translated by D. Kenny. Reproductions of a large number of prints, some in color, with brief essays on the various subjects treated.

Nihon Hanga Bijutsu Zenshū (Collection of Japanese Woodblock Prints), 9 vols., Tokyo, 1960–62.

A well-produced work tracing Japanese prints from their beginnings to the modern period, with 3,000 plates, 400 of which are in color. Brief text in Japanese by a Japanese scholar. Plate list in English.

Ukiyo-e Taikei, 17 vols., Tokyo, 1975–77.

Ambitious publication in Japanese, with English and German lists of plates.

Ukiyo-e Taikei Shūsei, 20 vols., Tokyo, 1931–32; 6 supplementary vols, Tokyo, 1933.

The most ambitious compendium of ukiyo-e prints, this work in Japanese is arranged by artists and has 1,238 illustrations, of which about 600 are in color.

Ukiyo-e Taisei, 12 vols., Tokyo, 1930–31.

Comprehensive publication in Japanese reproducing some 5,000 prints in small size.

Ukiyo-e Zenshū, 6 vols., Tokyo, 1956–58.

Compendium of ukiyo-e prints from Japanese collections, with text in Japanese by leading Japanese authorities and with 1,000 illustrations, of which 100 are in color.

Yoshida, S.: *Ukiyo-e: 250 Years of Japanese Art,* New York, 1980.

The most recent compendium of Japanese prints, edited by a Japanese scholar and with a long introductory essay by Roni Neuer. While the numerous plates, printed in Italy, are not of the best quality, they cover the field from the beginnings of ukiyo-e down to the Meiji era.

Yoshida, T.: *Harunobu Zenshū,* Tokyo, 1942.

This work in Japanese purports to reproduce every print by Harunobu. Though not complete, it is the best book of its type available.

———— : *Utamaro Zenshū,* Tokyo, 1942.

A supposedly complete compendium (in Japanese) of all the work done by Utamaro. Although it by no means includes everything the artist produced, it is useful in reproducing a large number of his prints.

Index

Abè no Nakamaro, 116

abstract prints, 163–64, 176–78

actor prints, 10, 23–30, 42–45, 56–63, 70, 79, 87, 120, 133; by Harunobu, 48; by Kiyomitsu, 43–45; by Kunichika, 138; by Kunimasa, 104; by Kuniyoshi, 131; of the Osaka school, 150–51; by Sharaku, 7, 98–106; by Shunshō, 56–59, 111–12; by Toyokuni, 106; by Toyonobu, 42

Adachi (publisher), 188

African servants, 149

Ainsworth (collector), 182

albums, 183; of Kyoto prints, 152

Alcock, Sir Rutherford, 5

American collectors, *see* collectors

Amida (Buddha of the Western Paradise), 12

Anchi, *see* Kaigetsudō Anchi

Anderson, William, 9; *Japanese Wood Engravings: Their History, Technique, and Characteristics,* 9; *Pictorial Art of Japan,* 9

Ando, *see* Kaigetsudō Ando

Andō Hiroshige, 5–10, 70, 109, 113, 120–27, 128, 131, 139; Plates 55–58; Color Plate 10; followers of, 126–27; as graphic artist, 152; as great master of ukiyo-e, 86; influence of, 7, 126–27; landscape prints by, 6–7, 121–26, 131, 142; prints by, in collections, 183–85, 187

appreciation of Japanese prints, 3–10

art-nouveau movement, 114, 160

Astruc, Zacharie, 5

auctions of ukiyo-e, 189

authenticity of prints, 187

Autumn Moon at Ishiyama (Hiroshige), 125

Bakin, *Suikoden,* 133

baroque works, European, 133

bathhouse girls, 32

battle scenes, by Yoshitoshi, 139

Beauties of the Pleasure Quarters (Eishi), 95

beautiful women (in prints), 31–36, 48–50, 64–67; by Eisen, 134; by Eizan, 134; by Goyō, 155; by Harunobu, 48–50, 80, 89; by Kiyonaga, 80–82, 89; by Kunisada, 129–30; by Shigemasa, 80; by Shinsui, 155–56, by Shunchō, 82; by Toyokuni, 105–6; by Uta-

maro, 87–92; see also *bijinga*,
women
beni, 39
benizuri-e, 37–45, 48
Bidwell, Raymond, 131
bijinga, 32, 64, 106, 119; artists,
155; by Eisen, 133–34; by Eizan,
133–34; by Hokusai, 111; by
Kunisada, 130; see also beautiful
women (in prints)
bin (hair style), 64
bin-sashi, 64
Bing, S. (dealer and collector), 7, 9,
182
bird-and-flower paintings, 50–55,
112, 115, 160
bird-and-flower prints, 160; by Hi-
roshige, 126; by Hokusai, 115; by
Koryūsai, 55; from Kyoto, 152;
by Shōson, 160; sponsored by Wa-
tanabe, 160; see also *kachōga*
Bishamonten, Guardian of the North,
11; Plate 1
black-and-white prints, 19, 27, 37;
see also *sumizuri-e*
Blair, Dorothy, 153
Blomhoff, J. Cock (collector), 4
Bonnard, Pierre, 8, 163, 164
book illustrations, by Kunichika,
138; by Kunisada, 129; by Kuni-
yoshi, 131; of Kyoto, 152; by To-
yokuni, 105; see also illustrated
books
Boston Museum of Fine Arts, see
Museum of Fine Arts, Boston
Boxer, C. P., 150
Bracquemond, Félix, 4, 5
Brinckmann (scholar), 110
British Museum, 9, 11
brocade pictures, see *nishiki-e*
Brown, Louise Norton, 152
Buddha (Shakyamuni), 12

Buddha, footprints of, 12; Plate 2
Buddhism, 23
Buddhist deities, 12
Buddhist iconography, 171
Buddhist prints, 11–15, 167, 171;
Plates 1–3
Buddhist statues, 175
Bukindō (publisher), 149
Bunchō, see Ippitsusai Bunchō
bunjin, 152
bunjinga, 152
Bunka era (1804–18), 111
Bunsei era (1818–30), 111
Burty, Philippe, 5

calendar prints, see *egoyomi*
care of prints, 188–89
Cassatt, Mary, 7, 86
Central Asian wall paintings, 172
Chandler (collector), 182
Cherry Blossoms at Arashiyama (Hiro-
shige), 125
Chibbett, D., 152
Chikanobu, see Toyohara Chikanobu
Chinese, in prints, 149
Chinese-style painting, 49–55, 83,
111–16, 126, 131, 152, 160; see
also bird-and-flower paintings
Ch'iu Ying, 49
Chōbunsai Eishi, 93–95, 105, 109;
Plate 40
Chōki, see Eishōsai Chōki
Chōkōsai Eishō, 95; Plate 41
Chōkyōsai Eiri, 95
Chōshun, see Miyagawa Chōshun
Christianity, 148
Christian prints, 12
Christie's (auction house), 189
chūban, 27
Chūshingura, or *The Story of the Forty-
seven Rōnin* (Yoshitoshi), 139
circuses, 144, 170

The "weathermark" identifies this book as a production of John Weatherhill, Inc., publishers of fine books on Asia and the Pacific. Book design and typography by Miriam F. Yamaguchi and Ruth P. Stevens. Layout of color illustrations by Nobu Miyazaki. Layout of monochrome illustrations by Ruth P. Stevens. Composition, printing, and binding by Samhwa, Seoul. The typeface used is 12-point Monotype Perpetua.